D0131734

WITHDRAWN

MONSTROUSLY FUNNY CARTOONS

CHRISTOPHER HART

MONSTROUSLY

FUNNY CARTOONS

WATSON-GUPTILL PUBLICATIONS
Berkeley

Copyright © 2014 by Cartoon Craft LLC

All rights reserved.
Published in the United States by Watson-Guptill Publications,
an imprint of the Crown Publishing Group, a division of Random
House LLC, a Penguin Random House Company, New York.
www.crownpublishing.com
www.watsonguptill.com

WATSON-GUPTILL and the WG and Horse designs are registered
trademarks of Random House LLC

Library of Congress Cataloging-in-Publication Data
Hart, Christopher, 1957-
 Monstrously funny cartoons / Christopher Hart. — First Edition.
 pages cm
1. Monsters in art. 2. Cartooning—Technique. I. Title.
 NC1764.8.M65H377 2014
 741.5'1—dc23
 2014018093

Trade Paperback ISBN: 978-0-8230-0716-5
eBook ISBN: 978-0-8230-0717-2

Printed in the United States of America

Design by M80 Design and Katy Brown
Production by Debbie Berne Design

10 9 8 7 6 5 4 3 2 1

First Edition

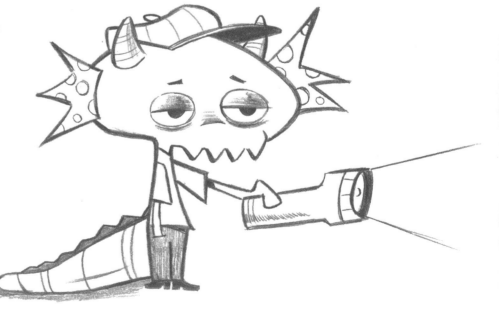

I'd like to thank the frighteningly good crew at Watson-Guptill/Ten Speed Press,
my preternaturally prescient literary agent, Susan Schulman,
and all of my terrifyingly talented loyal readers.

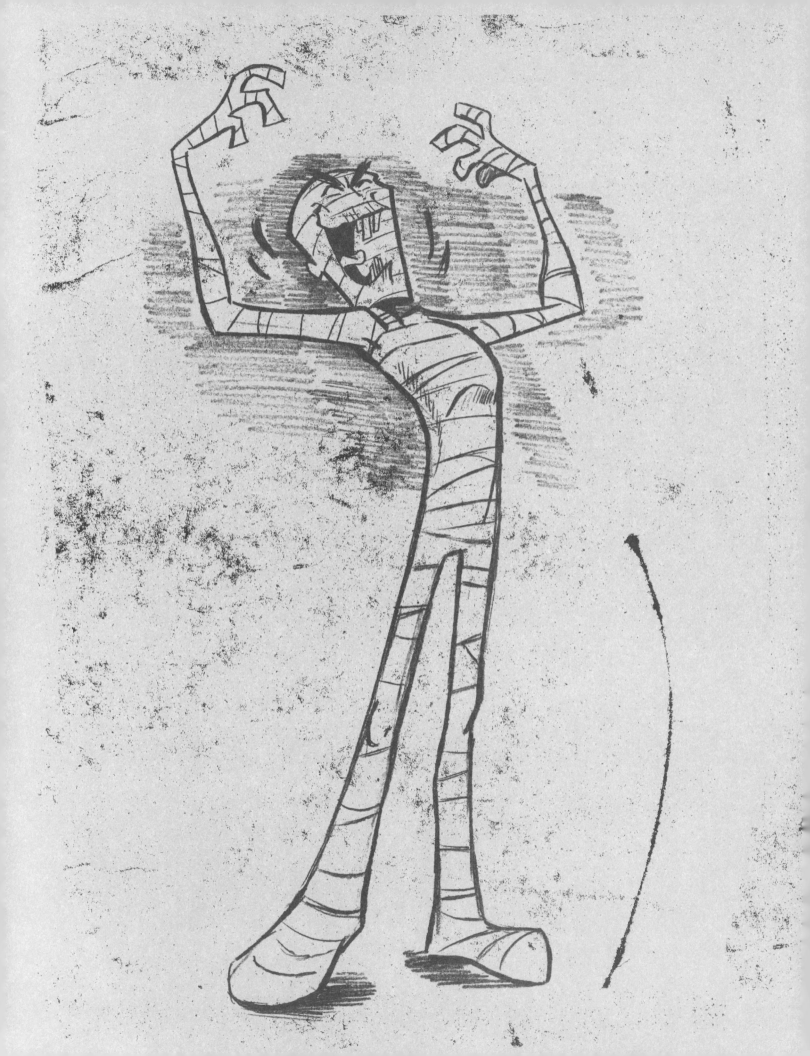

CONTENTS

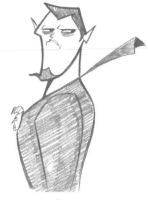
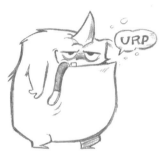
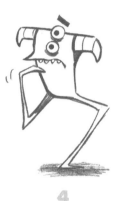
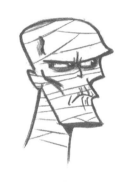
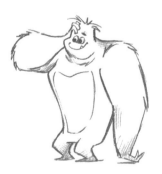

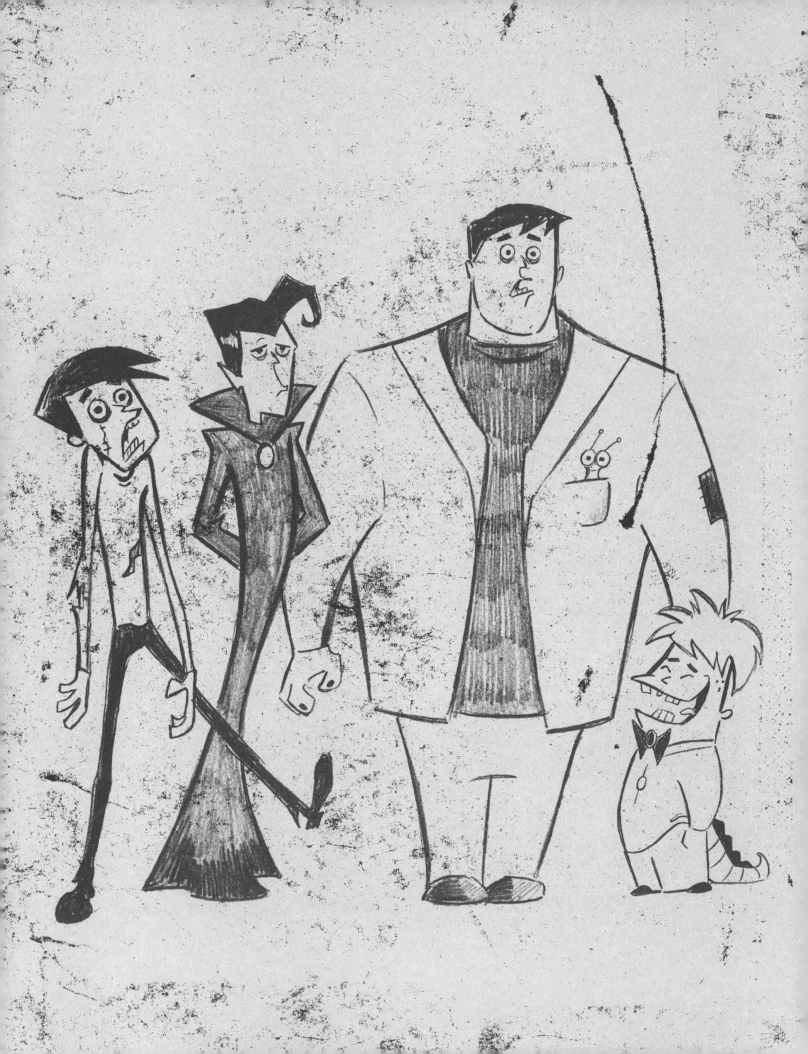

INTRODUCTION

BOO! Cartoon monsters are at the pinnacle of their popularity. Every year seems to bring another blockbuster animated movie featuring funny zombies, ghouls, aliens, vampires, mummies, and more. Hit films such as *Shrek*; *Monsters, Inc.*; *Monsters vs. Aliens*; *Hotel Transylvania*; and *Despicable Me* have catapulted these characters to the top of everyone's list of favorites. If you're interested in learning how to draw cartoon monsters, this is the perfect book to get you started. It features clear and easy-to-follow step-by-step instruction. It's also an excellent resource for more experienced artists and cartoonists who need to be fluent in the latest, most popular genres. My goal has always been to give you the tips and pointers you need to stay on top of changing cartooning styles. This book will keep you ahead of the curve.

There is a lot to drawing today's cartoon monsters. Gone are the days when you could just draw big, lumbering green goons. These new monsters have human foibles, coupled with inventive character designs. They are witty, flummoxed, sneaky, fearful, mischeivous, vain—and more.

I'll introduce you to many valuable and useful tools you can use to create cartoon characters, including proportions, posture, symmetry and asymmetry, expressions, costumes, props and icons, and contrast. You'll also learn how to create humorous settings and layouts for your characters.

The art instruction techniques you're about to learn are based on sound art and design principles taught in major art schools across the country. Therefore, this book's lessons may raise your skill level for drawing characters in any genre. Before I begin, a small word of caution: Please don't pet or feed the monsters. It's a really bad idea.

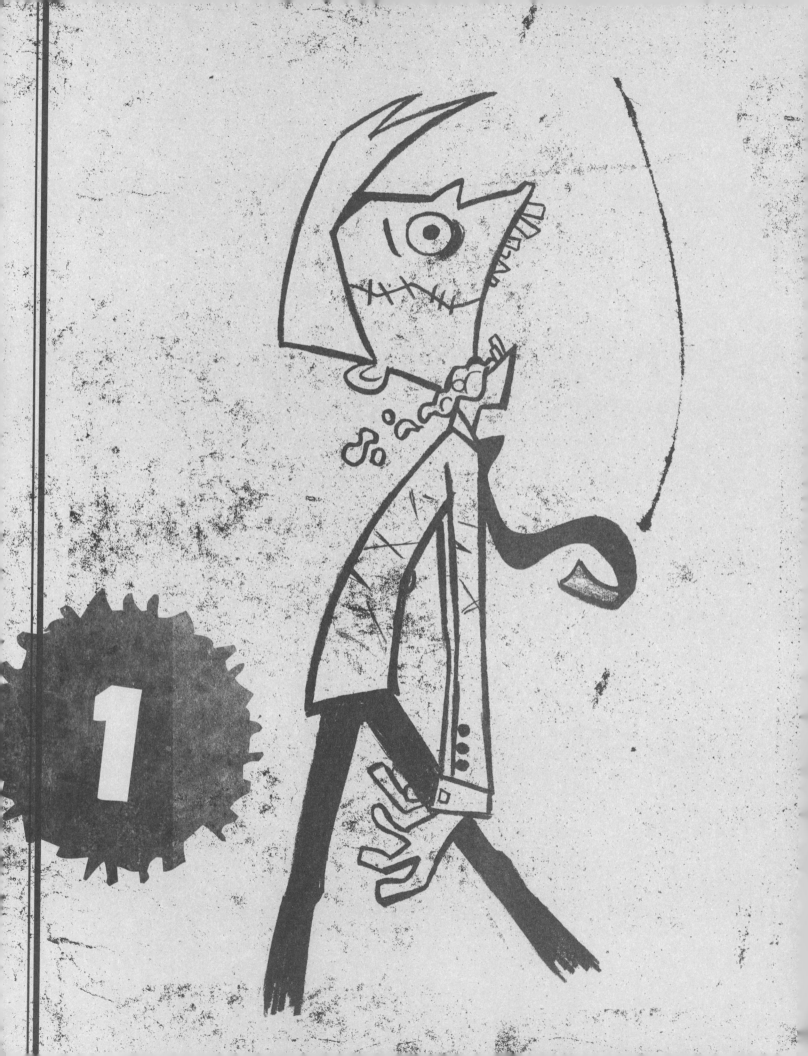

ZOMBIE MANIA

ZOMBIES are known as the quintessential "always-moving-forward-but-never-taking-a-step-backward" monsters. Like most monsters, they come with a well-established backstory: They're undead. This means that they're slow and are determined to turn all humans into the undead, too. No one really knows why they want that so badly, but since it's first on any zombie's to-do list, I'll show you how to caricature zombie actions and how to give these monsters a fresh, humorous twist. For many cartoonists, zombies are delicious characters. For zombies, you're pretty delicious, too.

Zombie Heads and Facial Features

Zombie heads are just like yours and mine. The only real difference is the "living dead" part. And that results in bigger eyes and creepier mouths.

ZOMBIE EYES

Drawing classic zombie eyes requires more than just drawing the pupils in the middle of the eyeballs. That's what you draw for a stare. Zombies don't stare. They look with *unfocused* eyes. This means you'll want to draw their eyes looking ever so slightly in opposite directions.

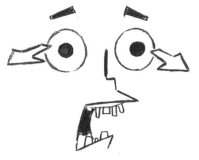

Normal eyes: The pupils are close together, and the pupils have small white highlights, which add liveliness.

Zombie eyes: Zombie pupils are too wide apart to see stereoscopically. But don't overdo it. It's funnier when things look only a little askew.

Remove the highlights from the eyes. You don't want them to look too lively, after all. Instead, add deep rings under both eyes. A sketchy gray works best for this task.

FEMALE ZOMBIE EYES

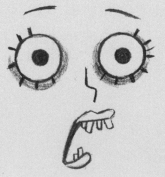

What's special about female zombie eyes? The eyelashes. That's not mascara that's making them look stiff. It's rigor mortis.

ZOMBIE MOUTH

The jaw muscles are the first thing to go on a zombie, leaving them with a vocabulary that consists of "words" like *Reeerrrr!* and *Urrrggghhh!* Of course, no one really expects much witty repartee from a zombie, anyway. Bring out the humor of the opened-mouth position by drawing a huge overbite combined with a small underbite. Sort of like a teenager's mouth before the first visit to the orthodontist.

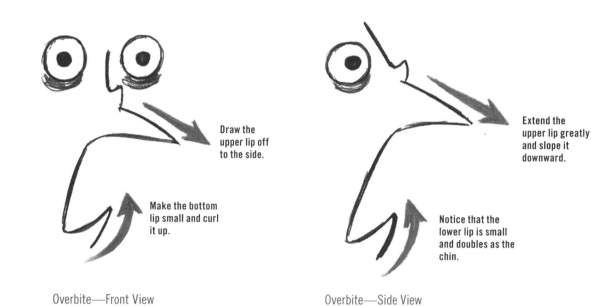

Draw the upper lip off to the side.

Make the bottom lip small and curl it up.

Overbite—Front View

Extend the upper lip greatly and slope it downward.

Notice that the lower lip is small and doubles as the chin.

Overbite—Side View

ZOMBIE TEETH

A zombie's teeth should look as if he spent a few days chewing on bricks. Never draw the teeth in an even row. Instead, add spaces between the teeth. The tooth fairy is going to be visiting him quite often over the next forty-eight hours.

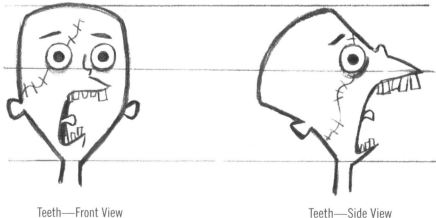

Teeth—Front View

Teeth—Side View

THE ZOMBIE MOUTH "STRETCH"

It's important to remember that the only movable part of the mouth is the bottom jaw. The maxilla—the top part—is fused to the skull. Not that you should ever let proper anatomy get in the way of a good cartoon. An excellent technique for emphasizing the mindless aspect of a zombie is to draw the chin w-a-a-a-y down low while keeping the opening of the mouth shallow.

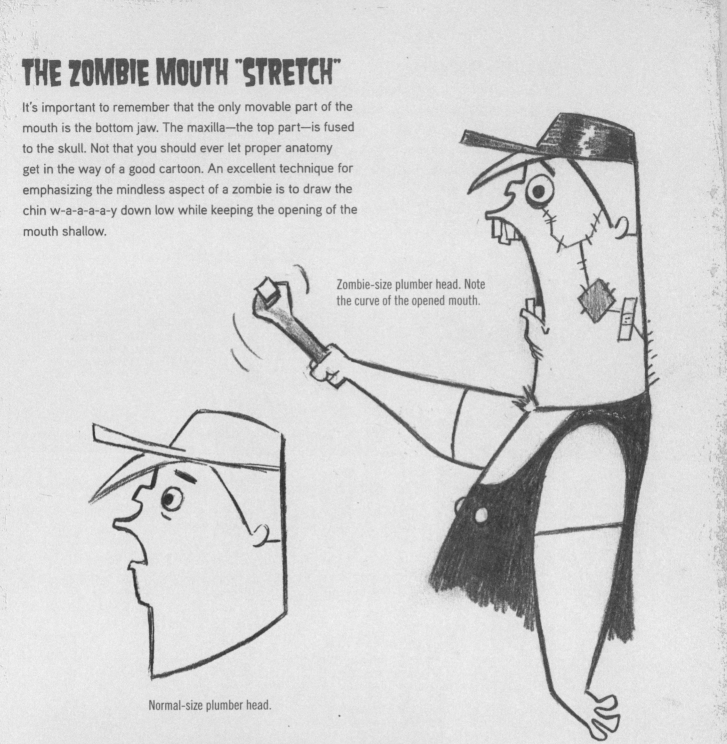

Zombie-size plumber head. Note the curve of the opened mouth.

Normal-size plumber head.

GENERAL CHARACTERISTICS OF ZOMBIES

- Zombies are not very limber.
- Zombies are very slow but will catch you anyway.
- Zomies are very ripe. One might say overripe.
- If someone shrieks because he sees a zombie, he usually freezes in fear and is caught by the zombie.
- Zombies don't generally look cheerful.

- Zombies never blink.
- Zombies can be drawn with fun motifs such as stitches, torn clothing, peeling skin, insect infestation, and falling limbs. But don't be insensitive about it. Remember, we're laughing *with* the zombies, not *at* them.

Zombie Surprise

In the example below, the joke is on the zombie, who doesn't realize that she's dead. Of course, when your liver becomes a nursery for insect larvae, you ought to get the hint. In humorous illustration, laughs often come from the *reaction* to the gag rather than from the gag itself. Therefore, let's draw this sight gag at the point where the zombie girl gives her big reaction.

Start with a normal, open mouth.

Angle the head back to make more room for the wider mouth.

The zombified mouth is wider.

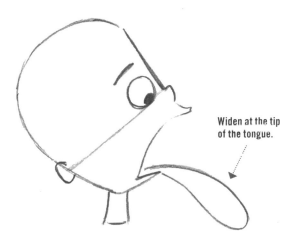

Widen at the tip of the tongue.

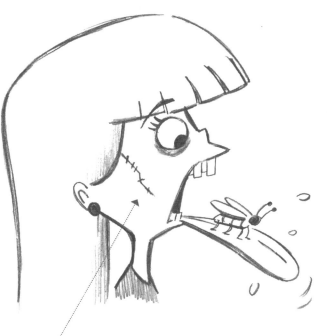

Add stitches. (If there's a strong breeze, you don't want her face flying apart!)

Transformation into a Zombie

It's educational to see how an ordinary person transforms into a zombie. I think you should ask your biology teacher if you can get class credit for this lesson. Let's start with an average, middle-class human. Look carefully at the image below. Note the soulless eyes, the lifeless look, and the quiet despair! Okay, now look at the zombie. He's got a similar expression, only he appears to be well past his expiration date.

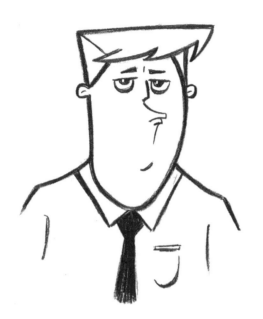

Normal Human

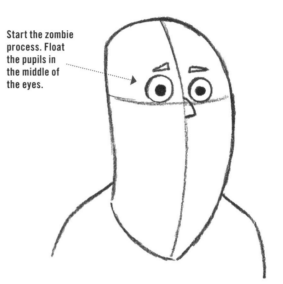

Start the zombie process. Float the pupils in the middle of the eyes.

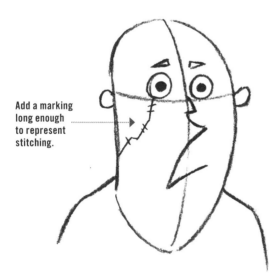

Add a marking long enough to represent stitching.

Give him bad hair and teeth.

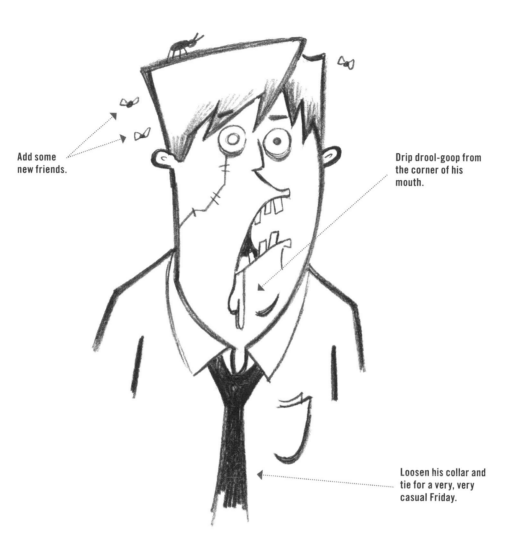

Add some
new friends.

Drip drool-goop from
the corner of his
mouth.

Loosen his collar and
tie for a very, very
casual Friday.

HEAD HINT

In this basic construction, his eye line is
two-thirds of the way up the head.

Hard to Kill

Have you ever tried to kill a zombie? If you have, you know it's nearly impossible to do, because they're *already* dead. What you're really trying to do when you attempt to kill a zombie is to make it even *deader*, which makes no sense whatsoever. Nevertheless, there will always be some courageous, not-too-bright hero who tries to take on the zombies to protect his friends. This is how zombies recruit other zombies.

For cartoonists, an effective way to portray zombie humor is through subtlety. Bet you never thought you'd see the words *subtlety* and *zombie* in the same sentence. By underplaying the comedy, you actually get *more* laughs.

SIMPLE CARTOONIST'S TRICK

Zombies' heads can tilt very far back. The farther they tilt, the funnier it looks. However, drawing a head at this extreme angle can be challenging. Is there an easier way? I'm so glad you asked. A simple method is to reoriente the piece of paper. Here are the two steps:

1. Start with a piece of paper vertically positioned. Before you draw, tilt the top of the page slightly to the left. Draw the zombie head in an upright position, as if the paper were still straight up and down.
2. Once you've drawn the head in the upright position, rotate the top of the page back so that the paper—not the drawing—is straight up and down. The zombie's head now appears to lean backward. Continue to draw the body from this position.

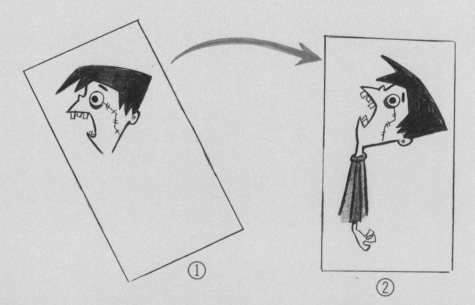

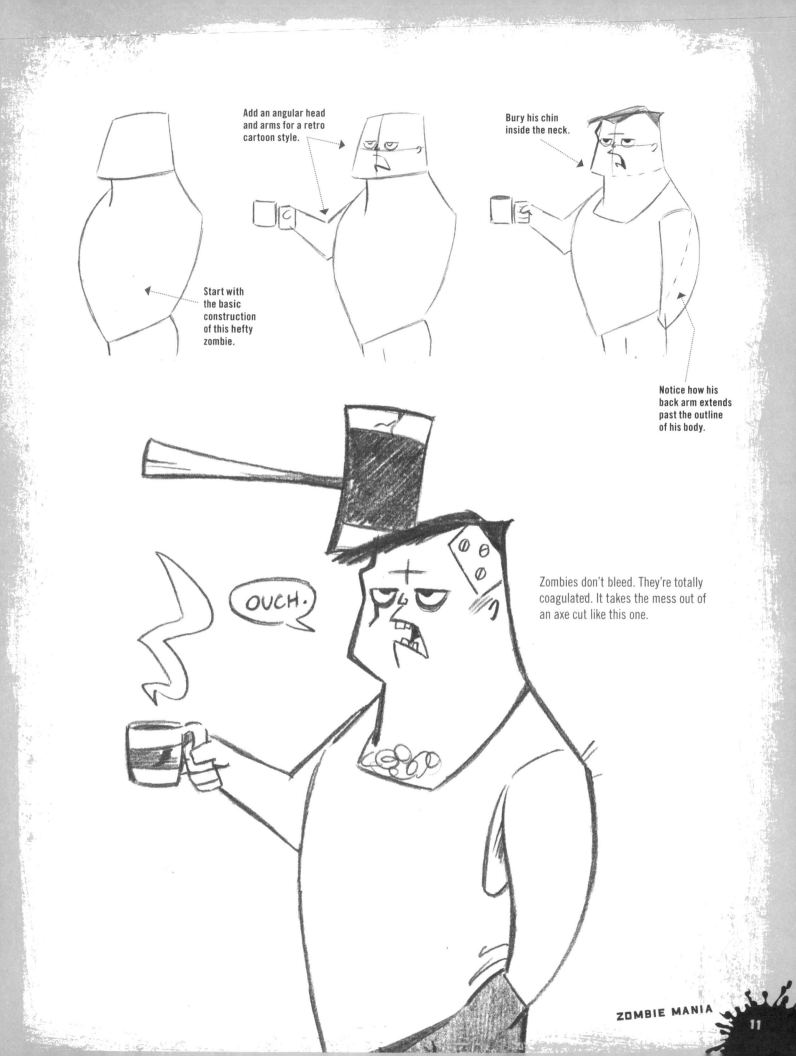

Add an angular head and arms for a retro cartoon style.

Bury his chin inside the neck.

Start with the basic construction of this hefty zombie.

Notice how his back arm extends past the outline of his body.

OUCH.

Zombies don't bleed. They're totally coagulated. It takes the mess out of an axe cut like this one.

Zombie Body Language

Body language is essential for conveying zombie poses. Zombie poses are stiff and therefore somewhat off balance. Zombies lumber. You'd know their walks a mile away, which raises the question: How do they catch anyone? Who in the world could miss that walk? And another thing: They're *slow*. How can *anyone* get caught by a zombie? Just move to the side!

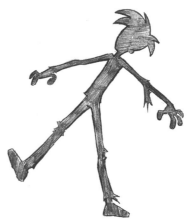

Normal posture: Relaxed, somewhat confident. All the blood vessels are engorged.

Failed zombie: Here's how your friend might pose as a zombie. He hasn't read my book. But this looks more like the pose of a math teacher who has caught a student in a good mood.

Classic zombie pose: To walk, a zombie throws one side of his body forward and then throws the other side. He leans as he walks and holds his arms out as if preparing to strangle someone.

ZOMBIE WALK

Here are some finer points for drawing a rigor mortis–induced stroll:

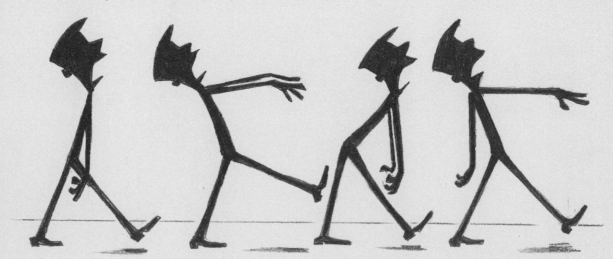

Upright walk

Arms straight ahead with a backward lean

Rare forward-lean with hanging arms

The single-arm shuffle walk (Oh look, a lefty!)

MONSTROUSLY FUNNY CARTOONS

FUNNY POSTURE

Being a stiff doesn't mean a zombie must walk with ruler-straight posture. Because zombies don't swing their arms, they don't appear to have any momentum as they walk. But you should add the appearance of momentum to suggest movement. This is done most commmonly by posing the zombie leaning forward at the waist. (Sometimes it's drawn leaning backward at the waist. The legs move forward, but the body drags behind.)

Your zombie can lean forward with either his chest in or his chest out. Either way, when combined with a backward-tilting head, this results in a truly funny walk:

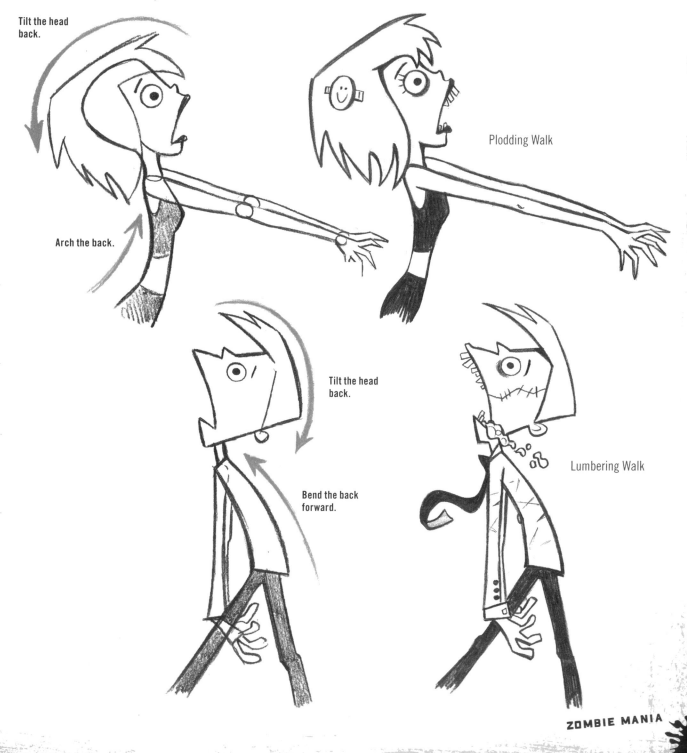

Tilt the head back.

Arch the back.

Plodding Walk

Tilt the head back.

Bend the back forward.

Lumbering Walk

The Zombie Family

Zombie children who grow up in a two-zombie-parent home are just as likely to grow up to feed on human flesh as are zombie children who grow up in a single-zombie-parent home. If you believe the statistics.

There is something that all zombie families have in common with just about every human family: They're all festivals of dysfunctional personalities.

DAWN OF THE DAD

Zombie dad is confident, optimistic, and clueless. His "can do!" spirit is not infectious. Note the self-assured smile. Sure, the zombies may have eaten his neighbors and the baby-sitter, but he's focused like a laser beam.

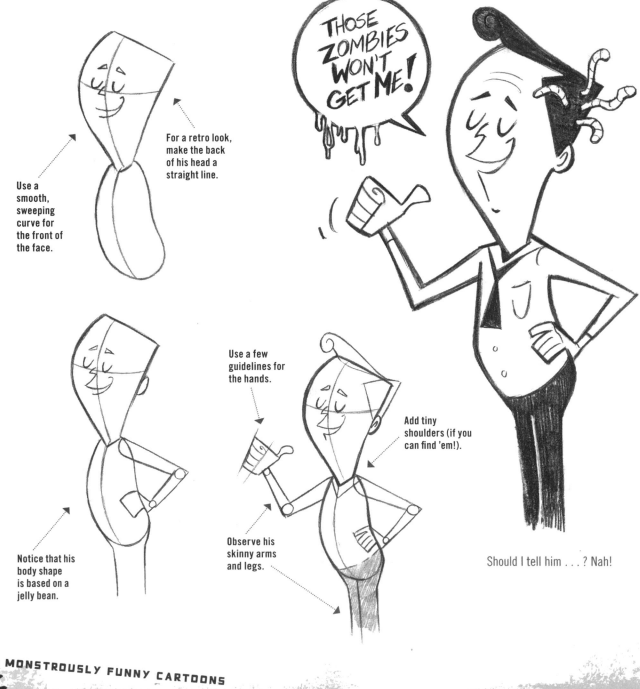

For a retro look, make the back of his head a straight line.

Use a smooth, sweeping curve for the front of the face.

Notice that his body shape is based on a jelly bean.

Use a few guidelines for the hands.

Observe his skinny arms and legs.

Add tiny shoulders (if you can find 'em!).

THOSE ZOMBIES WON'T GET ME!

Should I tell him . . . ? Nah!

ZOMBIE DEAREST

Indeed, moms do make great zombies. Their compulsive need to be helpful doesn't end when their hearts stop beating. Dead and decomposing? A mere speed bump! Have some milk and brains!

Every part of the undead mom's body is completely stiff. She also has razor-sharp teeth and deep circles under her eyes.

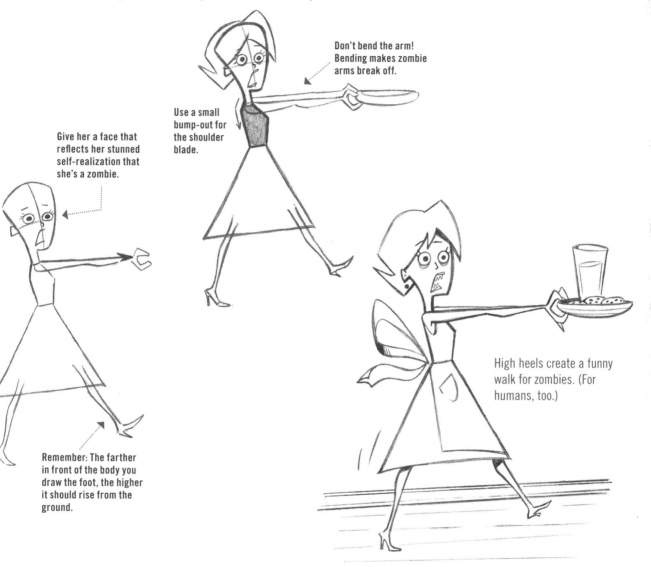

Don't bend the arm! Bending makes zombie arms break off.

Use a small bump-out for the shoulder blade.

Give her a face that reflects her stunned self-realization that she's a zombie.

Remember: The farther in front of the body you draw the foot, the higher it should rise from the ground.

High heels create a funny walk for zombies. (For humans, too.)

DETAIL: FEMALE FOOT

The cartoon female foot in a cartoon high heel can result in cartoon bunions. The front of the shin bone (tibia) travels in a straight line to the base of the toes.

LE SISTER D'MORTE (THE SISTER OF DEATH)

Who among us hasn't at one time or another suspected his little sister of being a zombie? You may already have noticed some of the signs.

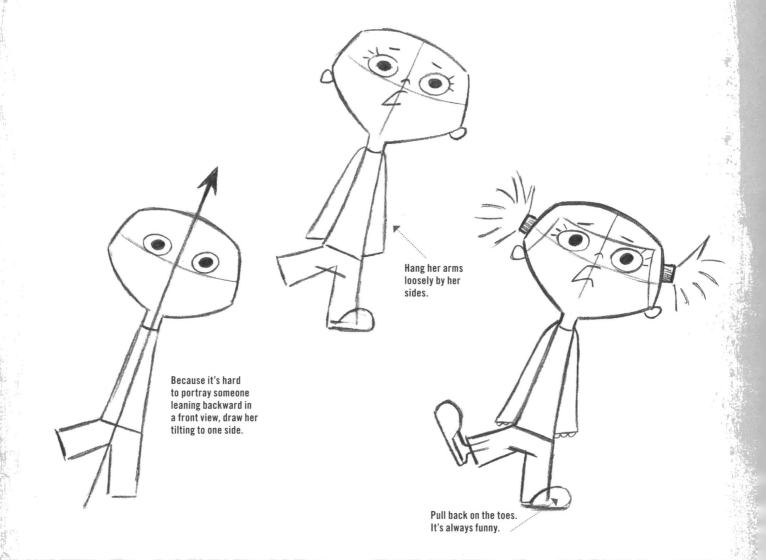

Because it's hard to portray someone leaning backward in a front view, draw her tilting to one side.

Hang her arms loosely by her sides.

Pull back on the toes. It's always funny.

ZOMBIE EYES HINT

Reinforce the oval shape of the pupils by making the shape of the eyeballs oval as well.

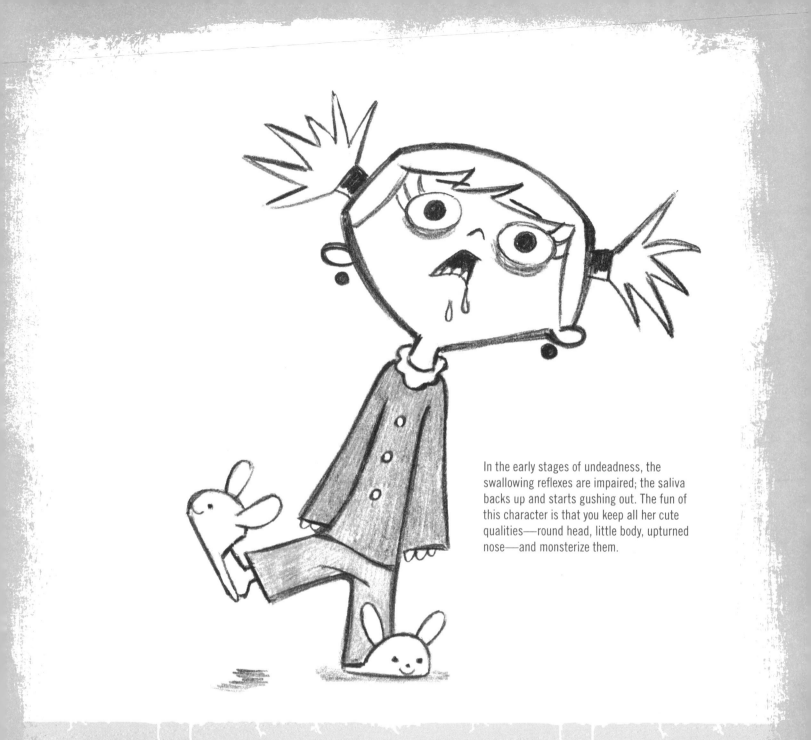

In the early stages of undeadness, the swallowing reflexes are impaired; the saliva backs up and starts gushing out. The fun of this character is that you keep all her cute qualities—round head, little body, upturned nose—and monsterize them.

ZOMBIE SISTER CHECKLIST

- Does she wake up each morning for school with a lifeless look on her face?

- Does she refuse to eat regular food?

- Does she stare blankly into space? (In social studies, for example.)

- Does she mumble?

- Are her clothes dark and dreary?

If you answered yes to the majority of these questions, sorry, your sister is merely a human preteen. The only way to tell she's a zombie is when her fingers are too stiff to text.

ROOM TEMPERATURE YOUNGER BROTHER

When everyone else scurries to class, who's always the last to arrive? The zombie. Who does the hall monitor always give a demerit to because he's late? The zombie. Who comes to the student dance without a date and sits out every song? The captain of the chess team . . . and the zombie.

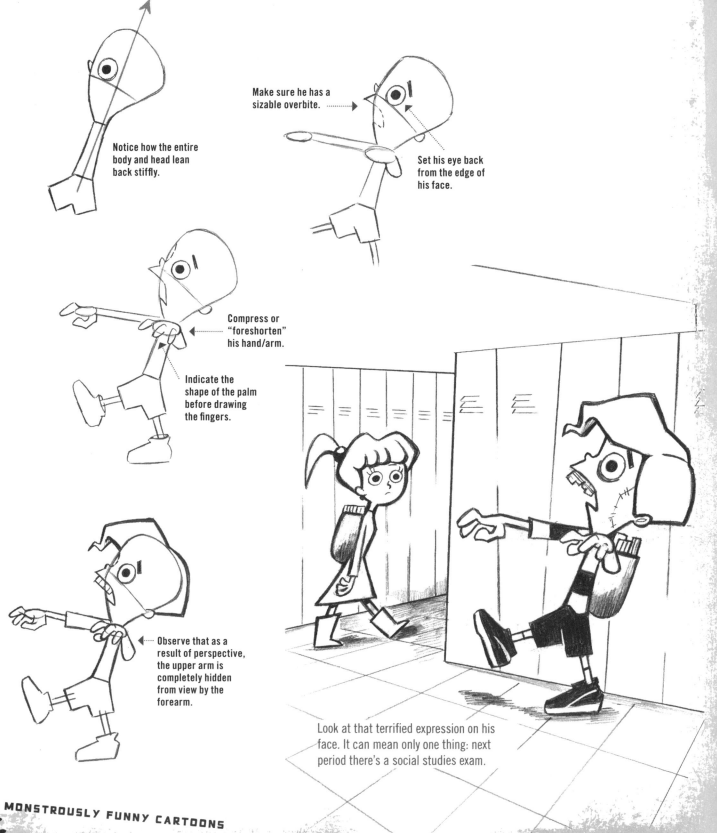

Notice how the entire body and head lean back stiffly.

Make sure he has a sizable overbite.

Set his eye back from the edge of his face.

Compress or "foreshorten" his hand/arm.

Indicate the shape of the palm before drawing the fingers.

Observe that as a result of perspective, the upper arm is completely hidden from view by the forearm.

Look at that terrified expression on his face. It can mean only one thing: next period there's a social studies exam.

THE OLDER, MOLDIER BROTHER

Life is complicated for zombies. Even the simplest tasks are hard for them. Ever try texting without bending your arms?

Zombies and other humanoid creatures of the night are fun to draw as superskinny characters. It's a highly stylized look that is popular in contemporary monster cartoons. And because this zombie may not have eaten anyone in days, it's also a very realistic look!

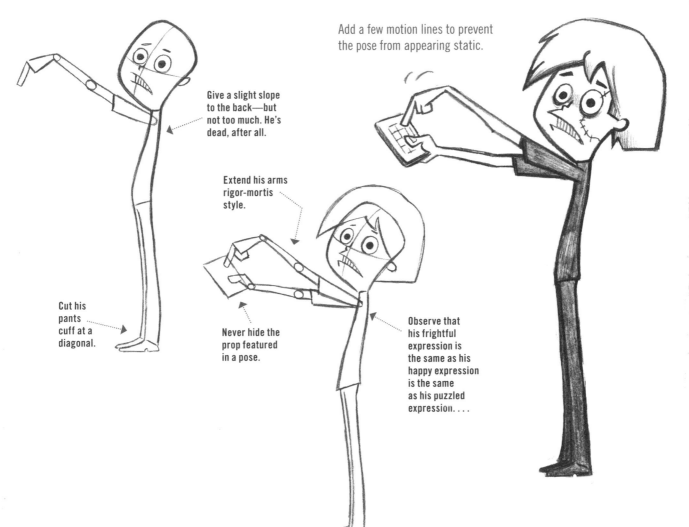

Add a few motion lines to prevent the pose from appearing static.

Give a slight slope to the back—but not too much. He's dead, after all.

Extend his arms rigor-mortis style.

Cut his pants cuff at a diagonal.

Never hide the prop featured in a pose.

Observe that his frightful expression is the same as his happy expression is the same as his puzzled expression. . . .

CLASSIC HAND POSE HINT

The "I will kill you!!" monster hand pose is a traditional look for all the undead. It's like a secret handshake.

Here's how to draw it: First, draw a downward slope from the wrist to the first row of knuckles. Then draw another downward slope from the second row of knuckles to the tips of the fingers.

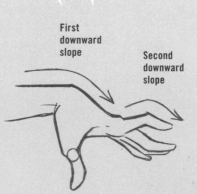

First downward slope

Second downward slope

High School Zombies

Teen zombies pose a challenge. They need to show boundless energy. That's hard to do when you've only recently been unearthed. It's a good idea to show the characters in preppy outfits.

RAH! RAH! SIS-BOO-BAH!

You have to hand it to her; she's trying hard to fit in with the other students. Uh-oh! Better close your eyes for this part—she's about to attempt to do the splits!

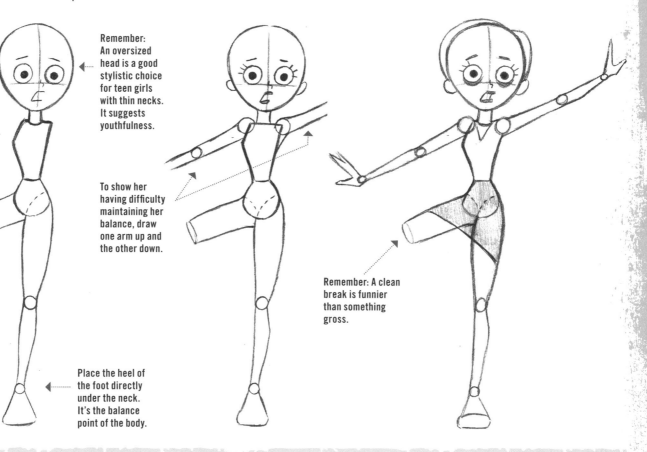

Remember: An oversized head is a good stylistic choice for teen girls with thin necks. It suggests youthfulness.

To show her having difficulty maintaining her balance, draw one arm up and the other down.

Remember: A clean break is funnier than something gross.

Place the heel of the foot directly under the neck. It's the balance point of the body.

SHOULDER HINT

The shoulders may be petite, but they are still well-defined and athletic. Note the gaps between the shoulders and the neck, where it dips.

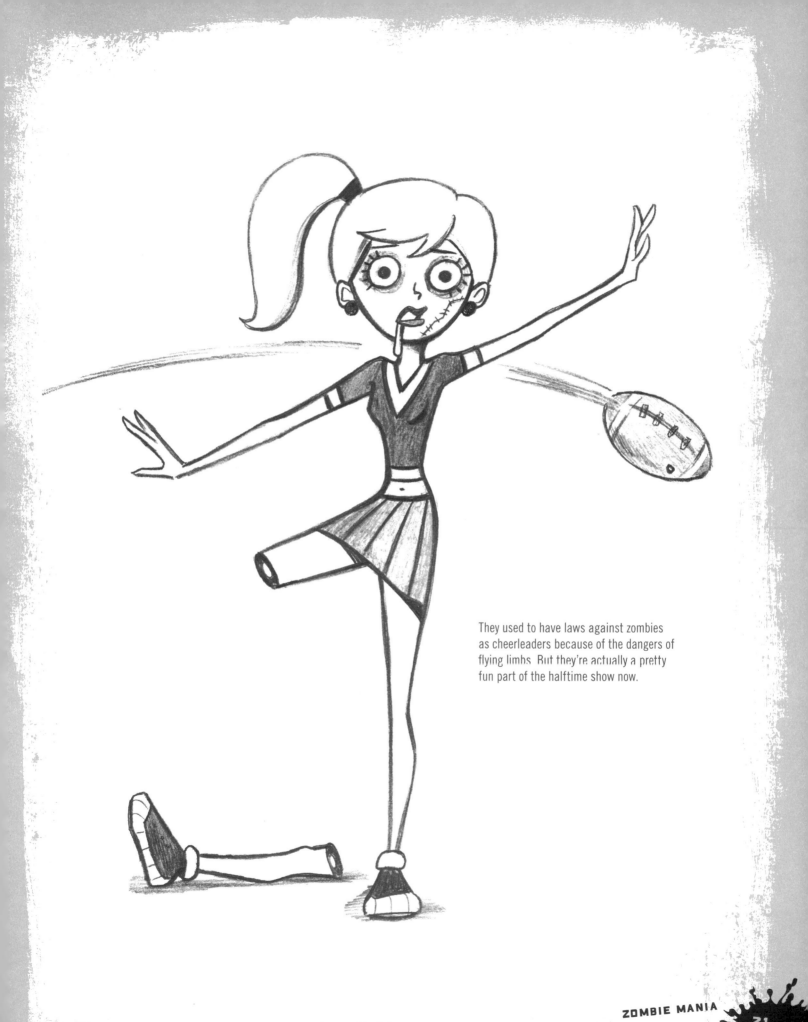

They used to have laws against zombies as cheerleaders because of the dangers of flying limbs. But they're actually a pretty fun part of the halftime show now.

MALL ZOMBIES

You may believe you're in danger of running into a zombie only if you get a flat tire on a desolate country road in Crapville, USA. (If that happens, do not—I repeat, do not—take shelter in a run-down shack at the bottom of a hill.) I'm afraid the danger is more widespread than that, my friends. Today's zombies are *everywhere*. They're even at the mall, where you can see them mindlessly wandering from store to store, buying up everything they can and returning the same items the next day.

Placing an unusual character in a mundane environment is called a "fish out of water" setup. It's a funny approach, especially with monsters, who appear *way, way* out of water.

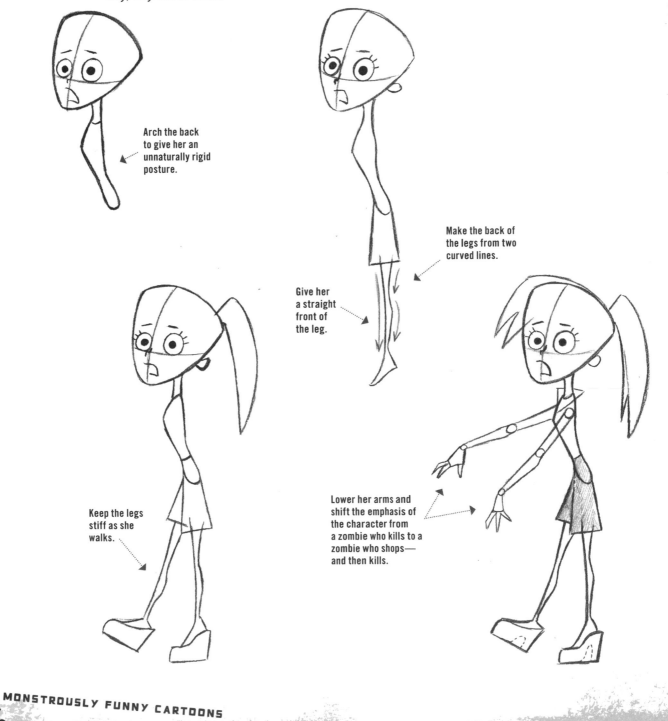

Arch the back to give her an unnaturally rigid posture.

Make the back of the legs from two curved lines.

Give her a straight front of the leg.

Keep the legs stiff as she walks.

Lower her arms and shift the emphasis of the character from a zombie who kills to a zombie who shops— and then kills.

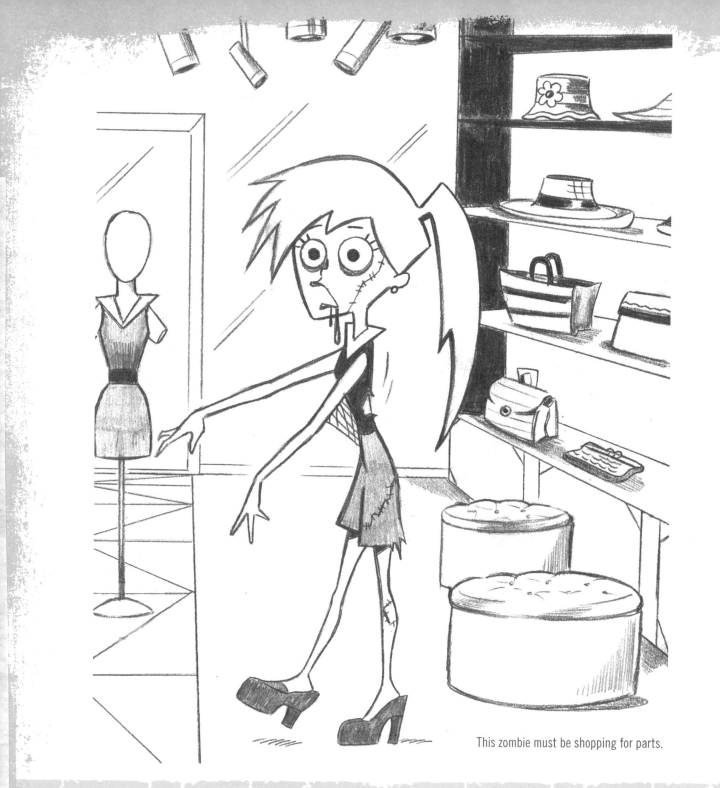

This zombie must be shopping for parts.

ALTERNATIVE MOUTH

Sometimes you need a little extra *ooomph* to make a pretty girl character look evil. One way to do it is to give her razor-sharp sharklike teeth but not fangs. Fangs are only for vampires, not zombies.

Caffeine Zombies

Caffeine zombies are part of a quiet epidemic affecting major metropolitan areas across the nation. You can see them every weekday morning at 6 a.m.—a mindless mob piling into subway stations.

Traveling three hours each way, every day, from the suburbs to the city turns everyone into a zombie sooner or later.

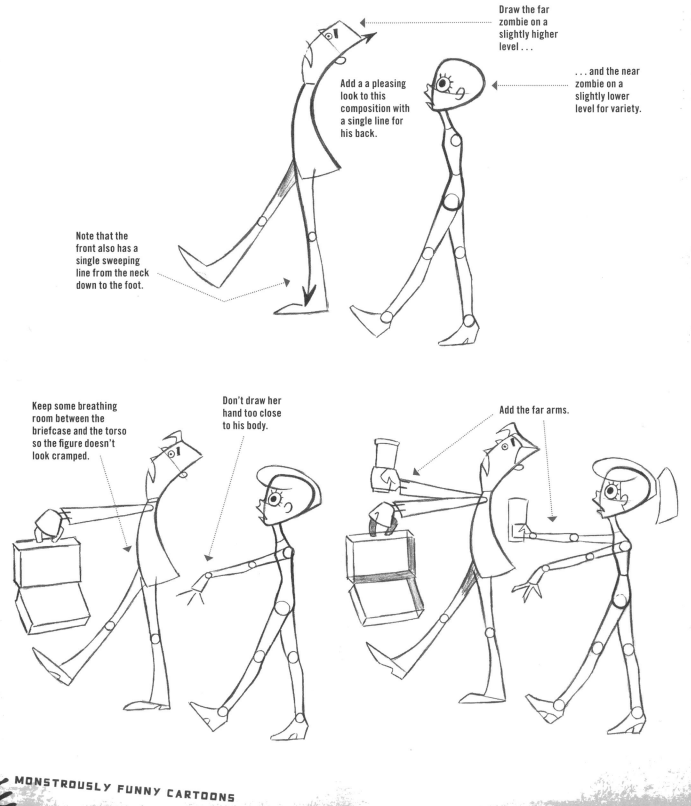

Draw the far zombie on a slightly higher level . . .

. . . and the near zombie on a slightly lower level for variety.

Add a a pleasing look to this composition with a single line for his back.

Note that the front also has a single sweeping line from the neck down to the foot.

Keep some breathing room between the briefcase and the torso so the figure doesn't look cramped.

Don't draw her hand too close to his body.

Add the far arms.

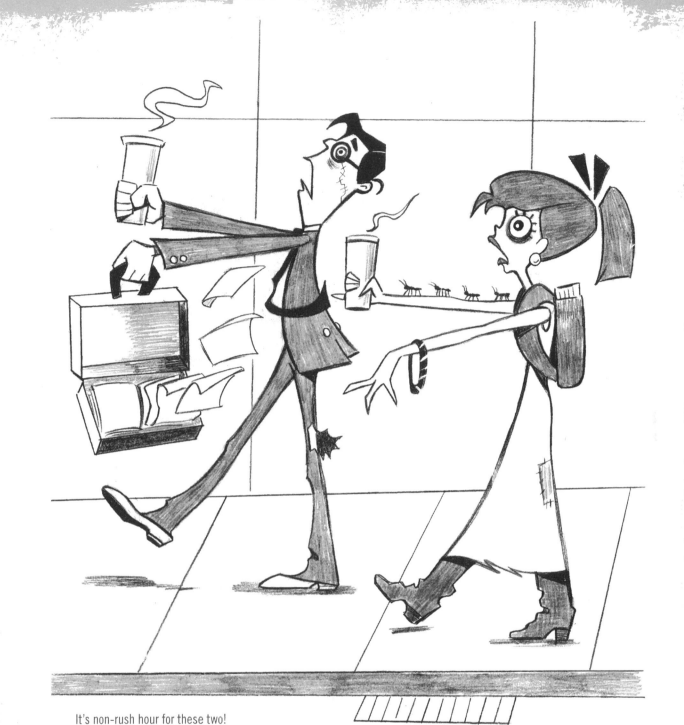

It's non-rush hour for these two!

DETAIL: HAND HOLDING THINGS

When you draw a smaller hand grasping something wide, such as this cup of coffee, don't let the thumb overlap the fingers. Instead, leave a gap between them.

The Zombie Bride and Goon

Love. It's such a mysterious word. What does it really mean? Does it mean one monster loving another monster against all odds? No, I don't think so. Could it be when a monster of one type defies his parents to marry a monster of another type? I don't know; I never thought about it before. Maybe it's simpler than all that. Maybe love just means two monsters, with nothing in common, who come from warring clans, forced to marry to keep the peace, who then end up liking each other after all. I think that comes closest to the definition of love.

Opposites may attract, but they also make funny monster couples. Look at all the differences between these two:

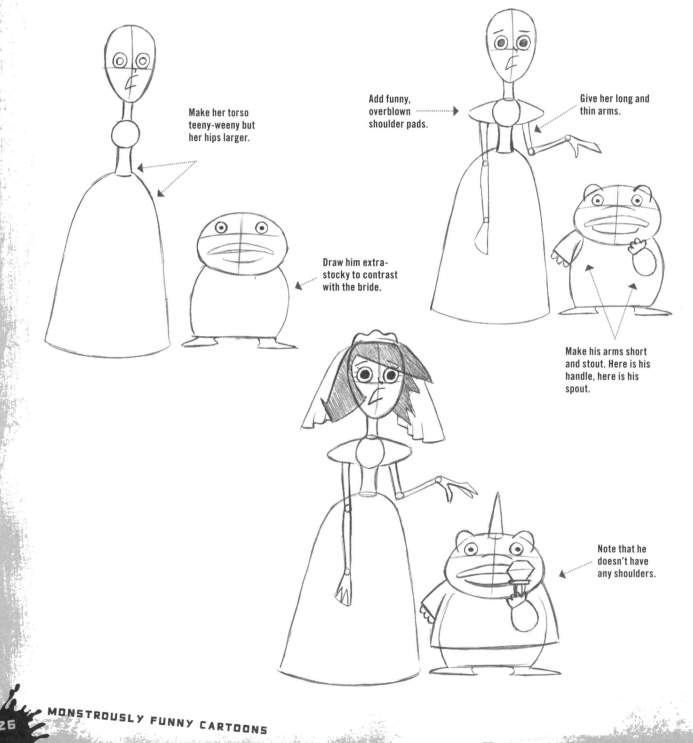

Make her torso teeny-weeny but her hips larger.

Add funny, overblown shoulder pads.

Give her long and thin arms.

Draw him extra-stocky to contrast with the bride.

Make his arms short and stout. Here is his handle, here is his spout.

Note that he doesn't have any shoulders.

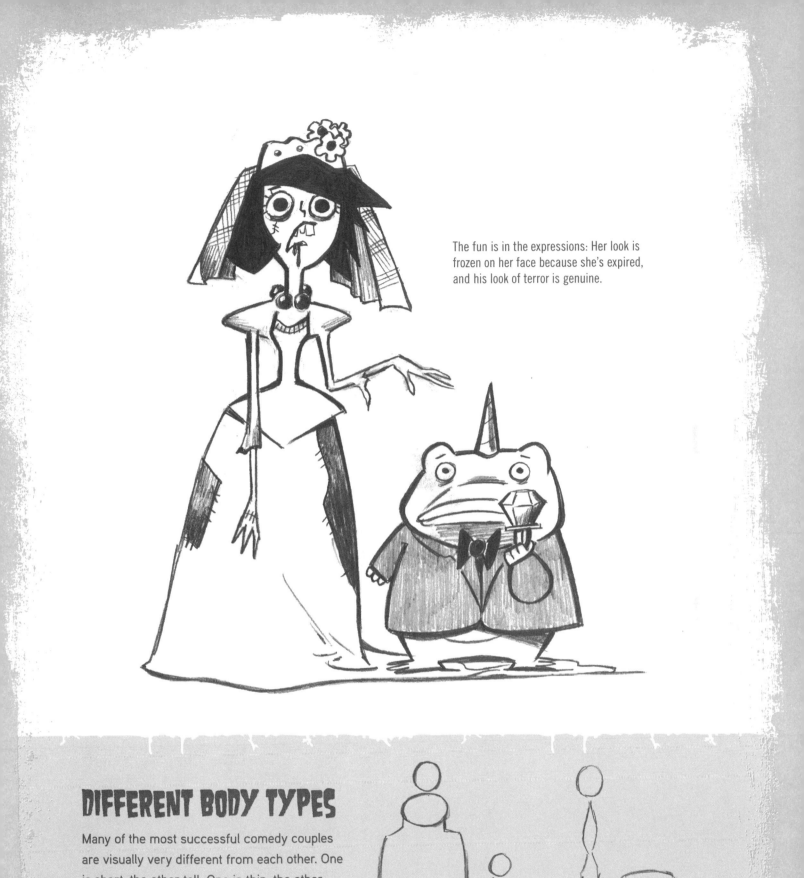

The fun is in the expressions: Her look is frozen on her face because she's expired, and his look of terror is genuine.

DIFFERENT BODY TYPES

Many of the most successful comedy couples are visually very different from each other. One is short, the other tall. One is thin, the other heavy. One is a dead human, the other is . . . what *is* that thing anyway?

Tall and heavy Short and thin Tall and thin Short and heavy

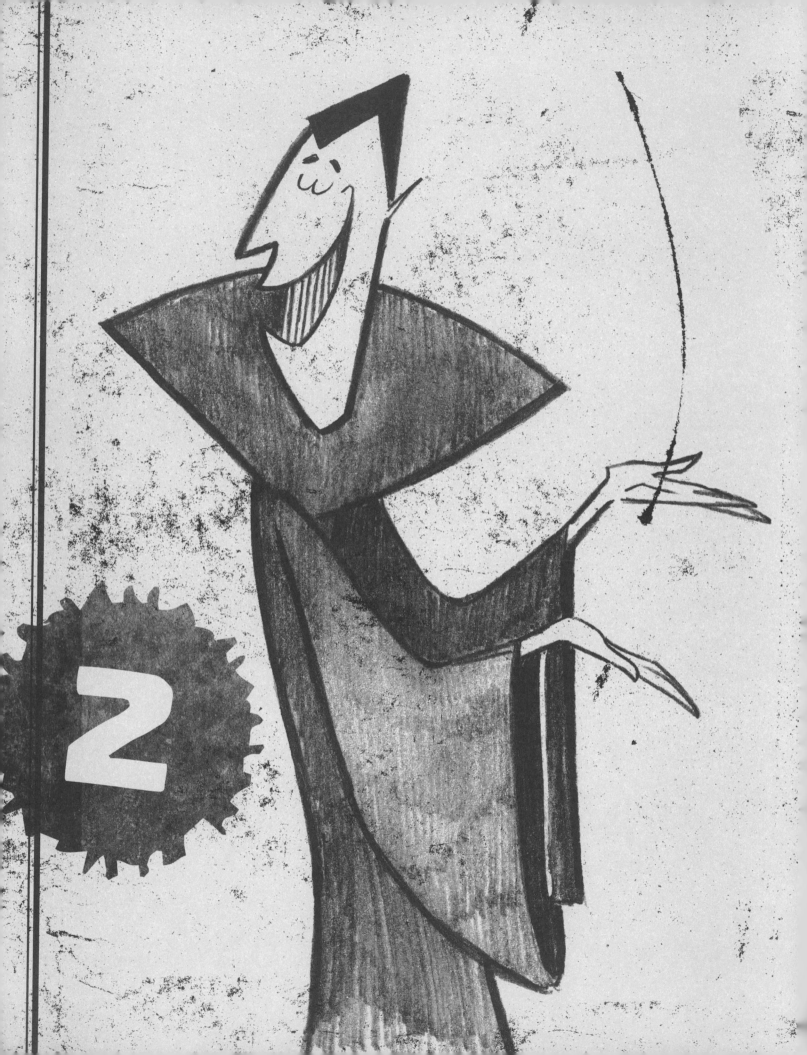

VAMPIRES
NARCISSISTS OF THE UNDERWORLD

VAMPIRES: These charismatic denizens of the dark are too popular *not* to draw. Every cartoonist worth his or her salt has to know how to draw them. Anyone can draw a cape and fangs. That's not a vampire. A vampire is charming, craven, and deliciously evil yet at the same time cultured and refined. He comes on with syrupy sincerity but will betray you at the first opportunity. Not unlike a best friend from middle school.

Vampire Heads and Facial Features

Before you sink your teeth into drawing full vampires, let's go over the basics of the eyes and mouth.

VAMPIRE EYES

Vampires' eyes are intense, grave, and goofy. Notice how many shapes they can assume, from circles to slender openings.

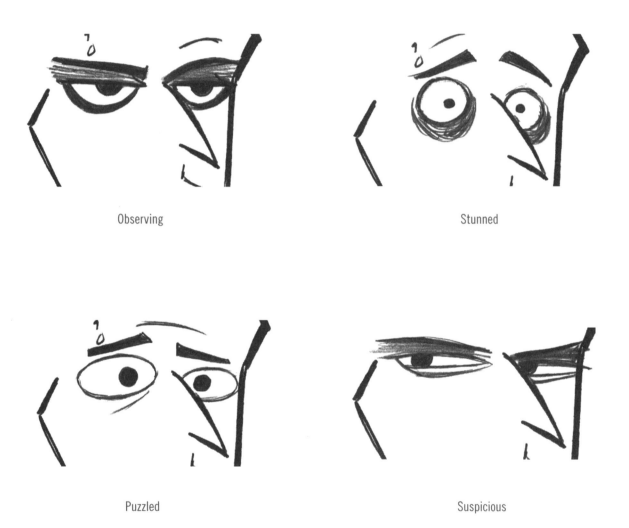

Observing

Stunned

Puzzled

Suspicious

THOSE FASHIONABLE FANGS

There are many different ways to portray vampire fangs and teeth. The three following approches are the funniest in my opinion:

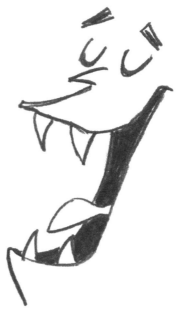

Fangs only: shows his vampire nature, even when he's trying to be charming.

Top and bottom fangs: great as a "reveal," reminding the viewer the vampire is still a bad guy.

Fangs and small (sharp) bottom teeth: these are the most expressive.

Bloodsucker Basics

There are as many different types of vampires as there are grains of sand on the beach. A really teensy-weensy beach! Let's begin with a popular, standard type of vampire.

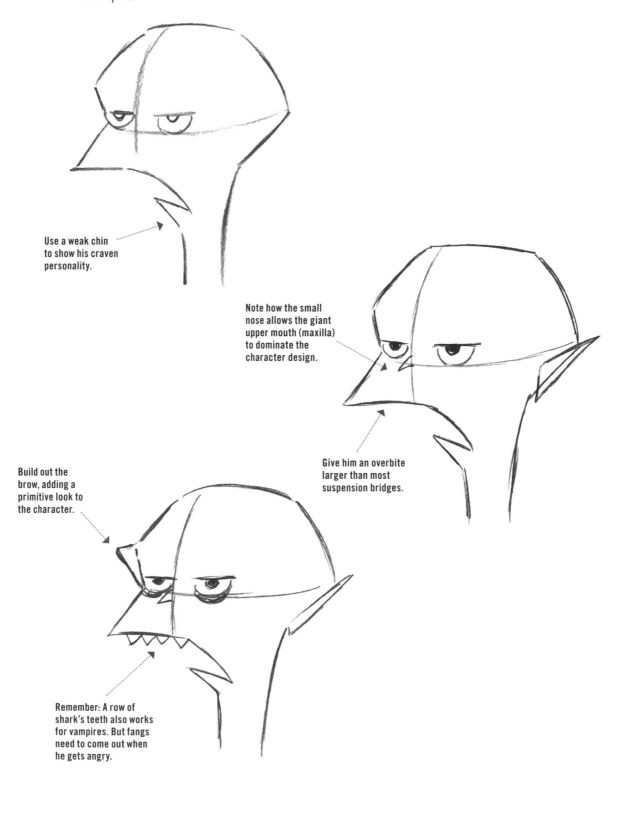

Use a weak chin to show his craven personality.

Note how the small nose allows the giant upper mouth (maxilla) to dominate the character design.

Give him an overbite larger than most suspension bridges.

Build out the brow, adding a primitive look to the character.

Remember: A row of shark's teeth also works for vampires. But fangs need to come out when he gets angry.

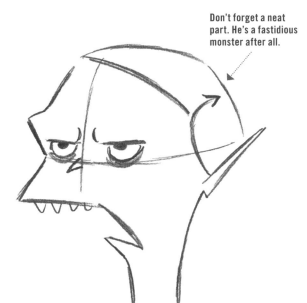

Don't forget a neat part. He's a fastidious monster after all.

CLASSIC VAMPIRE TRAITS

- Sharp teeth or fangs
- Sunken eyes
- Coiffed hair
- Ears that suggest that his mom had a fling with Mr. Spock

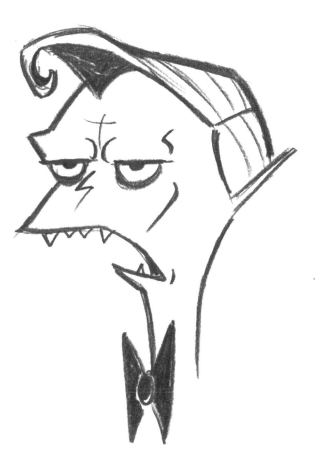

The added cheekbones make him look more extreme.

Aristocratic Vampire

He's rich, powerful, corrupt, and soulless. No, not your local congressman; I mean the *aristocratic vampire*. This guy has never worked a day in his life. Instead, he lives off the family fortune. Again, I'm not talking about your local congressman but the aristocratic vampire. If you allow it, he will bleed you dry of everything you possess. Again, I'm not . . . aw, what's the use!

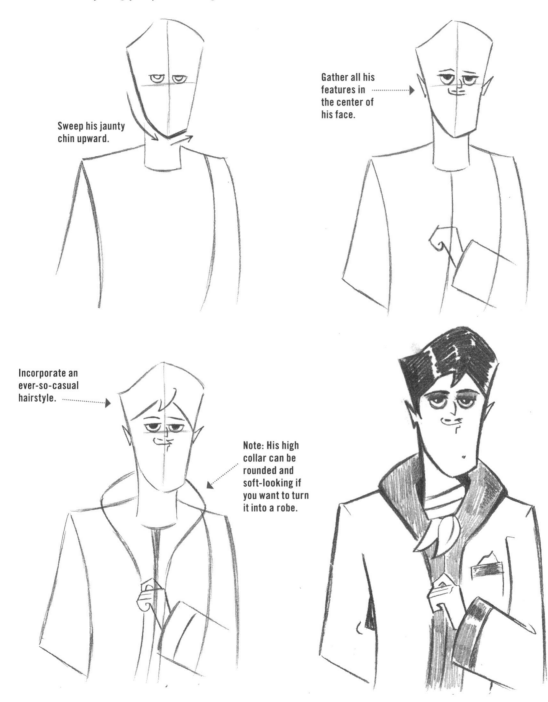

Sweep his jaunty chin upward.

Gather all his features in the center of his face.

Incorporate an ever-so-casual hairstyle.

Note: His high collar can be rounded and soft-looking if you want to turn it into a robe.

In the movies, you'll often see the aristocratic vampire wearing a smoking jacket as a sign of his villainy. As a society, we've come a long way when we use smoking to indicate that he's a bad person.

Devilish Vampire

This type of vampire absolutely adores evil. His charm lies in his inability to decide between diabolical plans. It all sounds soooo good! You'd think it would get monotonous after several centuries of the same old, same old: kill, gorge, sleep, kill, gorge, sleep, and so forth. But when you love what you do, it never gets old.

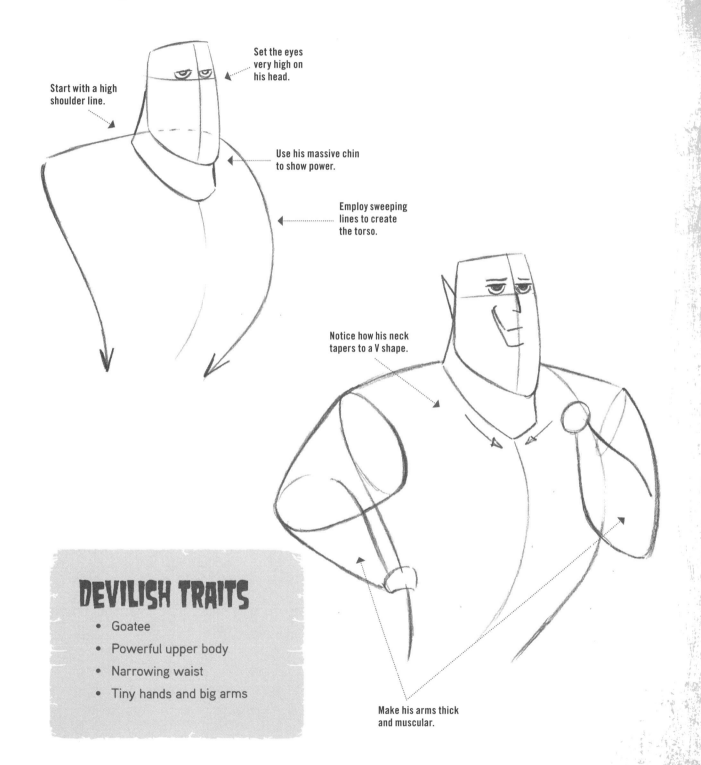

Set the eyes very high on his head.

Start with a high shoulder line.

Use his massive chin to show power.

Employ sweeping lines to create the torso.

Notice how his neck tapers to a V shape.

Make his arms thick and muscular.

DEVILISH TRAITS

- Goatee
- Powerful upper body
- Narrowing waist
- Tiny hands and big arms

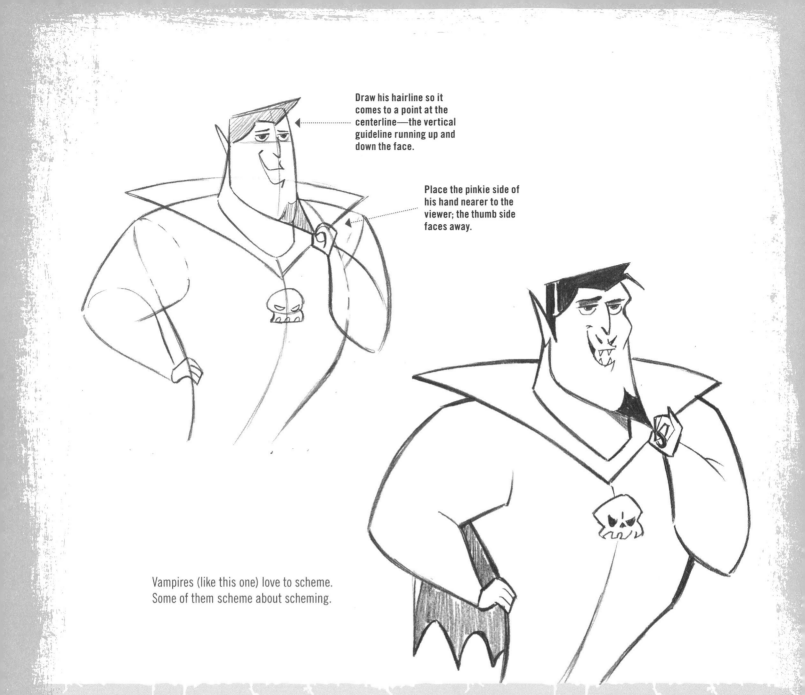

Draw his hairline so it comes to a point at the centerline—the vertical guideline running up and down the face.

Place the pinkie side of his hand nearer to the viewer; the thumb side faces away.

Vampires (like this one) love to scheme. Some of them scheme about scheming.

ADDING DEFINITION TO THE HEAD SHAPE

To add interest to your piece, draw some prominent features on the otherwise smooth outline of his face. But be careful not to overdo it. A complex head shape is unappealing to the eye.

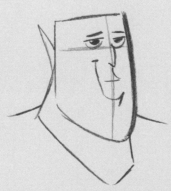

Let's start with a simple head shape.

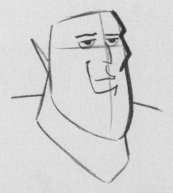

Here I've added prominence to the brow and cheekbone. You can add a third area of prominence to the chin. But it would make this drawing look too busy.

VAMPIRE VS. DEVIL

Vampires and devils have very similar character designs. In fact, you have to change only four minor elements to turn a vampire into a devil:

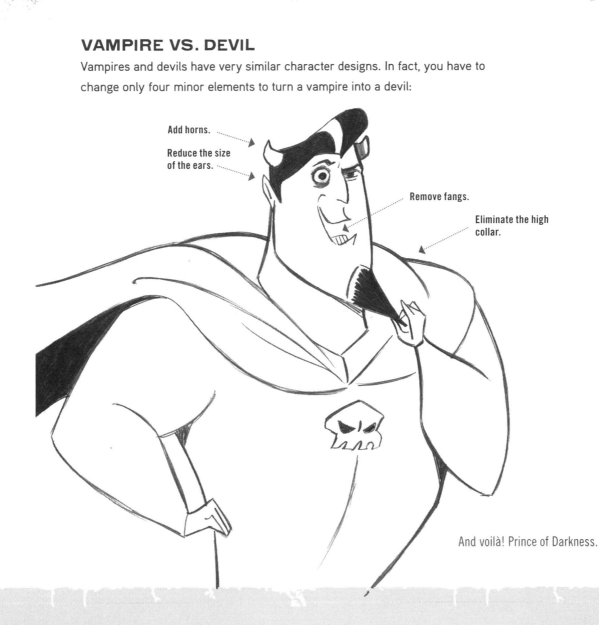

Add horns.

Reduce the size of the ears.

Remove fangs.

Eliminate the high collar.

And voilà! Prince of Darkness.

HORN TYPES

If you want your devil to look legendary, add long horns instead of the smaller type (which come standard with every devil as part of the package). Here are a few popular cartoon types of horns to choose from:

Princess style

Burnt longhorn

Ram style

Otherworldly Vampire

The "vampire-as-evil-spirit" looks like a vampire on top, but his body trails down to nothing more than a wisp of smoke, leaving him hovering just above the ground like an apparition. This type can move swiftly from room to room, gliding through the air. This inevitably leads to continuous badgering by the children of his house-guests, who tug at his cape and keep demanding, "Teach us how to do that!!"

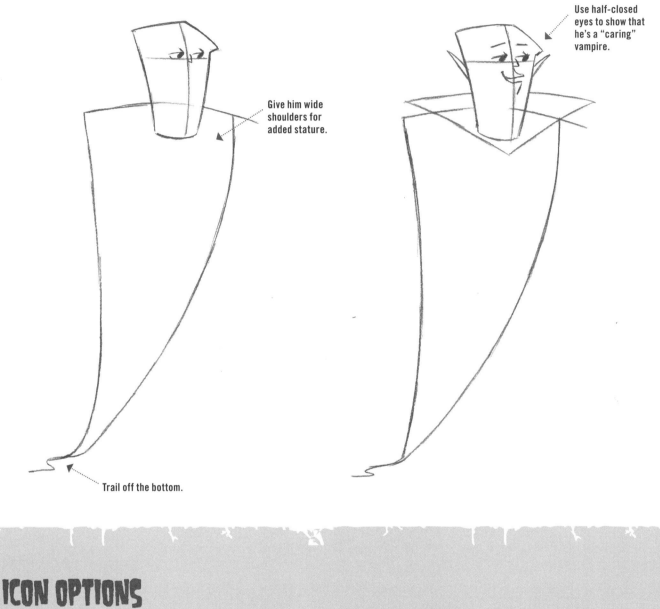

Use half-closed eyes to show that he's a "caring" vampire.

Give him wide shoulders for added stature.

Trail off the bottom.

ICON OPTIONS

Devil beast

Angry half skull style

Not-nice monster

Even not-nicer monster

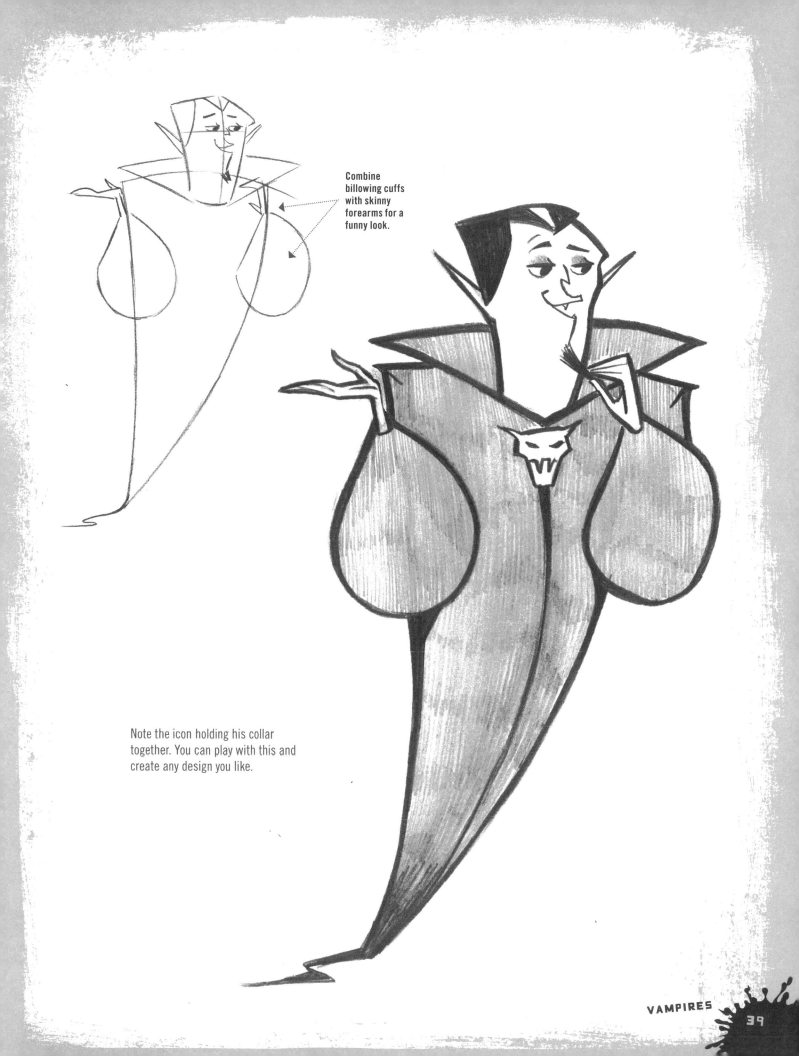

Combine billowing cuffs with skinny forearms for a funny look.

Note the icon holding his collar together. You can play with this and create any design you like.

Cartoony Vampire

You've got to love a vampire who can crack jokes and suck blood at the same time. Rather than seduce his victims, he "puns" them into submission with horrible word gags. If they don't give up after about three or four punch line groaners, he does the "pull my finger gag," which never fails. To give this character an ultra-cartoony look, give him rubbery flexibility, as if he's got no bones. His face stretches to create a toothy smile just dripping with sincerity.

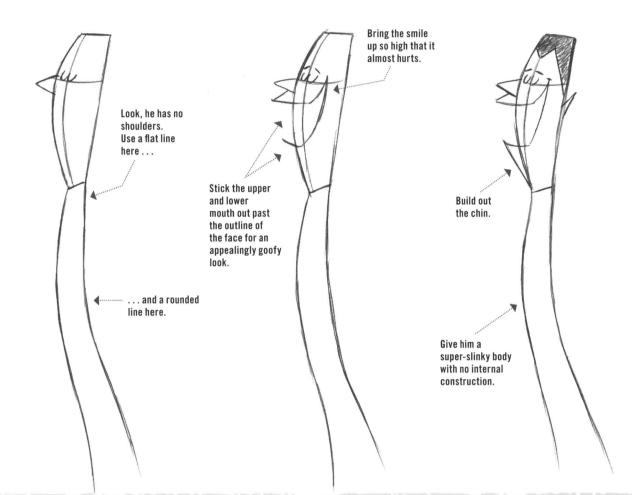

Look, he has no shoulders. Use a flat line here . . .

. . . and a rounded line here.

Stick the upper and lower mouth out past the outline of the face for an appealingly goofy look.

Bring the smile up so high that it almost hurts.

Build out the chin.

Give him a super-slinky body with no internal construction.

LINE FLOW

A flowing line is pleasing to the eye. Hard angles and jagged lines also can create cool designs but aren't as successful at representing floppy things such as giant sleeves.

A disjointed line isn't so hot for handling this swooping section.

A smooth, simplified, and streamlined approach works much better.

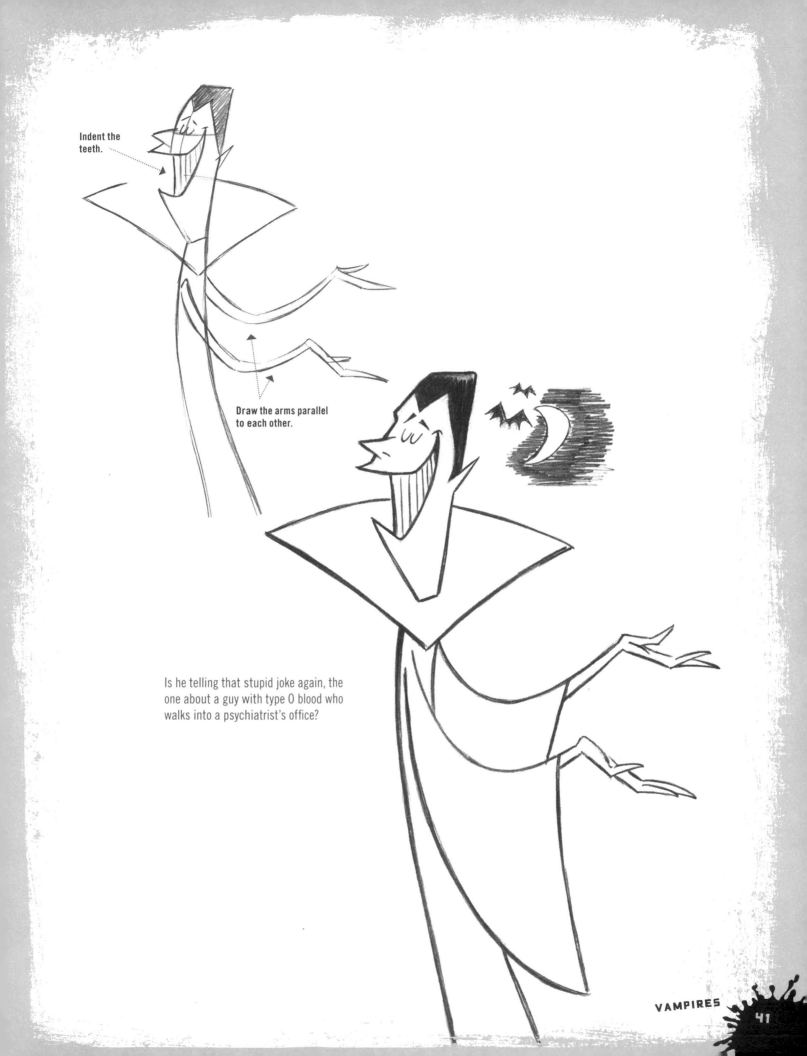

Indent the teeth.

Draw the arms parallel to each other.

Is he telling that stupid joke again, the one about a guy with type O blood who walks into a psychiatrist's office?

A VAMPIRE'S BEST FRIEND

They make lovable, loyal, true blue pets. Dogs, that is, not bats. But bats do make funny sidekicks for vampires. This type of comedy team works best when the vampire treats his bat as if it were a puppy, giving it belly rubs and trying to engage it in a game of fetch. To flesh out the bat's character, choose how it responds to such affection. For example, perhaps it finds the belly rubs incredibly annoying and therefore spends all its free time plotting to kill its master.

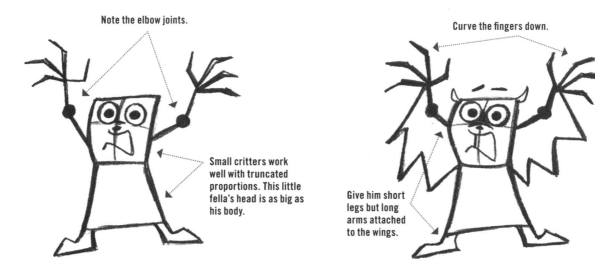

Note the elbow joints.

Small critters work well with truncated proportions. This little fella's head is as big as his body.

Curve the fingers down.

Give him short legs but long arms attached to the wings.

His ears are created with a combination of straight and curved lines.

Vengeful Vampire

Vampires are often the subjects of relentless teasing by classmates during their grade school years. By the time he's fourteen, the average vampire has heard about a thousand orthodontist jokes. Even his best friends have repeated the one about him being so pale that even his dog has a darker tan line. Or the one about how he has such a stupid hairdo, if only he could see his reflection in the mirror.

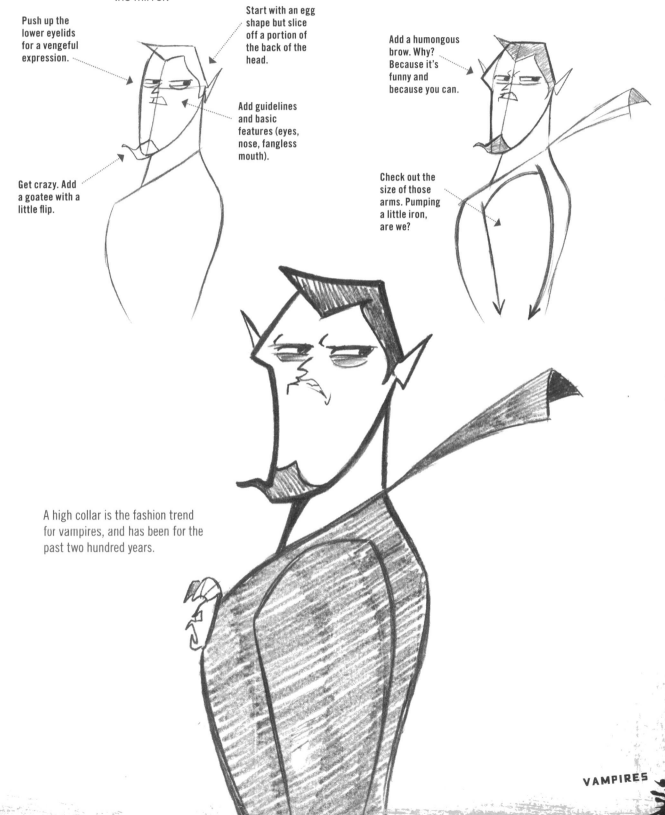

Push up the lower eyelids for a vengeful expression.

Start with an egg shape but slice off a portion of the back of the head.

Add guidelines and basic features (eyes, nose, fangless mouth).

Get crazy. Add a goatee with a little flip.

Add a humongous brow. Why? Because it's funny and because you can.

Check out the size of those arms. Pumping a little iron, are we?

A high collar is the fashion trend for vampires, and has been for the past two hundred years.

The Romantic Vampire

This is the problem with online dating services. You never really know if the profile is accurate: "Rich, charming man of Eastern European descent seeks woman of any age and blood type." When drawing the romantic vampire, emphasize his over-the-top seductive qualities. Rather than making him truly suave, make him *so suave* that he almost comes off as silly. Characters who are slightly full of themselves but don't realize it make for very funny cartoons.

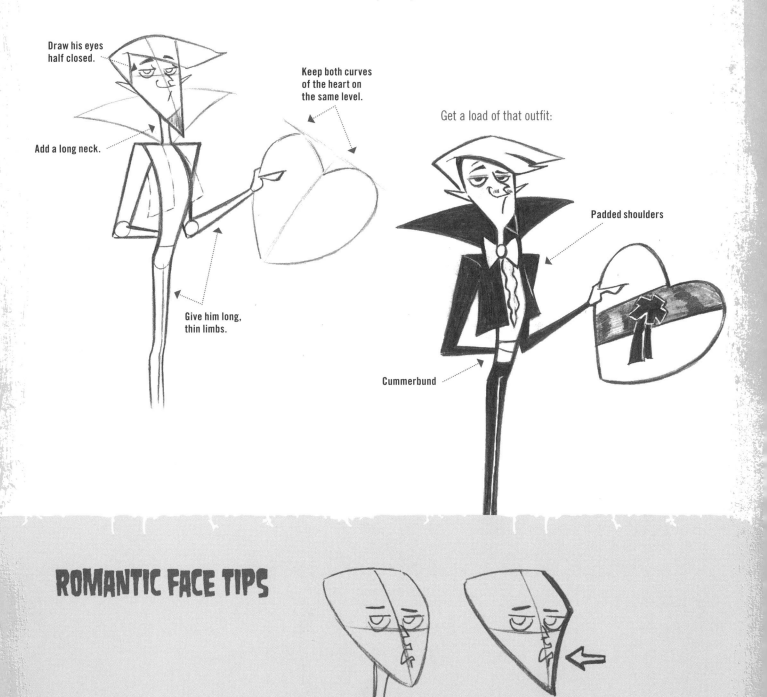

Draw his eyes half closed.

Add a long neck.

Keep both curves of the heart on the same level.

Give him long, thin limbs.

Get a load of that outfit:

Padded shoulders

Cummerbund

ROMANTIC FACE TIPS

Full face: okay

Sharper face: adds attitude

A Vampire's Powers

Vampires use the power of hypnosis to mesmerize their victims. This vampire is potty-training his new puppy. Man, how I wish I'd had one of those pocket watches when I bought my spaniel.

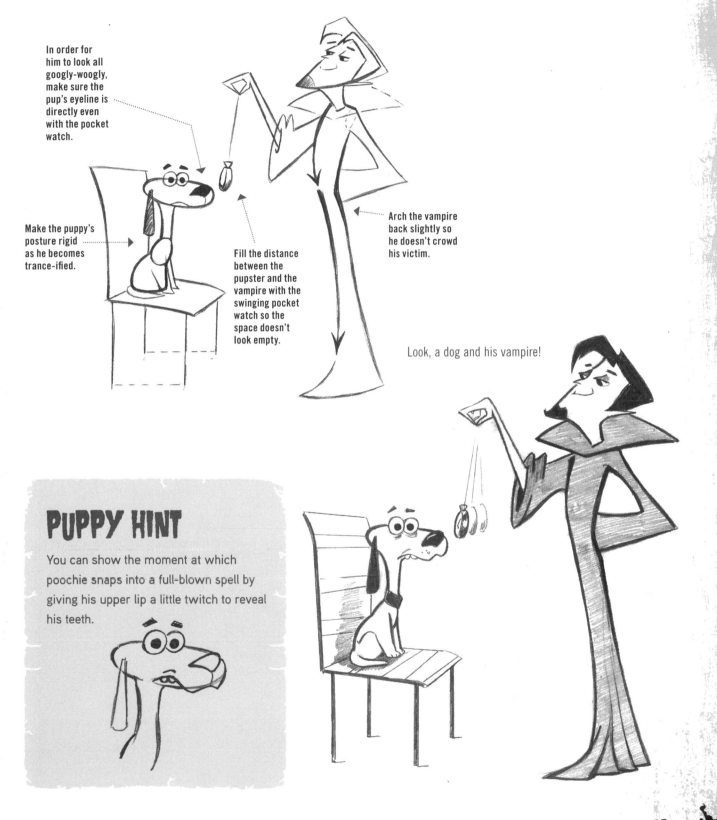

In order for him to look all googly-woogly, make sure the pup's eyeline is directly even with the pocket watch.

Make the puppy's posture rigid as he becomes trance-ified.

Fill the distance between the pupster and the vampire with the swinging pocket watch so the space doesn't look empty.

Arch the vampire back slightly so he doesn't crowd his victim.

Look, a dog and his vampire!

PUPPY HINT

You can show the moment at which poochie snaps into a full-blown spell by giving his upper lip a little twitch to reveal his teeth.

La Femme d'Vampire

The middle-aged female vampire is a great character type. She's seen it all before and is not impressed by her vampire husband's scary expressions. Her attitude is totally flat. Nothing elicits an emotion from her. A bouquet of thorns? A broach with a golden tarantula? Perhaps dinner for two at a local blood bank? (Maybe another time.)

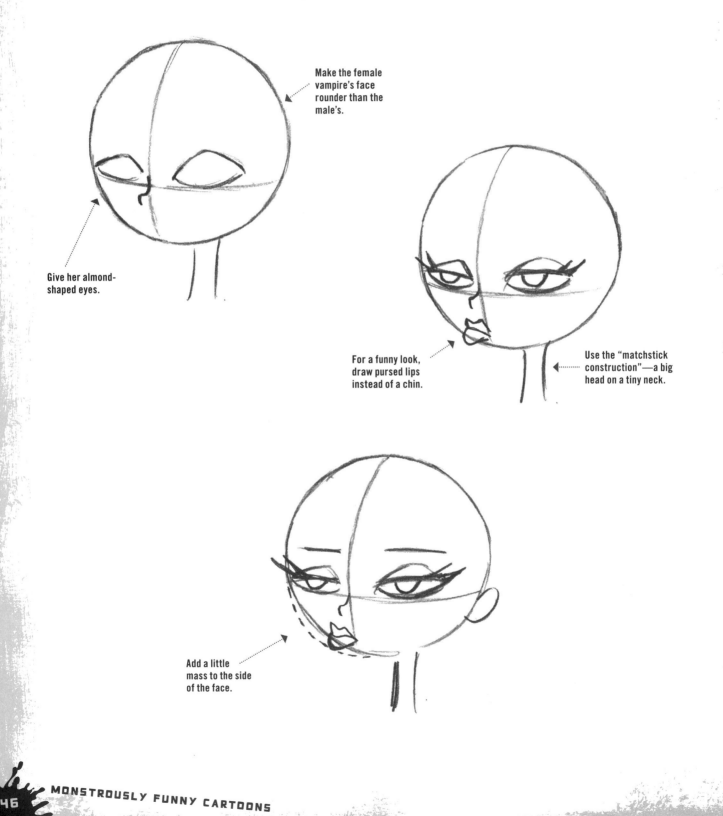

Make the female vampire's face rounder than the male's.

Give her almond-shaped eyes.

For a funny look, draw pursed lips instead of a chin.

Use the "matchstick construction"—a big head on a tiny neck.

Add a little mass to the side of the face.

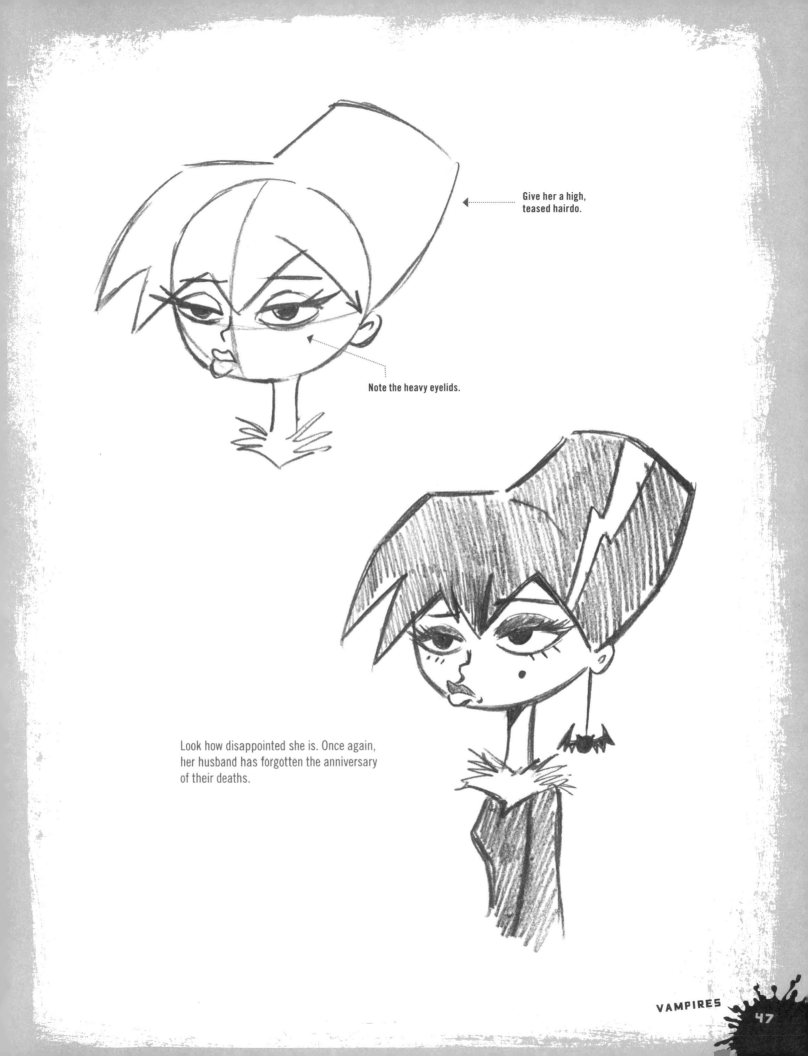

Give her a high, teased hairdo.

Note the heavy eyelids.

Look how disappointed she is. Once again, her husband has forgotten the anniversary of their deaths.

Teen Vampires

Teen vampires have it good. They can stay up all night with their parents' blessing. (As long as they are home before daylight!)

TEENAGE REBEL

Teenage vamps wear gothic clothes and occult jewelry and have tattoos—all in a failed effort to be noticed by their parents. If this rebel really wanted to freak out her parents, she'd wear a conservative pants suit, go to church regularly, and get a part-time job.

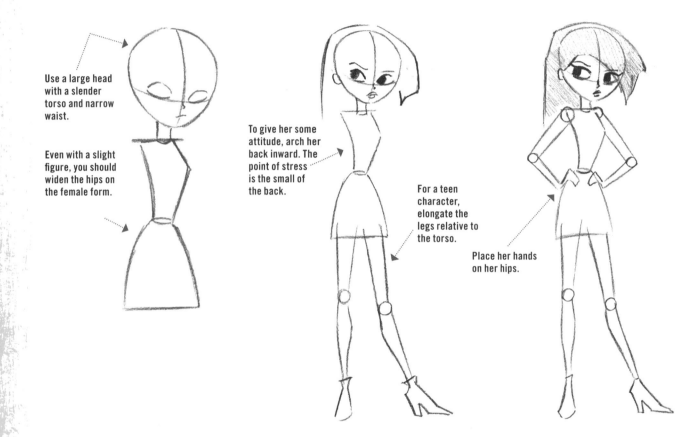

Use a large head with a slender torso and narrow waist.

Even with a slight figure, you should widen the hips on the female form.

To give her some attitude, arch her back inward. The point of stress is the small of the back.

For a teen character, elongate the legs relative to the torso.

Place her hands on her hips.

TWEAKS AND TOUCHES

A final drawing doesn't necessarily have to be the exact cleaned-up duplicate of its rough version. Compare the final construction step of the character above with the finished drawing on the next page and you'll notice a few tweaks and changes I made in the final version, including adding bat wings, giving her a choppier hairstyle, repositioning the eyes, and incorporating a little more hip action in the stance.

You can try this, too, as you draw characters from this book. You can make small adjustments to the eye position, hair, mouth position, hand gestures, and so on. Then, as your skill level rises, the changes you make can become more extensive and include alterations to costumes, expressions, body gestures, and more. And before you know it, you're creating your own characters!

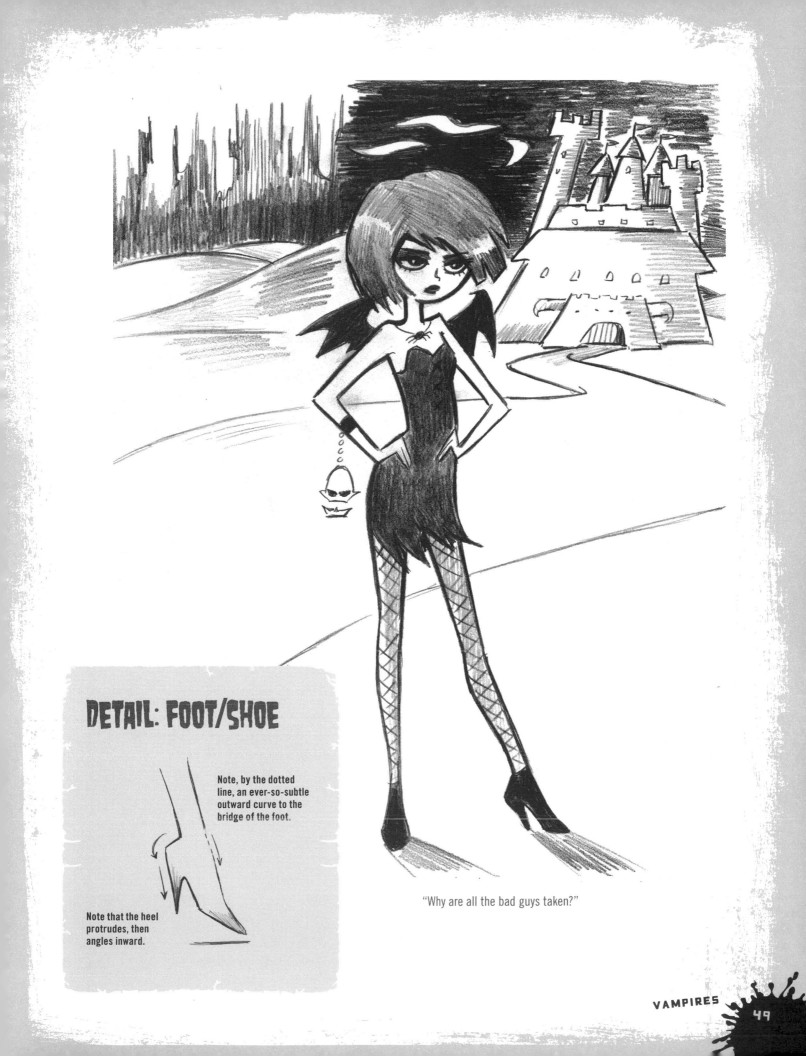

DETAIL: FOOT/SHOE

Note, by the dotted line, an ever-so-subtle outward curve to the bridge of the foot.

Note that the heel protrudes, then angles inward.

"Why are all the bad guys taken?"

VAMPIRE ANGST

Inner pain is oh so chic. Yes, my friends, angst is the new cool. It's no longer enough for a vampire to simply kill his victims; now he's also got to feel guilty about it!

I must confess to having perpetuated the stereotype of the angst-filled male vampire. A couple of years back, I wrote a vampire graphic novel called *The Reformed* (published by Del Ray Manga). My partner on the project, Anzu, a fantastic manga-occult illustrator, drew the images. *The Reformed* is an angst-ridden tragic love story about a vampire who discovers he has a conscience and must choose between immortality and the woman he loves. The premise worked, in large part because of the extra scoops of angst heaped onto the character. Although that book was a drama and this book is about cartooning, which is comedic, the principles for portraying young male vampires are the same: Gore is out and gloom is in.

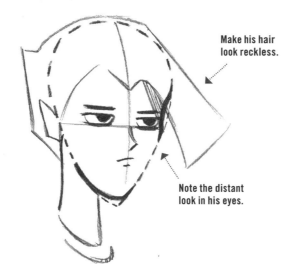

Make his hair look reckless.

Note the distant look in his eyes.

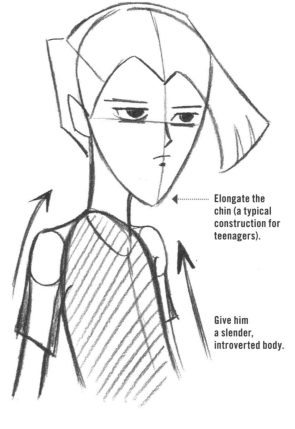

Elongate the chin (a typical construction for teenagers).

Give him a slender, introverted body.

ANGSTY VAMPIRE TRAITS

- Brooding look
- Hair casually flopped in front of eyes
- Slouching posture
- A faraway look in his eyes
- Looking thin and unhealthy, as if he doesn't take care of himself
- A preoccupation with the morose

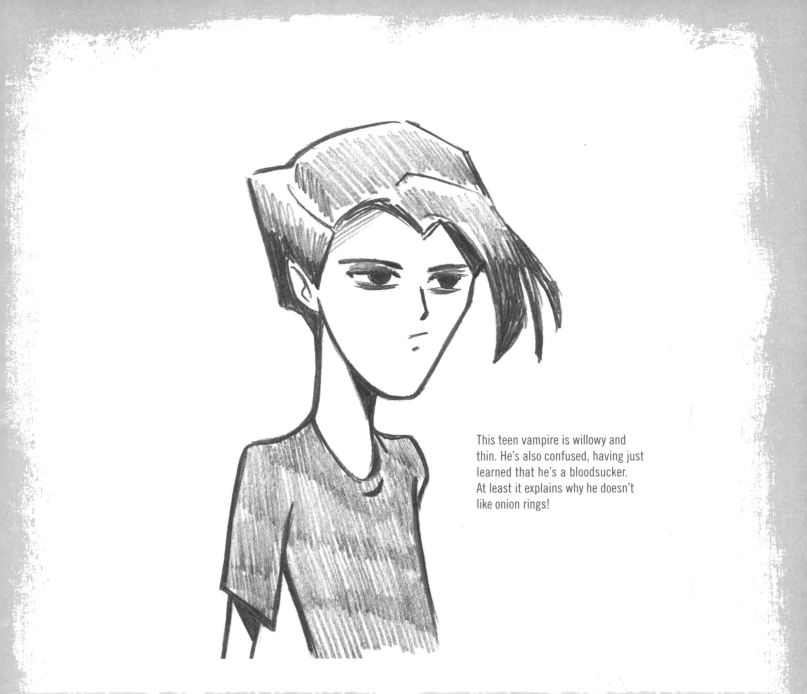

This teen vampire is willowy and thin. He's also confused, having just learned that he's a bloodsucker. At least it explains why he doesn't like onion rings!

CONCEPT SKETCH

Here's the quick initial sketch I did as a concept for the drawing. Sketch messy, finish clean.

ONCE BITTEN

Whether you are a human or a vampire, that first kiss is unforgettable. Those lips, those eyes, those . . . platelets! Here's a lovestruck teenager praying to the Gods of Darkness to cast a spell on her crush.

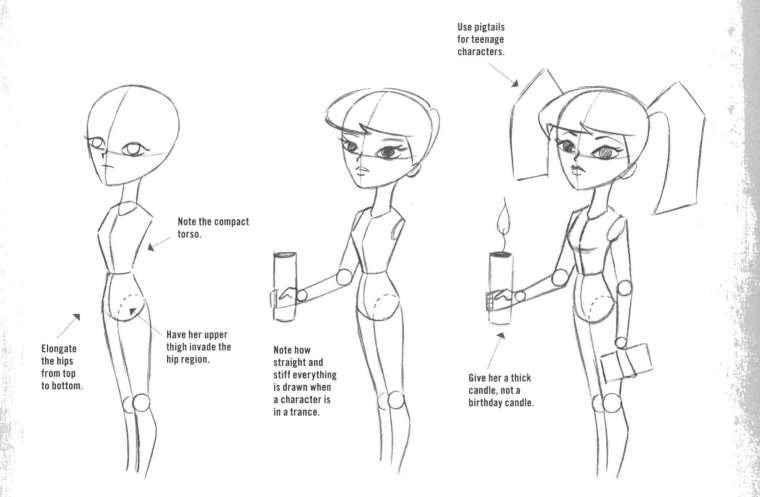

Use pigtails for teenage characters.

Note the compact torso.

Elongate the hips from top to bottom.

Have her upper thigh invade the hip region.

Note how straight and stiff everything is drawn when a character is in a trance.

Give her a thick candle, not a birthday candle.

DETAIL: EYES

Darken the upper eyelid to make the eyes pop.

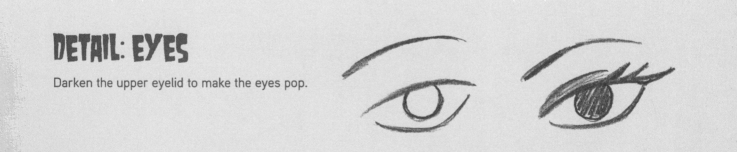

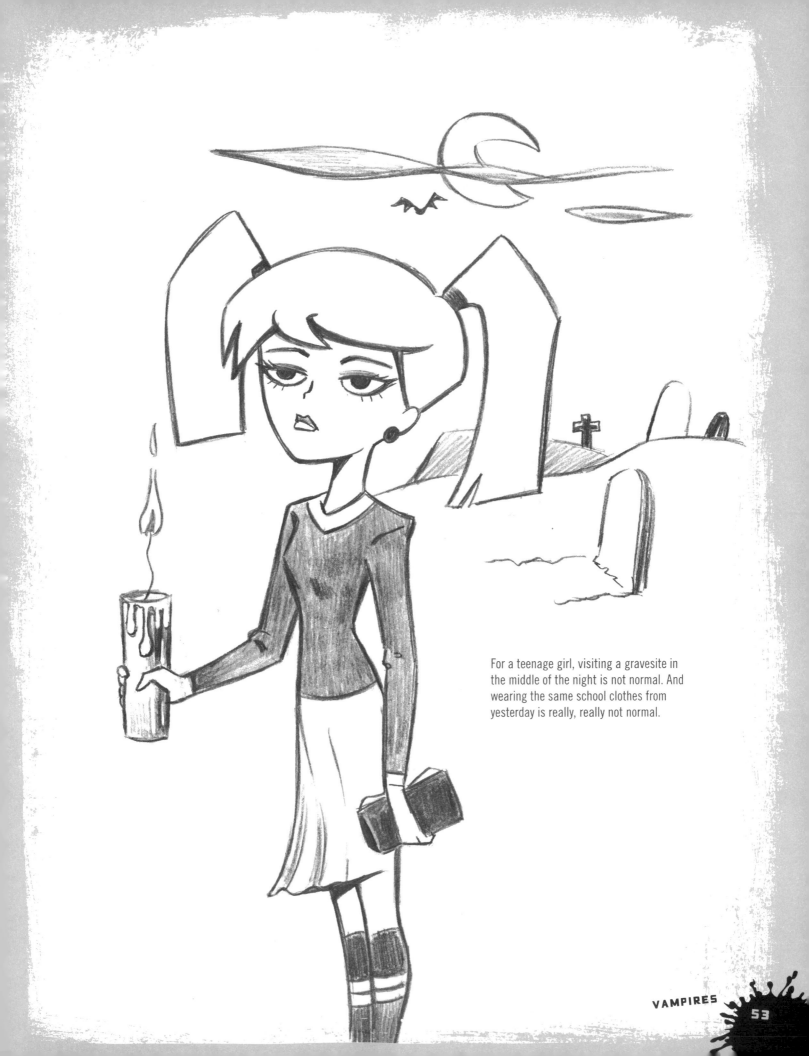

For a teenage girl, visiting a gravesite in the middle of the night is not normal. And wearing the same school clothes from yesterday is really, really not normal.

A VAMPIRE'S FIRST CRUSH

Some people give chocolates on Valentine's Day. Flowers are also popular. Skulls with candles in them, not so much—but it's the *thought* that counts. In typical vampire comedies, young vampires have crushes on humans, not on other vampires. That's what gives these stories *conflict*, which is essential for humor.

The visual secret to creating a character like this one is to draw the entire figure's outline superslinky with flowing lines—without hard angles or sharp curves.

To make this vampire somewhat sly-looking, make his head a bit angular instead of round and friendly.

Give him a superthin, waferlike body.

Avoid drawing the arm parallel to the ground, because it's such a neutral look. Instead, draw it on a diagonal.

Sunken eyes indicate he's been up all night. This means he's either a vampire or there's an algebra test tomorrow.

THE "GOOD GIRL" VAMPIRE

This vampire is around fourteen or fifteen years old, and it's just now dawning on her that she's *different* from everyone else. Maybe she just sprouted wings. Or instead of molars, her fangs started to come in. She's typically a neatly groomed character, subdued and sweet, but with a minor-key type of spirit.

Use big, dewy eyes.

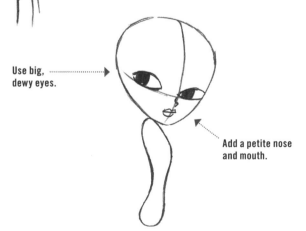

Add a petite nose and mouth.

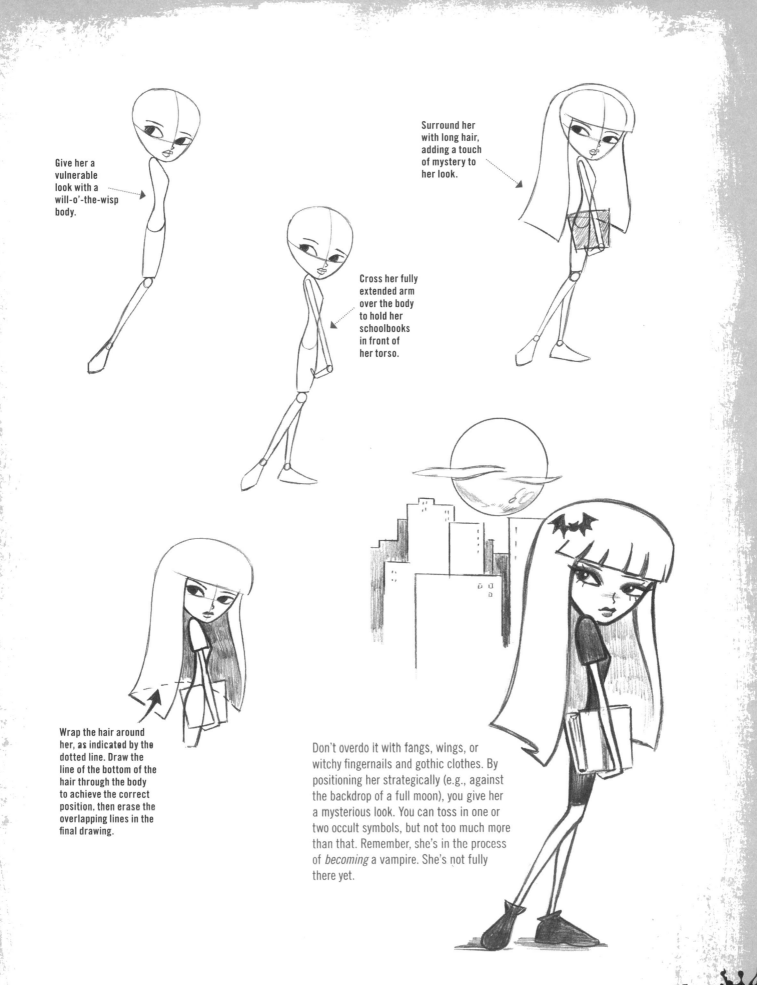

Give her a vulnerable look with a will-o'-the-wisp body.

Cross her fully extended arm over the body to hold her schoolbooks in front of her torso.

Surround her with long hair, adding a touch of mystery to her look.

Wrap the hair around her, as indicated by the dotted line. Draw the line of the bottom of the hair through the body to achieve the correct position, then erase the overlapping lines in the final drawing.

Don't overdo it with fangs, wings, or witchy fingernails and gothic clothes. By positioning her strategically (e.g., against the backdrop of a full moon), you give her a mysterious look. You can toss in one or two occult symbols, but not too much more than that. Remember, she's in the process of *becoming* a vampire. She's not fully there yet.

Keys for Creating Funny Vampires

What personality types make for the funniest vampires? (The answers may surprise you.)

GEEKY VAMPIRE

The more *ordinary* the personality type is, the funnier the vampire will be. How does that work? It's due to a *shift in emphasis*. Remember this practical technique for creating humor: Instead of placing the emphasis on the vampire's *monstrous qualities*, I've switched the primary focus to the most mundane human characteristics. The kid is a total geek! I almost don't comment—visually—on the elephant in the room, which is that he's *also* a vampire! Now that you know how it's done, you can use this technique to create your own original characters.

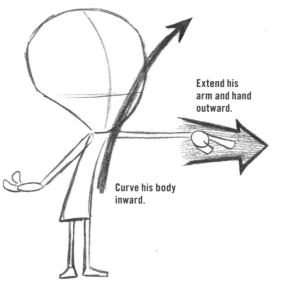

Extend his arm and hand outward.

Curve his body inward.

Use one smooth line for the front of his face.

Note the two angled lines used for the back of his head.

ACTION LINES

When a pose is drawn with action lines (basic thrust of the pose) that are going in different directions, it makes the pose awkwardly funny. This approach is often used to create funny poses in retro-style cartoons.

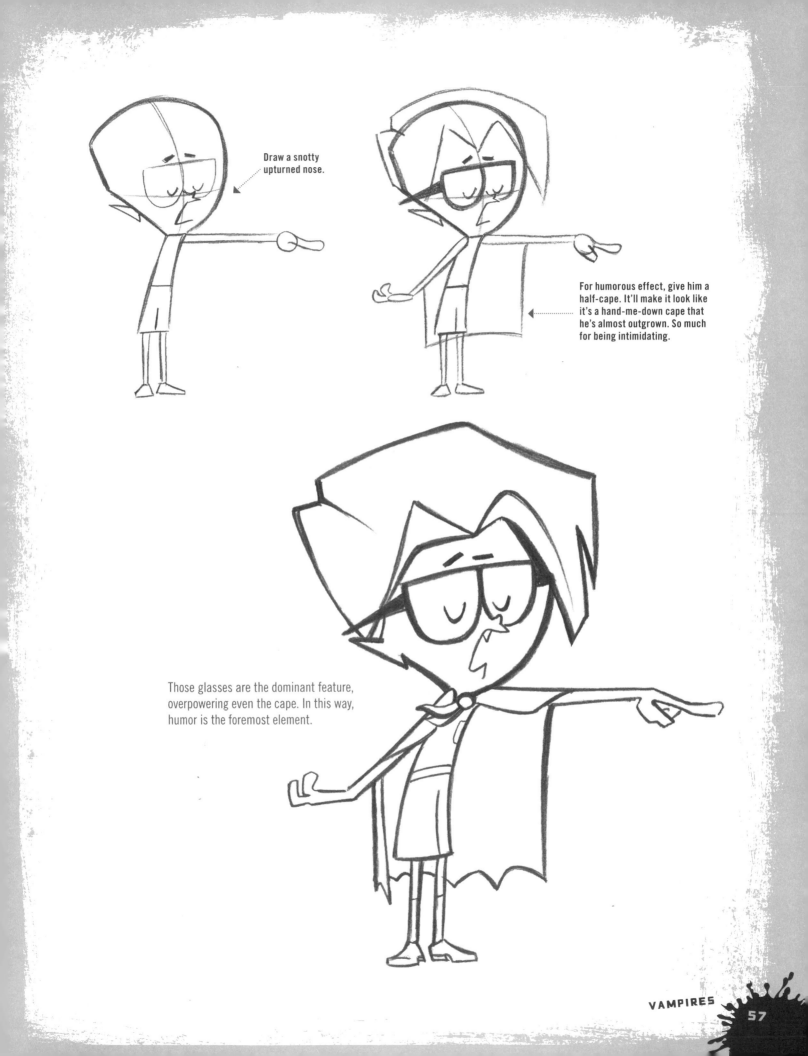

Draw a snotty upturned nose.

For humorous effect, give him a half-cape. It'll make it look like it's a hand-me-down cape that he's almost outgrown. So much for being intimidating.

Those glasses are the dominant feature, overpowering even the cape. In this way, humor is the foremost element.

THE BLACK SHEEP

Many monster families, including vampires, often have a black sheep character who doesn't get with the program. This character, for example, would *rather be human*. She *likes* humans. Oh, where did her vampire parents go wrong?!

Every kid disappoints his or her parents at some time. Even vampire kids. How many times has this one heard her mom exclaim, "You've been watching too much TV! Go outside and bite the other children!"

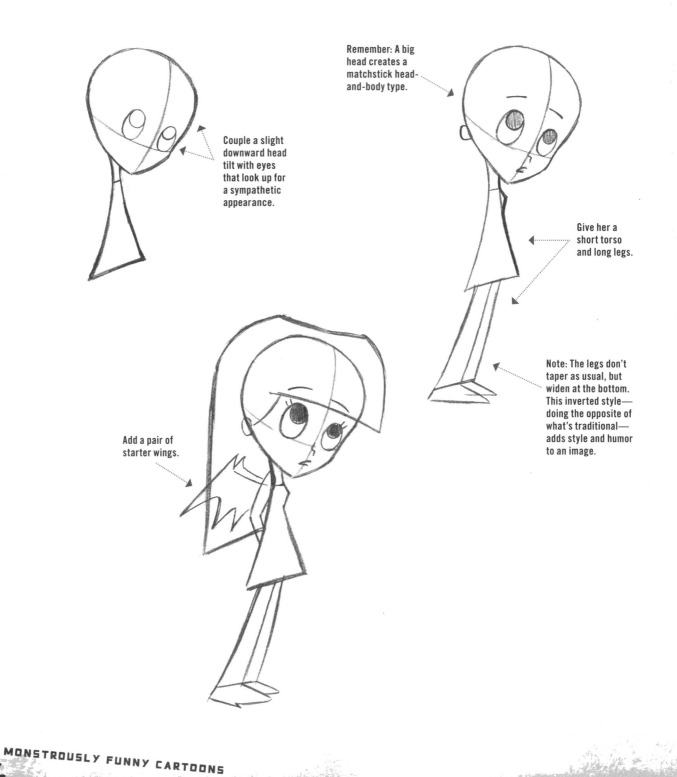

Remember: A big head creates a matchstick head-and-body type.

Couple a slight downward head tilt with eyes that look up for a sympathetic appearance.

Give her a short torso and long legs.

Note: The legs don't taper as usual, but widen at the bottom. This inverted style—doing the opposite of what's traditional—adds style and humor to an image.

Add a pair of starter wings.

Can a vampire look innocent, cute, and charming? Only as a teen or a kid. The big eyes and young proportions (big head, little body) make it work. Once her fangs start to come in, it's a whole new ball game.

ORDINARY EYES VS. INNOCENT EYES

Regular cartoon eyes, like the first pair here, are cute but don't emphasize the look of *innocence* you want to portray for the black sheep character type. You need to add at least one and maybe even several huge shines to each pupil to add a glistening quality.

Just okay

Utter innocence

"VINCENT, DON'T PLAY WITH YOUR FOOD!"

I love drawing kid vampires caught in the act of being bad. I never know why they're embarrassed. Aren't evil monsters *supposed* to be bad? You'd think he would get into trouble if he got caught doing something good. An effective way to enhance empathy for a particular character is to draw him shorter than another character who is chewing him out. From the direction of the kid's eyes in this cartoon, it's obvious that whoever is scolding him is much taller, which you can assume is his parent.

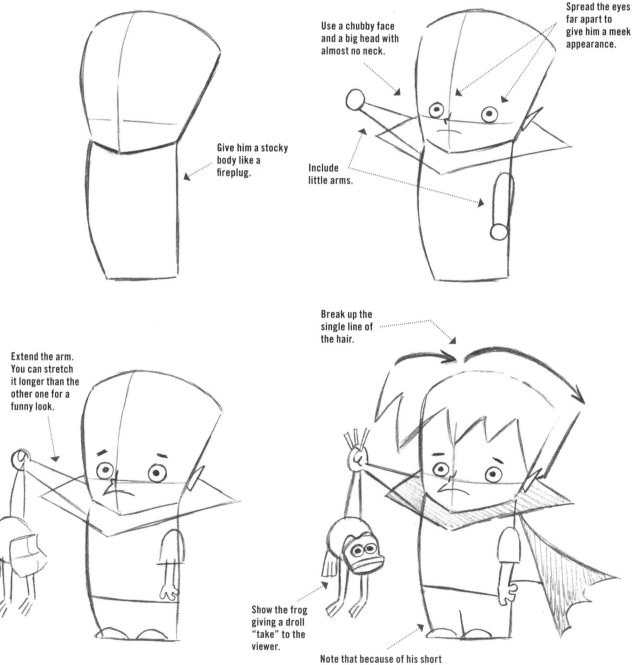

Give him a stocky body like a fireplug.

Use a chubby face and a big head with almost no neck.

Spread the eyes far apart to give him a meek appearance.

Include little arms.

Extend the arm. You can stretch it longer than the other one for a funny look.

Break up the single line of the hair.

Show the frog giving a droll "take" to the viewer.

Note that because of his short legs, his shoes are almost hidden under his trousers.

Toads, frogs, lizards, and snakes are all frequently featured with monsters. It's the same as having dogs and cats, only not as fluffy.

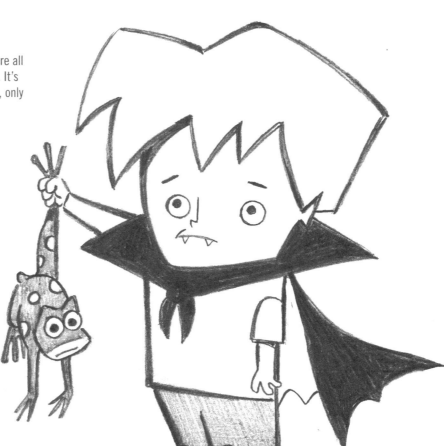

EYE TYPES AND DISTANCE

The closer together the eyes, the wider the range of expressions available. In contrast, cartoon eyes that are spaced far apart are better for expressions of innocence, embarrassment, and concern.

Eyes drawn close together give a character a mischievous look.

Eyes spread apart give a character a sweeter, simpler look.

THE TERRIBLE TWOS

In cartoons, as long as you draw a vampire with wings, the viewer accepts that he or she is flying. You actually *don't* need to draw *flapping* wings to indicate that the character—this vampire tyke, for example—is remaining aloft.

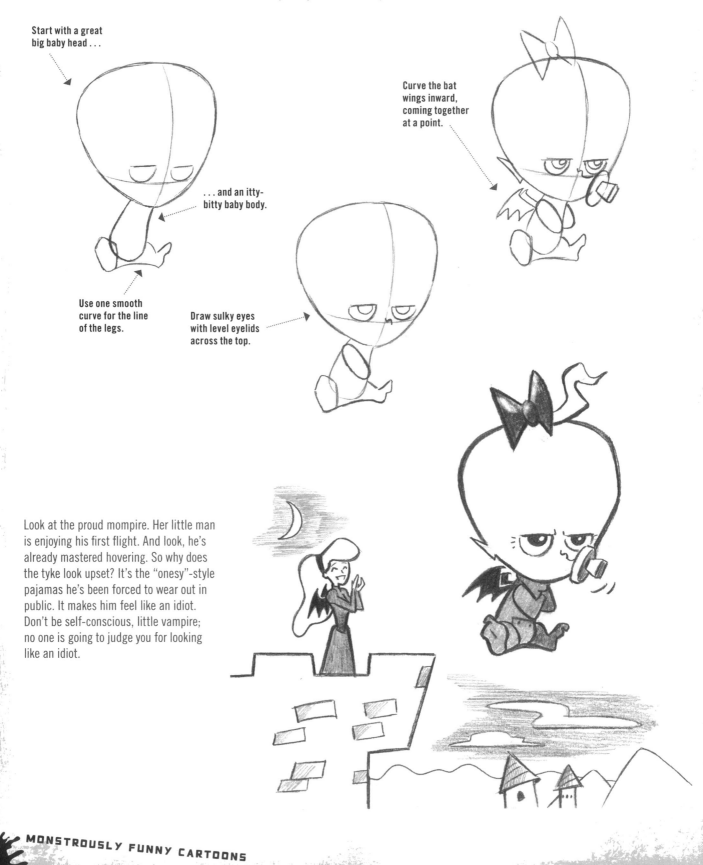

Start with a great big baby head . . .

. . . and an itty-bitty baby body.

Use one smooth curve for the line of the legs.

Draw sulky eyes with level eyelids across the top.

Curve the bat wings inward, coming together at a point.

Look at the proud mompire. Her little man is enjoying his first flight. And look, he's already mastered hovering. So why does the tyke look upset? It's the "onesy"-style pajamas he's been forced to wear out in public. It makes him feel like an idiot. Don't be self-conscious, little vampire; no one is going to judge you for looking like an idiot.

Nosferatu-Type Vampire

This ever-popular vampire type is noted for its ancient, grumpy appearance. He usually has a bald head and craggy old-man features. Sometimes it's difficult to tell whether he's a vampire or simply a retiree with liver spots. Liver spots aside, he's a wonderfully cranky, mean, and sneaky character. His character design puts the focus squarely on his *odd head shape*, leaving his body slender and nondescript. (Extreme expressions also contribute to his evil appeal.)

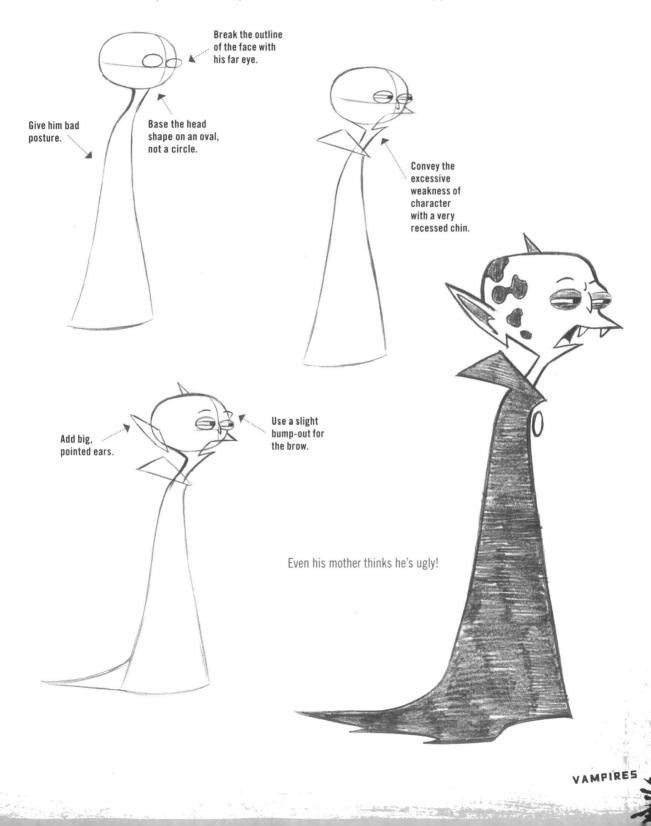

Break the outline of the face with his far eye.

Give him bad posture.

Base the head shape on an oval, not a circle.

Convey the excessive weakness of character with a very recessed chin.

Add big, pointed ears.

Use a slight bump-out for the brow.

Even his mother thinks he's ugly!

Ugly Creature-Type Vampire

This hideous little vampire is curiously adorable, although not in a cuddly sort of way. He's more like a cute, angry hamster. Portray his unusually high intelligence with the oversized dimensions of his head. This character's design is a combo of three visual motifs: a reptile, a baby, and a troll.

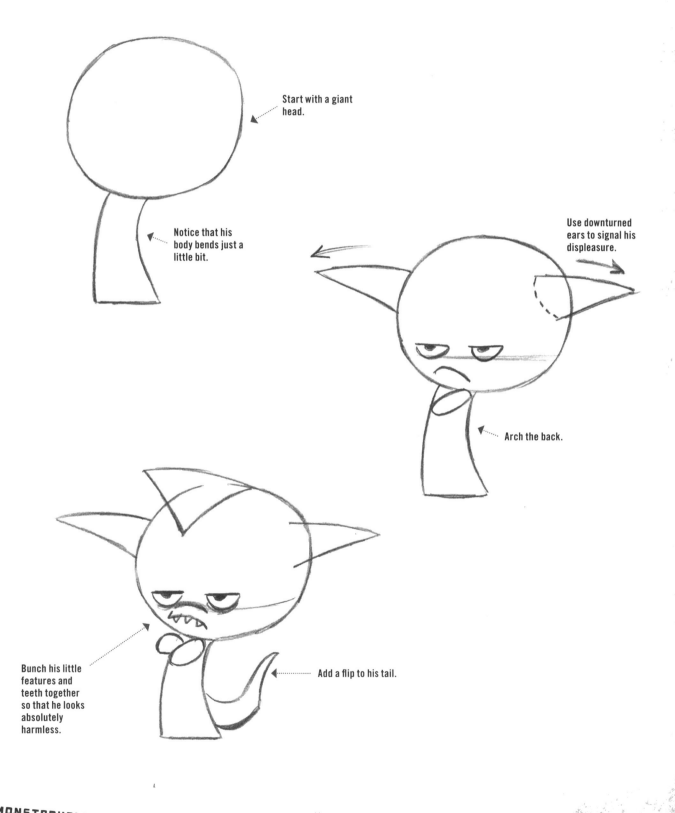

Start with a giant head.

Notice that his body bends just a little bit.

Use downturned ears to signal his displeasure.

Arch the back.

Bunch his little features and teeth together so that he looks absolutely harmless.

Add a flip to his tail.

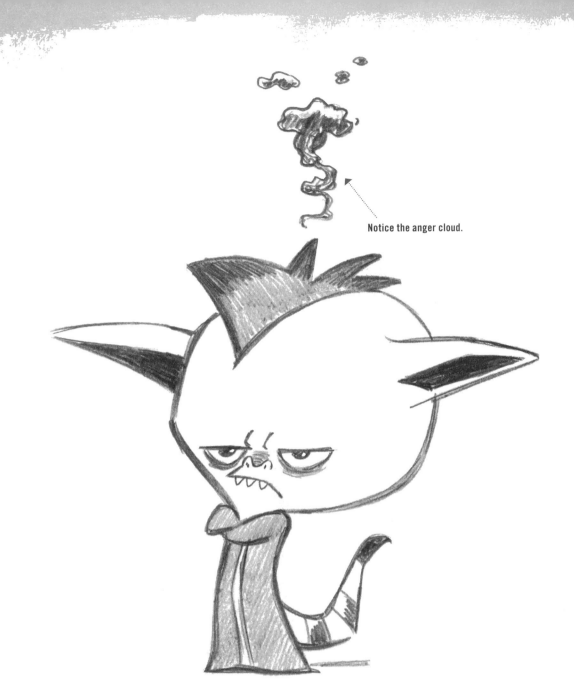

Notice the anger cloud.

Note the special effect cloud of gloom. His universally high intellect is matched only by his ineffectiveness. His schemes rarely work out.

DETAIL: EYEBROW

Show the eyebrow muscles for a severe look of gloom. Squeeze them together.

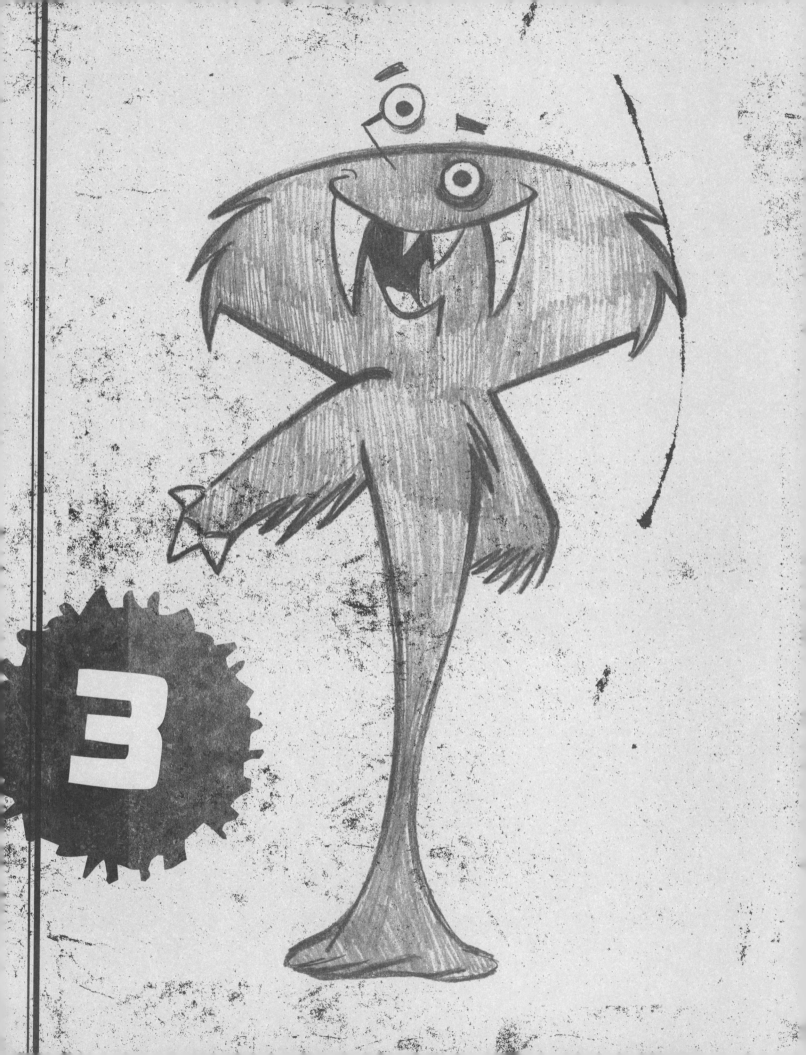

MONSTERS
THAT GO BUMP IN THE NIGHT

MONSTERS born of dreams and nightmares are mega-popular in animated movies and children's books. There's an art to designing make-believe cartoon monsters. They are often drawn as fuzzy creatures with curious—often *extreme*—proportions. It's not uncommon to see a monster with its head where its tummy should be!

A monster that looks like a mammal can be drawn with tentacles for arms. You can even rearrange facial features to create a wild appearance. Although there are no hard-and-fast rules about how to create an original make-believe cartoon monster, I have found that the following elements are very helpful in designing funny, whimscial monsters with strong audience appeal:

- A cute, funny, or angry personality
- Unusual shapes for the head and body
- Odd proportions
- As simple a design as possible given its unusual qualities

Single Animal—Based Monster

Here I used an ostrich as the basis for this monster. Starting with a funny animal makes the process easier. It's not necessary for the viewer to recognize that you started with an ostrich. The only purpose the animal serves is to give you inspiration. The animal type you decide to use as the basis for your monster is for you alone. This creature is a good example of how you can create a funny look by subtracting elements, not just by adding them. It has no beak and no wings, giving it a unique and humorous appearance.

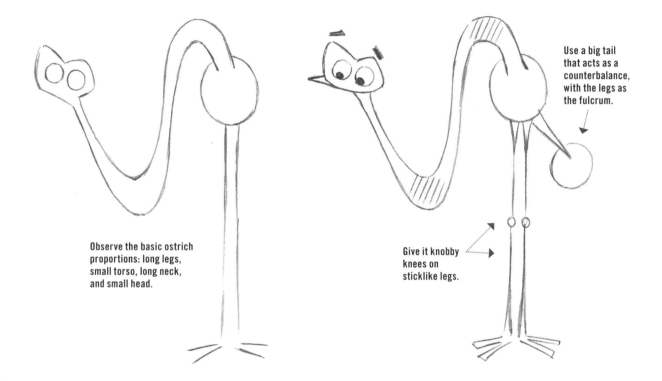

Observe the basic ostrich proportions: long legs, small torso, long neck, and small head.

Use a big tail that acts as a counterbalance, with the legs as the fulcrum.

Give it knobby knees on sticklike legs.

THE MONSTER LIST OF CHARACTER-GENERATING IDEAS

You can create original monsters by using one or more of the following techniques:

- Use an animal as the basis for the design.
- Combine two or more animal types.
- Exaggerate an ordinary physical trait: teeth, eyes, tail, and so on.
- Caricature a body type, such as skinny, muscular, hefty, or gawky.
- Draw the eyes and mouth in weird places.

- Give the monster too many arms or legs. Or eliminate arms and base the character on a simple shape.
- Build the character around an action, for example, a monster that blows bubbles from its ears.
- Create different ways for your monster to get around, such as slithering, flying, swimming, rolling, and bouncing.
- Add funny textures (such as fur or scales) and eye-catching extras (such as horns or a trunk).

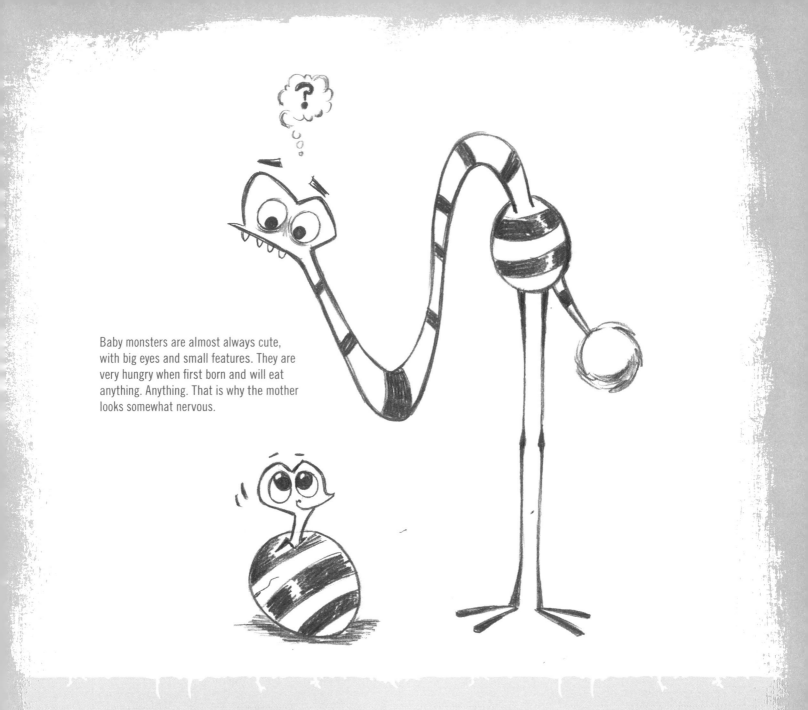

Baby monsters are almost always cute, with big eyes and small features. They are very hungry when first born and will eat anything. Anything. That is why the mother looks somewhat nervous.

CREATING A FUNNY TUBE

You'll have many opportunities in cartooning to draw a tubelike shape that can be used for a neck, arm, trunk, and the like. To make it funny and avoid a monotonous look, draw it with an uneven thickness.

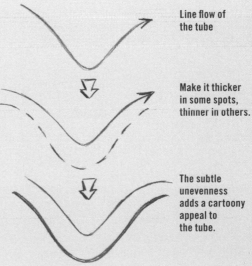

Line flow of the tube

Make it thicker in some spots, thinner in others.

The subtle unevenness adds a cartoony appeal to the tube.

Monster Based on Two Animals: Wild Boar + Elephant

For the next monster, let's take the funniest features of two different animals and combine them to create a single nonsensical, funny-looking character. If a scientist were to create a monster by combining two different species, he probably would take an equal amount of traits from each animal and then experiment on it. Cartoonists approach character design differently: We borrow only the elements we think are funny. It doesn't matter if you favor one animal's traits over the other's. And we don't go, "mwa-ha-ha!" when we're done.

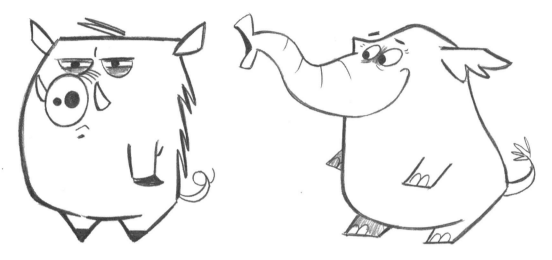

From the wild boar, borrow deep-set eyes, little ears, tusks, and a hairy coat.

From the elephant, borrow the trunk.

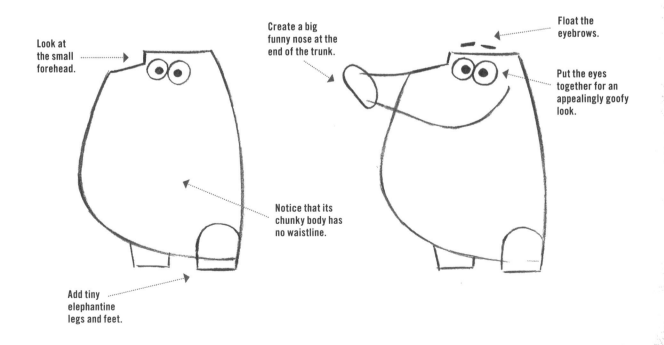

Look at the small forehead.

Create a big funny nose at the end of the trunk.

Float the eyebrows.

Put the eyes together for an appealingly goofy look.

Notice that its chunky body has no waistline.

Add tiny elephantine legs and feet.

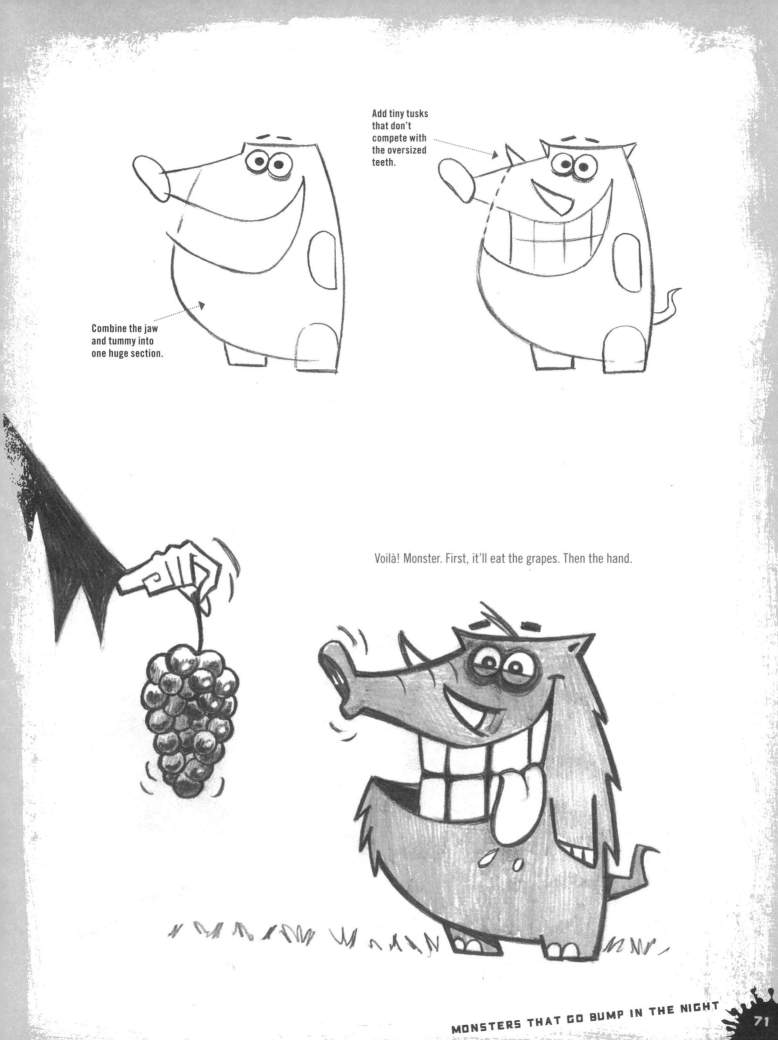

Add tiny tusks that don't compete with the oversized teeth.

Combine the jaw and tummy into one huge section.

Voilà! Monster. First, it'll eat the grapes. Then the hand.

Insect Monster

This monster is a ball of fluff with insect legs. By positioning each leg differently, you create a humorous tangle of confusion. I can only imagine how fast this thing must be able to scamper!

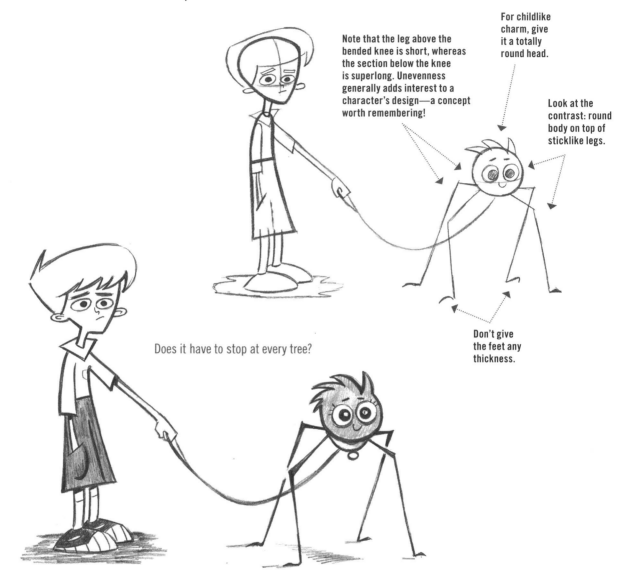

For childlike charm, give it a totally round head.

Note that the leg above the bended knee is short, whereas the section below the knee is superlong. Unevenness generally adds interest to a character's design—a concept worth remembering!

Look at the contrast: round body on top of sticklike legs.

Don't give the feet any thickness.

Does it have to stop at every tree?

COMPARING SYMMETRICAL TO ASYMMETRICAL PLACEMENT

Notice how much funnier the monster's jumble of legs appears to be when they are not posed symmetrically:

Legs evenly placed together

Legs evenly placed apart

Legs unevenly placed: funnier

Fluffy Buddy

Often, a very busy design isn't really imaginative but is actually the opposite. If you start with a fresh, fun, simple idea, you'll have no need to overcomplicate it. You should still feel free to add monstrous features to your character to finish it. But those features can also be appealingly simple.

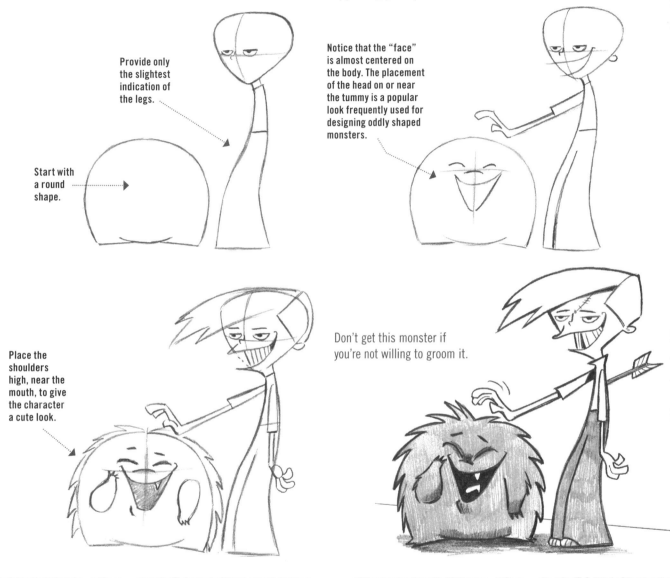

Provide only the slightest indication of the legs.

Start with a round shape.

Notice that the "face" is almost centered on the body. The placement of the head on or near the tummy is a popular look frequently used for designing oddly shaped monsters.

Place the shoulders high, near the mouth, to give the character a cute look.

Don't get this monster if you're not willing to groom it.

RESPECT THE OUTLINE

When you create deep ruffles on a fuzzy character, attach ruffles to the body's outline or you may start to lose the integrity of the shape (in this case a circle).

Notice that on the first diagram, the ruffles invade the *outline*. As a result, the body looks *less* round. The second example shows the indented parts of the ruffles *touching* but not invading the outline. This version appears rounder—and cuter.

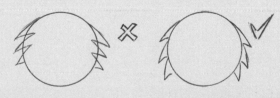

The zigzaggy lines invade the outline of the body: less effective.

The zigzaggy lines do *not* invade the outline of the body: more effective.

Plush Doll Monster

This monster is based on the basic shape of a child's plush doll. As such, it vaguely approximates the human form. Plush doll constructions are wonderful starting points from which you can mold an original monster character.

These adorable little monsters have a heck of a time trying to scare humans. When faced with a monster of this type, humans don't generally run away in fear; instead, they prefer to *squeeze* the monster mercilessly.

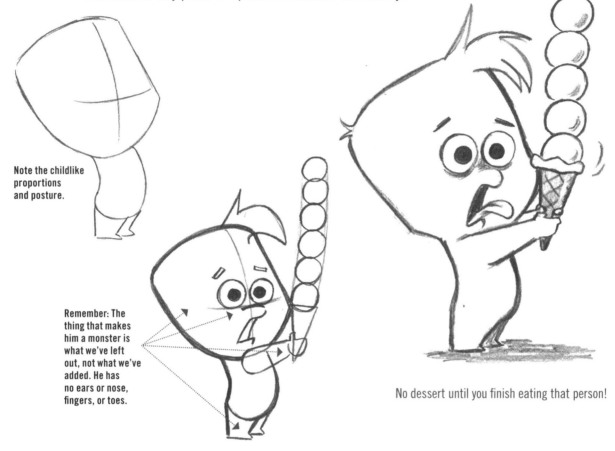

Note the childlike proportions and posture.

Remember: The thing that makes him a monster is what we've left out, not what we've added. He has no ears or nose, fingers, or toes.

No dessert until you finish eating that person!

SHOULDER PLACEMENT

The placement of the shoulders is important for an adorable look. When the shoulder is drawn high enough on a cute character to touch or overlap the character's chin, it creates a childlike "dearness" that is quite appealing.

Shoulder with normal placement: okay

Shoulder raised above chin level: adorable

Exaggerated Monster

If you thought a teenage boy was an insatiable eating machine, you ain't seen nothing yet. Allow me to introduce the always popular big mouth–type monster. This voracious character gives new meaning to the term *fast food*. Its mouth is its most prominent feature. By itself, that wouldn't make it funny. What makes it funny are its proportions: Its mouth takes up nearly the entire length of its body.

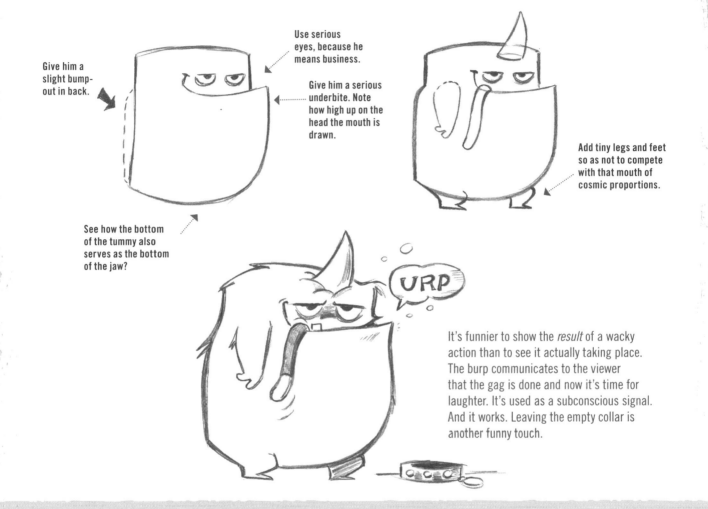

Give him a slight bump-out in back.

Use serious eyes, because he means business.

Give him a serious underbite. Note how high up on the head the mouth is drawn.

See how the bottom of the tummy also serves as the bottom of the jaw?

Add tiny legs and feet so as not to compete with that mouth of cosmic proportions.

URP

It's funnier to show the *result* of a wacky action than to see it actually taking place. The burp communicates to the viewer that the gag is done and now it's time for laughter. It's used as a subconscious signal. And it works. Leaving the empty collar is another funny touch.

STRETCHING FOR A JOKE!

To create a sight gag with a mouth-based monster, open the mouth up wide and *s-t-r-e-t-c-h* it! Stretching the mouth requires adding some length (or height) to your character. This extra length is taken up by the huge vertical stretch of the mouth. If you compare the two examples, you can see that the open-mouthed monster is slightly taller than the closed-mouthed monster.

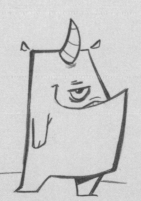

Closed mouth: slightly shorter

Opened mouth with s-t-r-e-t-c-h: slightly taller

Monsters with Big Personalities

You might have assumed that because cartoon monsters are so zany, they should be drawn with *understated* or *subtle* expressions to balance the look. That's good, sound reasoning—for everything, that is, except cartoon monsters. Subtle and small expressions would get drowned out by the over-the-top character designs of these monsters. They couldn't compete. Therefore, the expressions have to be *enormous, exuberant,* or, if a droll expression is called for, *diabolically* droll.

These big expressions should have a manic quality because they also convey a weird sense of danger. For example, when a cartoon monster greets you for the first time, it's with the level of excitement of a fan meeting her favorite musical celebrity. It's just *too* happy. It's bizzare—and funny!

FUZZY EXUBERANCE

This character is a good example of how a cuckoo look can be created from quite ordinary shapes. It's all in how you arrange them.

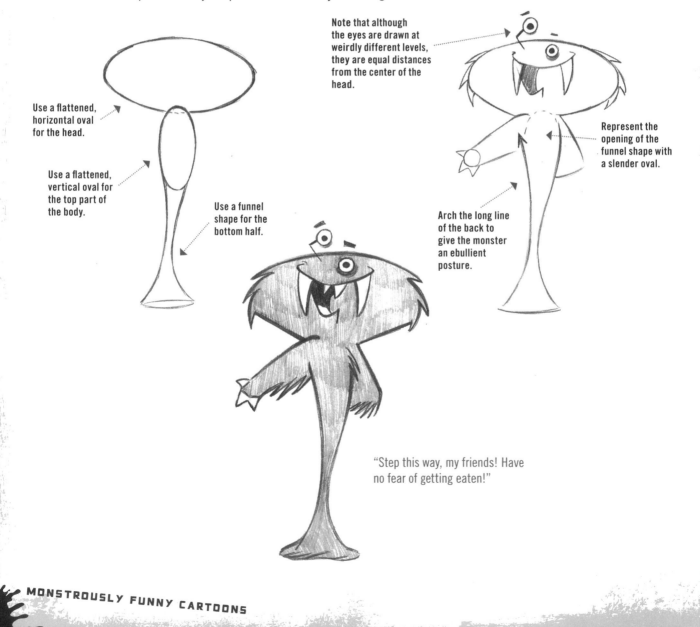

Use a flattened, horizontal oval for the head.

Use a flattened, vertical oval for the top part of the body.

Use a funnel shape for the bottom half.

Note that although the eyes are drawn at weirdly different levels, they are equal distances from the center of the head.

Represent the opening of the funnel shape with a slender oval.

Arch the long line of the back to give the monster an ebullient posture.

"Step this way, my friends! Have no fear of getting eaten!"

FRIENDLY MONSTER

The whimsical monsters of dreams and nightmares are often depicted as friendly, but not a "let's play tennis" type of friendly. When you find yourself confronted by a nightmare monster, the best thing to do is to think about kale and turnips and try not to look yummy.

Although numerous physical traits have been used to create the weird and beguiling look of this monster, they don't clutter up the character design. Once again, simple is better.

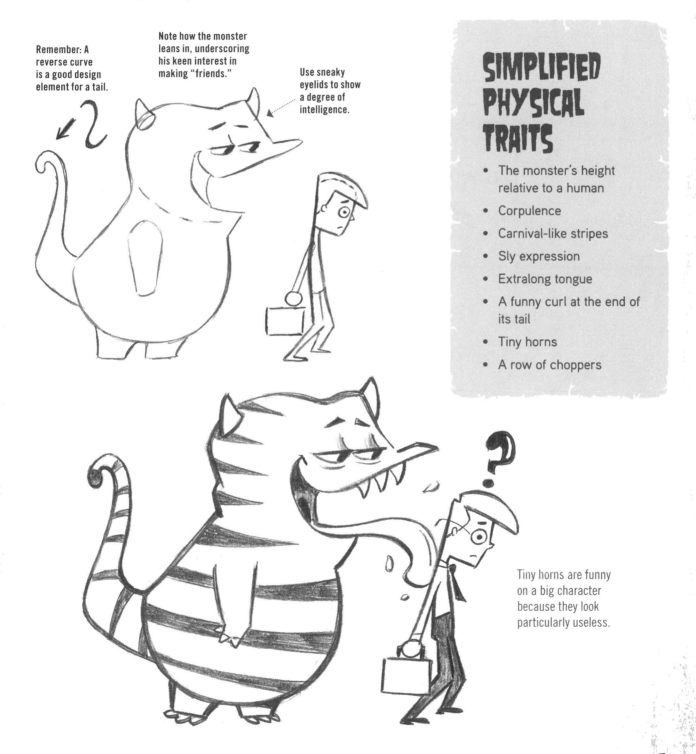

Remember: A reverse curve is a good design element for a tail.

Note how the monster leans in, underscoring his keen interest in making "friends."

Use sneaky eyelids to show a degree of intelligence.

SIMPLIFIED PHYSICAL TRAITS

- The monster's height relative to a human
- Corpulence
- Carnival-like stripes
- Sly expression
- Extralong tongue
- A funny curl at the end of its tail
- Tiny horns
- A row of choppers

Tiny horns are funny on a big character because they look particularly useless.

CARTOON ALIENS

WHAT'S THE DIFFERENCE between a monster and an alien?

If you don't know, you're in good company. Even the greatest minds of the twentieth century tried—and failed—to answer that question. Einstein guessed, "Because all aliens are green?" Oh, Albert, how uncharacteristically naïve of you! Dr. Jonas Salk took a stab: "Perhaps the green color has something to do with it?" Jonas, don't quit your day job. Sigmund Freud ventured, "Their mothers are all green, which makes them terribly jealous!" Poor Siggy!

No, my friends, the answer lies not in the green but in the *eyes*! The number of eyes, to be exact. Humans have two eyes. Most mammals do, too. For most monsters, it's the same. In contrast, aliens can have one, two, three, four, or even *more* eyes!

Alien Based on Two Shapes

Another effective approach for designing aliens is to combine two totally unrelated shapes. To the average viewer, the drawing appears advanced. But you can laugh at that person, because you know the drawing is actually based on a simple construction. Just be sure to stop laughing before you get punched.

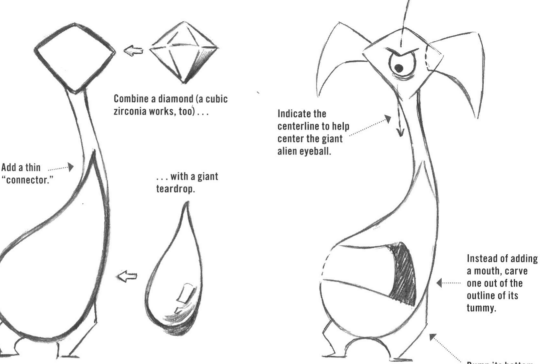

Combine a diamond (a cubic zirconia works, too) . . .

Add a thin "connector."

. . . with a giant teardrop.

Indicate the centerline to help center the giant alien eyeball.

Instead of adding a mouth, carve one out of the outline of its tummy.

Bump its bottom out slightly.

HOW A ONE-EYED ALIEN CHANGES EYE DIRECTION

Support the look of the one-eyed character by drawing the eyebrow as a muscle, pointed in the same direction as the pupil.

Eyebrow crushed down in the middle because the pupil is centered

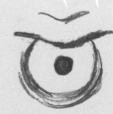

Eyebrow pointed right because the pupil points right

Eyebrow pointed left because the pupil points left

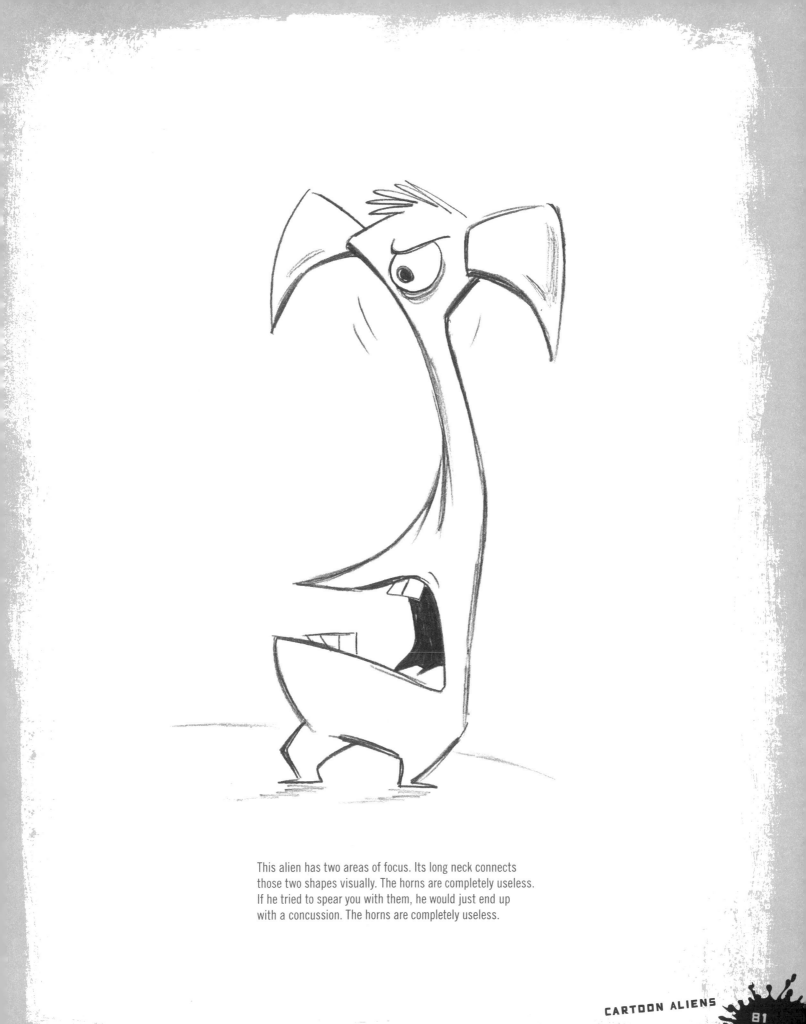

This alien has two areas of focus. Its long neck connects those two shapes visually. The horns are completely useless. If he tried to spear you with them, he would just end up with a concussion. The horns are completely useless.

Retro Alien

The popular retro cartoon style is a throwback to the late 1950s and early 1960s, a time often thought of as one of peace, prosperity, and shared moral values. Filmmakers of the time used the metaphor of invading aliens to show what might happen if you ripped the veneer off the social uniformity that kept everyone calm.

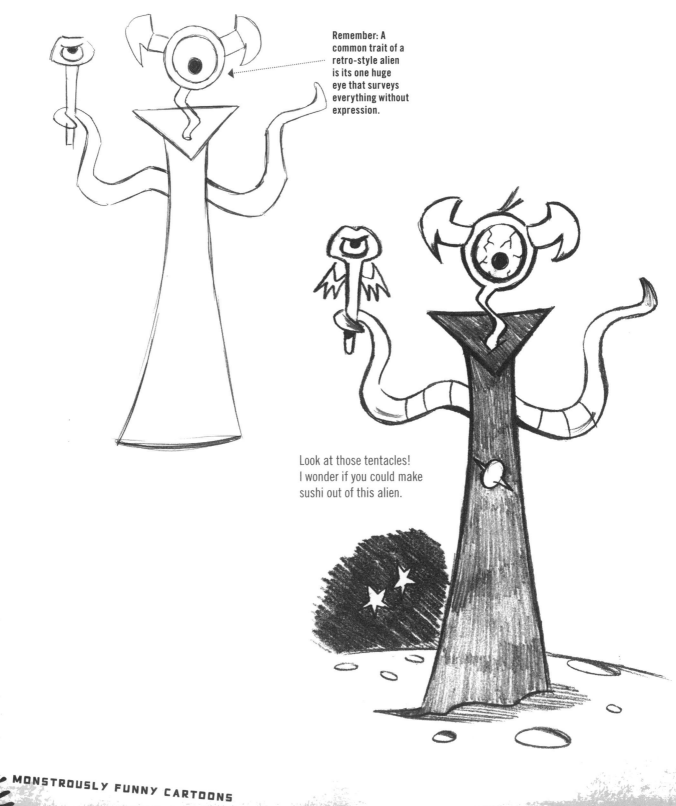

Remember: A common trait of a retro-style alien is its one huge eye that surveys everything without expression.

Look at those tentacles! I wonder if you could make sushi out of this alien.

Two-Eyed Alien

Contrary to popular belief, some aliens do in fact have two eyes, just like you and me. Well, maybe not *just* like you and me. Sometimes their eyes are arranged differently. For example, they can be stacked on top of each other. Others have eyes that come in varying sizes.

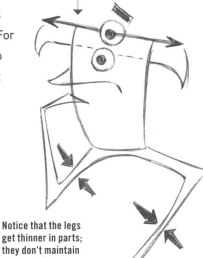

Draw both sides of the horn on the same level, using a guideline for positioning.

Notice that the legs get thinner in parts; they don't maintain an even thickness throughout the limbs.

Two stacked eyes

Three-Eyed Alien

It's human nature. When a creature has three eyes—something you don't see every day—most people will move a little closer to get a better look at it. Let me step in here with some avuncular advice: If it has three eyes, wherever you're standing is close enough. Part of the fun of inventing aliens is stretching them to make room for their strange features. This alien was elongated vertically to make room for its stack of eyes.

Use the centerline to help keep the three eyes stacked neatly in a column.

Note that the body tapers as it goes downward.

Three stacked eyes

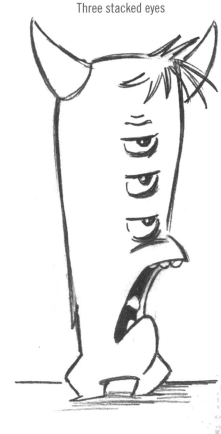

Aliens with Four or More Eyes

Don't hesitate to add as many eyes as you'd like to your alien characters. But when you start to go beyond four, five, or six eyes, aliens can begin to look like radioactive giant insects rather than Martians. That's not necessarily a bad thing. The insect-type alien is an entertaining and quirky fellow. It scampers about, is nervous, and is usually mute. They make good pets but multiply like crazy, so you may have to use bug spray. If you live in a New York City apartment, you're already familiar with some of its terrestrial relatives.

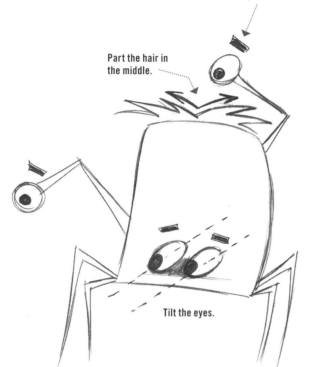

Add eyebrows.

Part the hair in the middle.

Tilt the eyes.

Keep the expression the same for each eye.

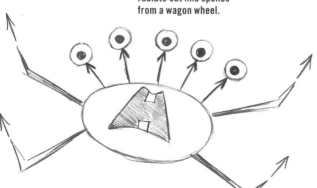

Note that all the eyes are attached to stems that radiate out like spokes from a wagon wheel.

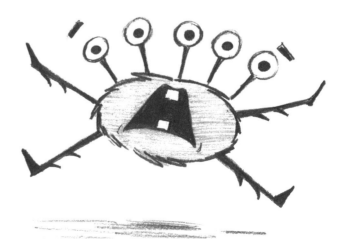

This is an optometrist's dream patient.

GOOD ALIENS VS. BAD ALIENS

It's not the number of eyes that indicates whether an alien is good or bad but the *shape* of its eyes. Generally speaking, the friendlier the alien, the more circular its eyes. The eviler the alien, the flatter its eyes (think semicircles). Deep rings under the eyes are a sign of malevolence, insomnia, or both.

Giant fangs are also a giveaway. There are, however, "good" aliens who have giant fangs. Bad aliens bite. Good ones swallow their victims whole.

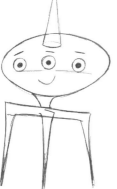

Circles—friendly eyes: Round eyes with small pupils floating in the middle create a perky appeal. Thin eyebrows are consistent with an affable look.

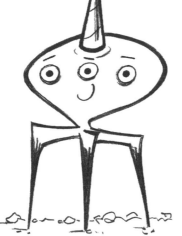

Semicircles—evil eyes: Heavy eyebrows sit on the eyeballs, flattening them into semicircles.

DEEP SHADOWS

Deep shadows drawn under the eyes are a good indicator that the character is in a very bad mood.

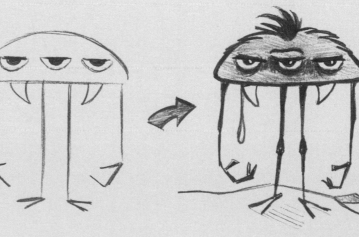

Aliens with Human Occupations

In animated movies, you'll often see aliens working menial jobs on earth, where they're treated like second-class citizens. Good help must be really hard to find.

IT'S A LIVING

For example, this little fella was recruited from a planet thirty light-years away to work as a night watchman at a big box store on earth. This is what you get when you hire nonunion.

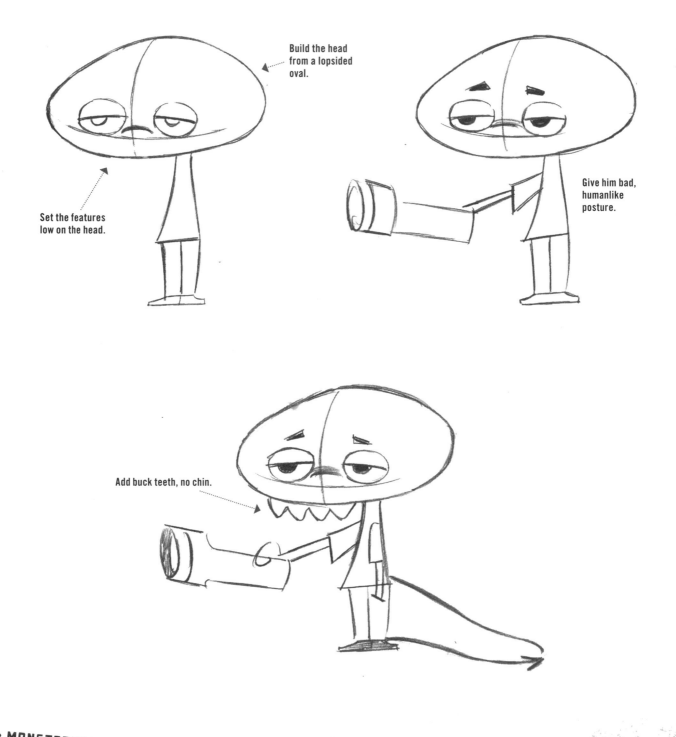

Build the head from a lopsided oval.

Set the features low on the head.

Give him bad, humanlike posture.

Add buck teeth, no chin.

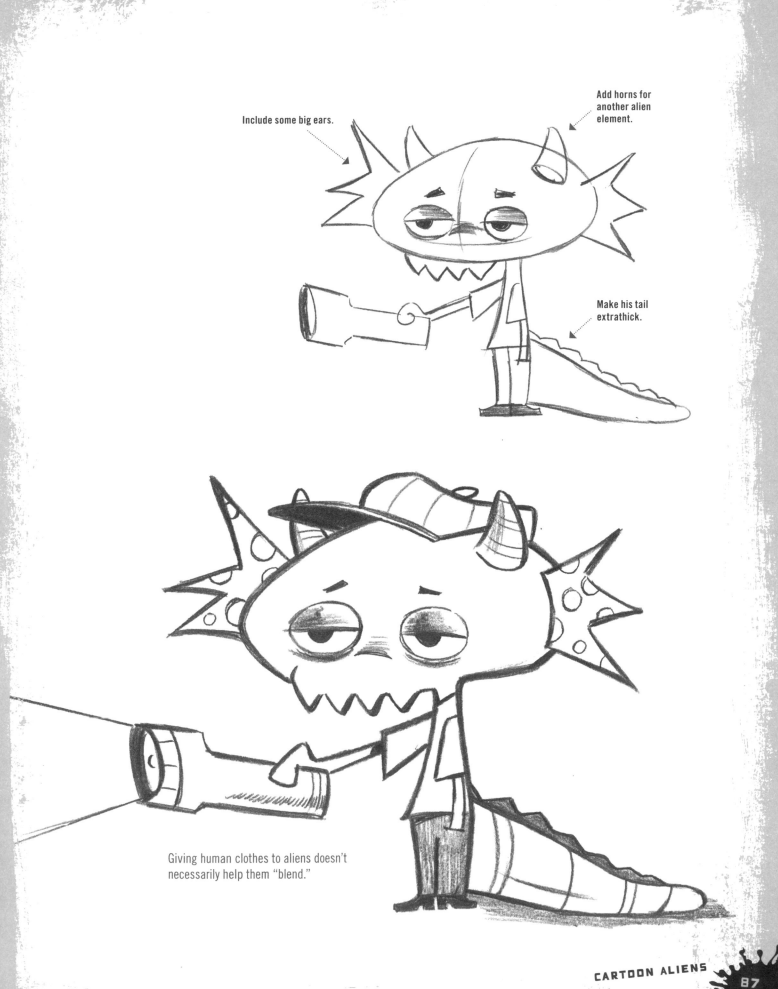

Include some big ears.

Add horns for another alien element.

Make his tail extrathick.

Giving human clothes to aliens doesn't necessarily help them "blend."

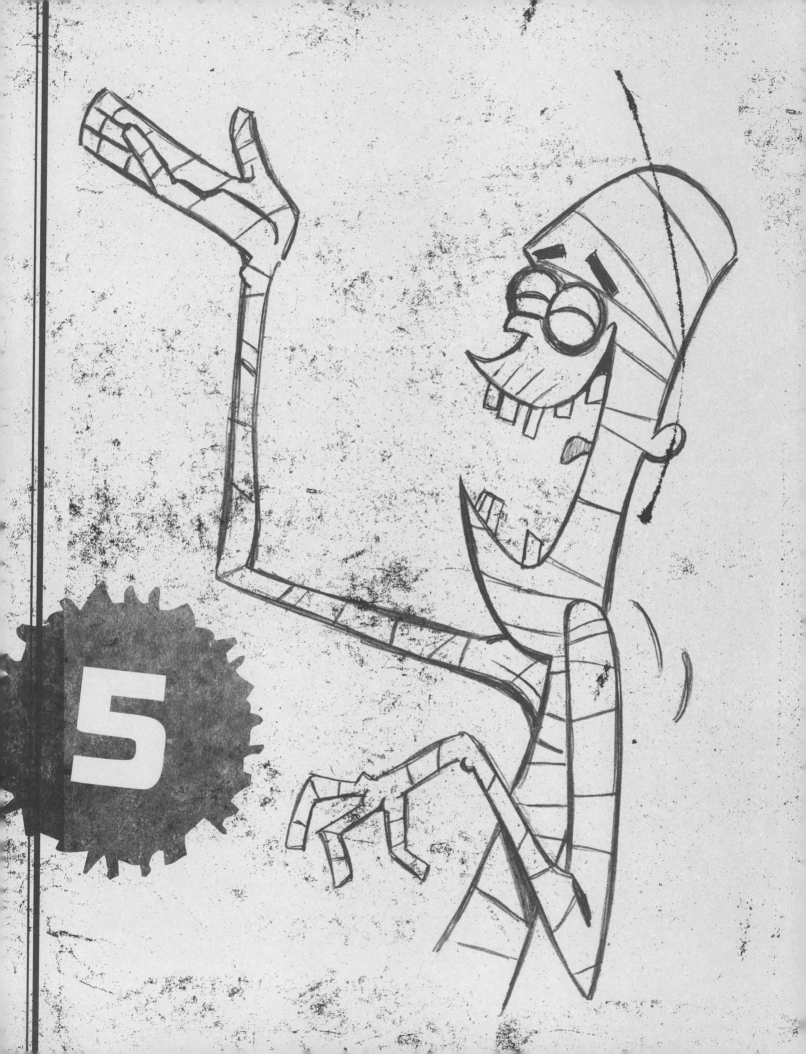

MAD FOR MUMMIES

MUMMIES are the clown princes and princesses of cartoon horror. Covered from head to toe in bandages, they look easy to draw. Indeed, they are simple, but that's also the problem: They give you almost nothing to work with. How do you draw a character with a personality when the only facial feature that shows are the eyes? How do you draw an expressive cartoon with a body that's all gift-wrapped bones?

The answer is: *Be inventive and resourceful.* How? By using and expanding every available visual trait the character has. Milk the designs for all they're worth!

Mummy Head and Facial Features

Look at the typical mummy on the next page. Notice the intelligence behind the eyes? Me neither. Keep it that way. Mummies are creaky, cranky, and crafty. They're so sneaky and sinister that they give evil a bad name.

USING BANDAGES TO CREATE EXPRESSIONS

Many cartoonists ignore the fact that you can't see the eyebrows over mummies' bandages and draw them anyway. Let's try another approach that is a little more inventive.

Start with the observation that the mummy's bandages are drawn *horizontally* across the face. That's the same direction as the eyebrows. Therefore, you can take a line from one of the horizontal bandages and use it to double for the eyebrows. Which line do you use? The one that's closest to the top of the eyes. This single flowing "eyebrow" creates funny expressions.

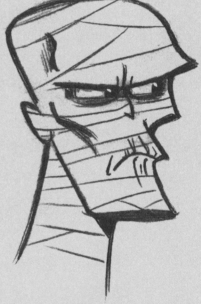

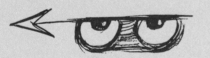

Monobrow: straight across

Monobrow: dips left, looks right

Monobrow: dips right, looks left

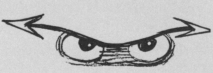

Monobrow: curves down evenly for an angry expression

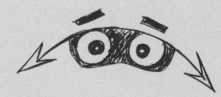

Monobrow: curves up evenly for a sad expression

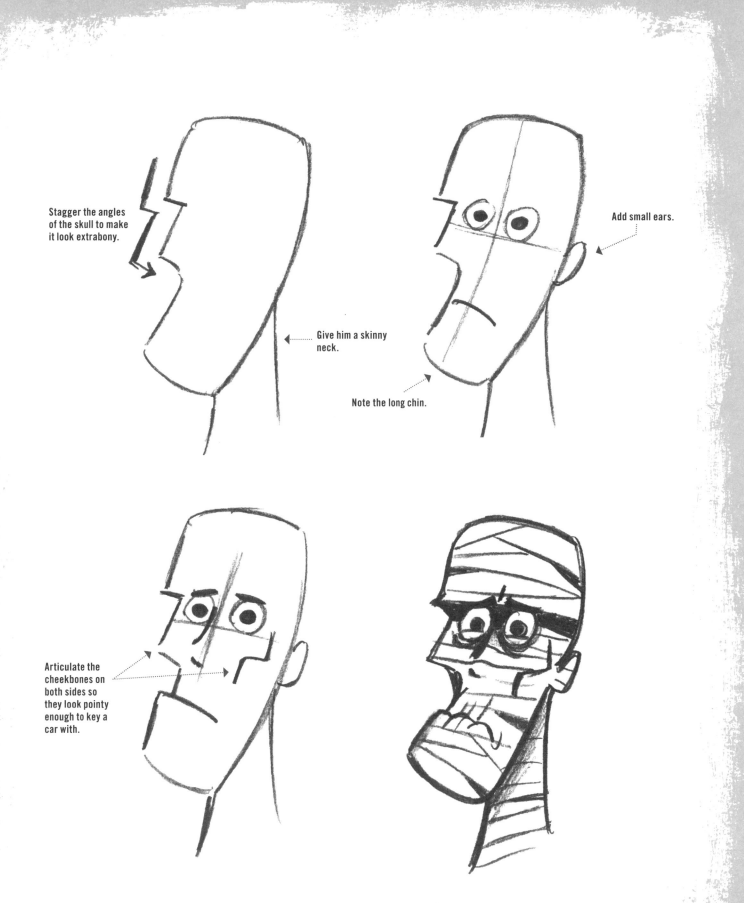

Stagger the angles of the skull to make it look extrabony.

Give him a skinny neck.

Add small ears.

Note the long chin.

Articulate the cheekbones on both sides so they look pointy enough to key a car with.

Surround the eyes with darkness. Add wrinkles to the edges of the lips.

Evil Enjoys a Good Chuckle

It's important to use a wide variety of expressions—*especially happy ones*—when drawing evil characters. Even though they have nasty dispositions, these characters are quick to laugh under certain circumstances. For example, who doesn't enjoy giggling at someone else's misfortune? Not that I've ever done that.

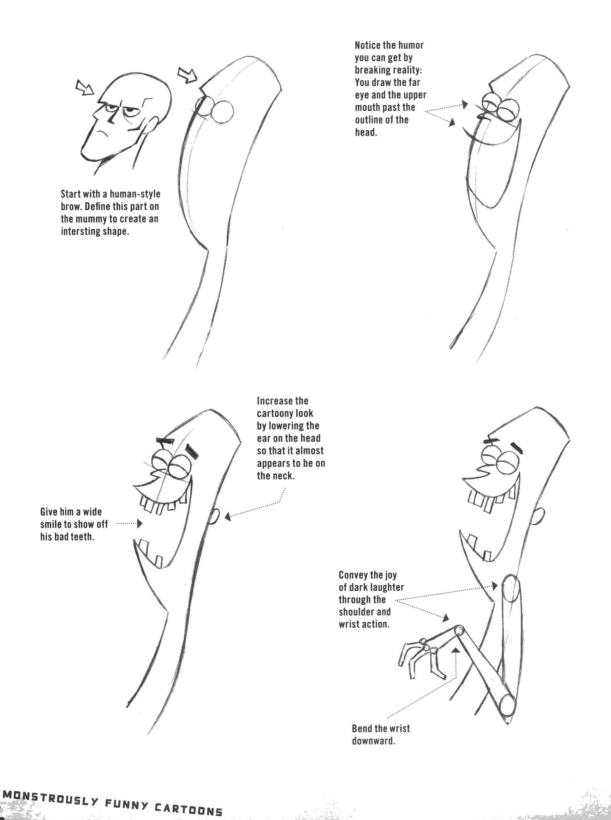

Start with a human-style brow. Define this part on the mummy to create an intersting shape.

Notice the humor you can get by breaking reality: You draw the far eye and the upper mouth past the outline of the head.

Give him a wide smile to show off his bad teeth.

Increase the cartoony look by lowering the ear on the head so that it almost appears to be on the neck.

Convey the joy of dark laughter through the shoulder and wrist action.

Bend the wrist downward.

Affix huge padded hands to skinny little forearms for a humorous combo.

Make the lip pointed.

Notice the uneven and slopppy manner in which the bandages have been wrapped. This is important. In comedy, neatness counts—against you.

ROUGH SKETCH

I find free-sketching to be a important aspect of character creation. When I free-sketch, I let my pencil go wherever it wants, without regard for messy lines or smudges. I draw quickly, following my impulses. Then I'll take look at the mess of lines I just drew and examine them to see if there is the beginning of a character hidden somewhere inside. If my scribbles seem to suggest a character, I'll redraw it, this time with an eye toward editing and making corrections. If I have a difficult time reproducing the image in finished form, I'll quickly return to the exact same step-by-step process you've followed in this book to formulate as solid a foundation for the character as possible. That usually solves whatever problem I'm having with the image.

THE INFAMOUS MWA-HA-HA! LAUGH

The *Mwa-Ha-Ha!* is a type of a laugh cartoonists use to depict evil characters gloating *in advance*. Usually, it is used to celebrate something terrible that's about to happen to the good guy. Mummies are accomplished gloaters. They can gloat with the best of them.

The Mwa-Ha-Ha! is also an extreme expression that requires the full involvement of the body as well as the correct facial expression. The face may be enough to provide the "Mwa," but it's the body that supplies the "Ha-Ha!"

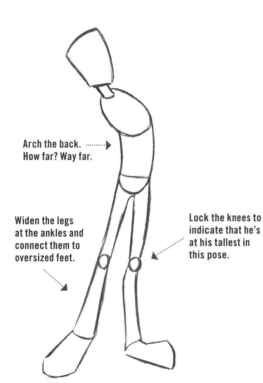

Arch the back. How far? Way far.

Widen the legs at the ankles and connect them to oversized feet.

Lock the knees to indicate that he's at his tallest in this pose.

Give him a tiny waistline.

DIAGRAM OF A POSE

The line of action shows that the basic thrust of the pose is severe but simple.

Notice that the big bend of the torso occurs *lower* on the back . . .

. . . but *higher* on the chest (at the level of the sternum).

Position the elbows out and away from the body.

Make his stance wide, with the feet pointed outward at a 45-degree angle.

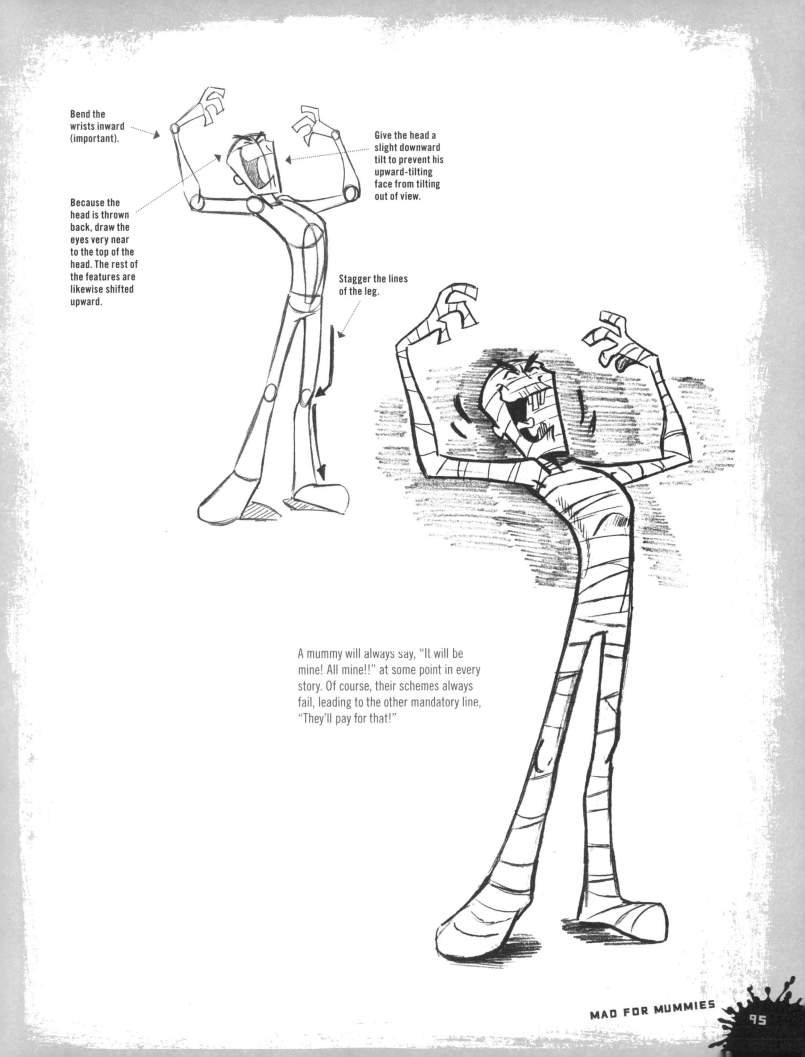

Bend the wrists inward (important).

Give the head a slight downward tilt to prevent his upward-tilting face from tilting out of view.

Because the head is thrown back, draw the eyes very near to the top of the head. The rest of the features are likewise shifted upward.

Stagger the lines of the leg.

A mummy will always say, "It will be mine! All mine!!" at some point in every story. Of course, their schemes always fail, leading to the other mandatory line, "They'll pay for that!"

Play Nice

Monster parents always warn their monster children not to go near mummies, and with good reason. Mummies don't play nice. If a mummy ever asks you what your favorite toy is, don't answer. The seemingly innocent question often leads to unfavorable results.

This leads us to a very important principle of cartooning: *Do not compete with your own jokes!* That simply means that when you've drawn a funny gag, don't attempt to do more with the pose. Referring to the example here, you can see that the yo-yo gag shown below is effective. It's amusing. It's funny. But the mummy's pose doesn't consist of much except a hyperextended arm. In instances like this, there may be the temptation to do more with the pose. Don't! Because the rest of the pose is underplayed, nothing distracts the viewer from the visual gag. By doing less with the pose, you actually *strengthen* the comedic effect.

Tilt the head back for a tentative look.

For a funny effect, give him a low center of gravity.

Make his chest small.

TIPS FOR CREATING FUNNY BANDAGES

Symmetrical wrappings are boring. A funny touch is to make it appear that whoever bangaged this mummy missed a few spots. Give the black slits a random placement. Adding a light streak of shading horizontally along a bandaged limb gives it the illusion of roundness.

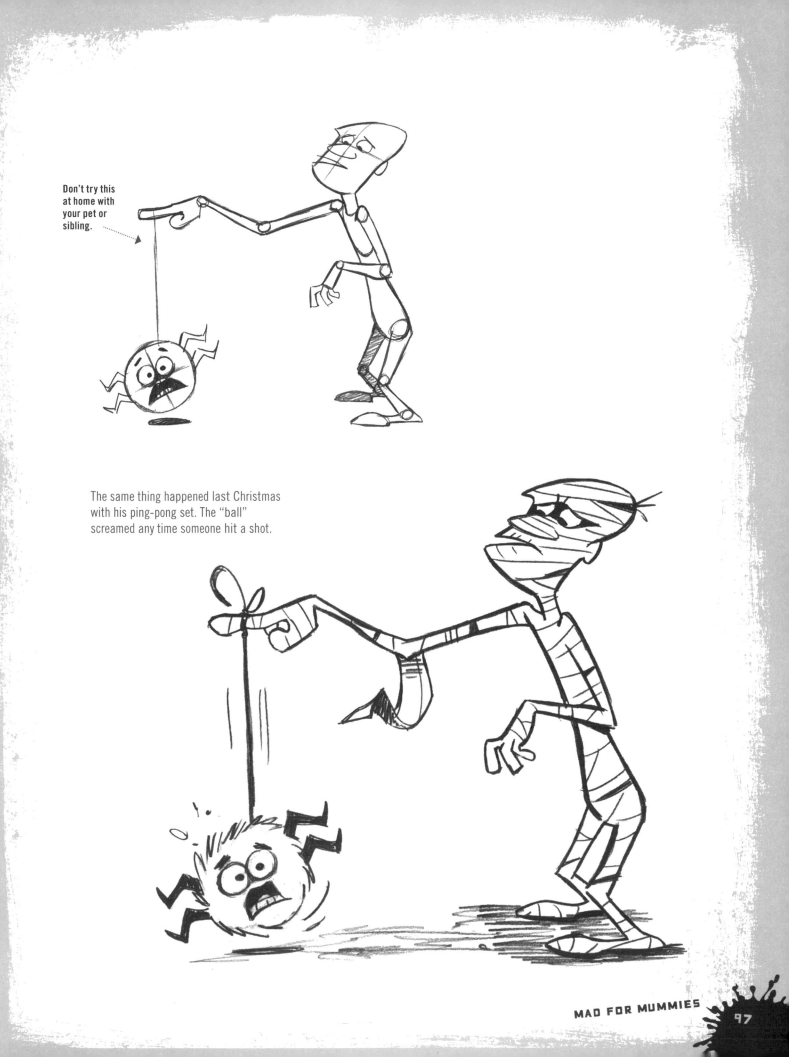

Don't try this at home with your pet or sibling.

The same thing happened last Christmas with his ping-pong set. The "ball" screamed any time someone hit a shot.

The Mummy Walk

Mummies walk. They don't run. They don't skip. They don't hop. And they certainly don't do the hokey pokey. Or at least they do it so badly that you can't tell it's the hokey pokey.

If zombies walk with stiff legs, what about mummies, who ought to be at least as stiff as zombies? Mummies often have a little more *life* in their step. Why does it work like that? How come some undead are stiff and other undead are more flexible? The stiff walk of the zombie is its defining trait. It shouts "Zombie!" If a mummy were to walk the same way as a zombie, the zombie shuffle would no longer be distinctive. Since no one really knows how a mummy is supposed to walk, you can be more inventive with it.

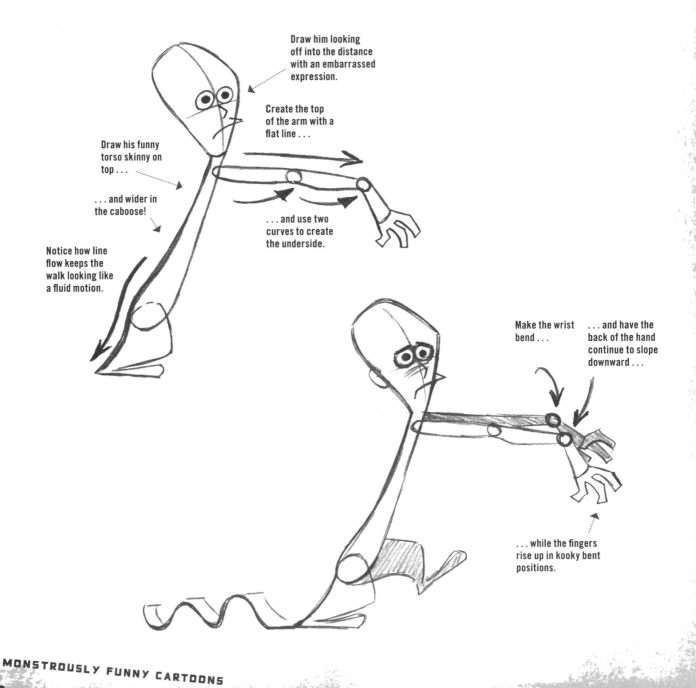

Draw him looking off into the distance with an embarrassed expression.

Create the top of the arm with a flat line . . .

Draw his funny torso skinny on top . . .

. . . and wider in the caboose!

. . . and use two curves to create the underside.

Notice how line flow keeps the walk looking like a fluid motion.

Make the wrist bend . . .

. . . and have the back of the hand continue to slope downward . . .

. . . while the fingers rise up in kooky bent positions.

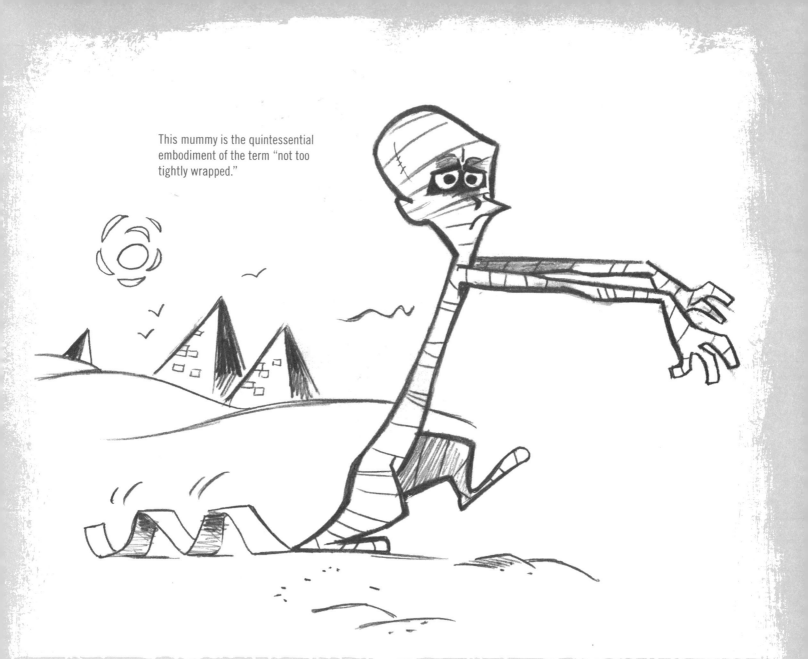

This mummy is the quintessential embodiment of the term "not too tightly wrapped."

DETAIL: FUNNY FEET

Flat feet are funny. By making the heel protrude, you make the foot look longer (and therefore, flatter).

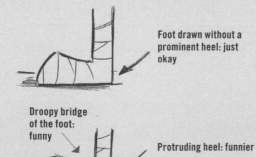

Foot drawn without a prominent heel: just okay

Droopy bridge of the foot: funny

Protruding heel: funnier

MUMMY HAND CLOSE-UP

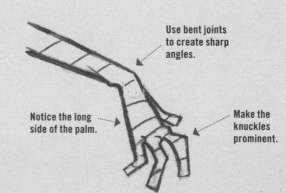

Use bent joints to create sharp angles.

Notice the long side of the palm.

Make the knuckles prominent.

Big Tummy Mummy

How does a mummy retain so much heft without leaving his pyramid for thousands of years? One word: *delivery*. Here's a riddle: What are the seven most frightening words a mummy can hear?

"No free cheese sticks with your order."

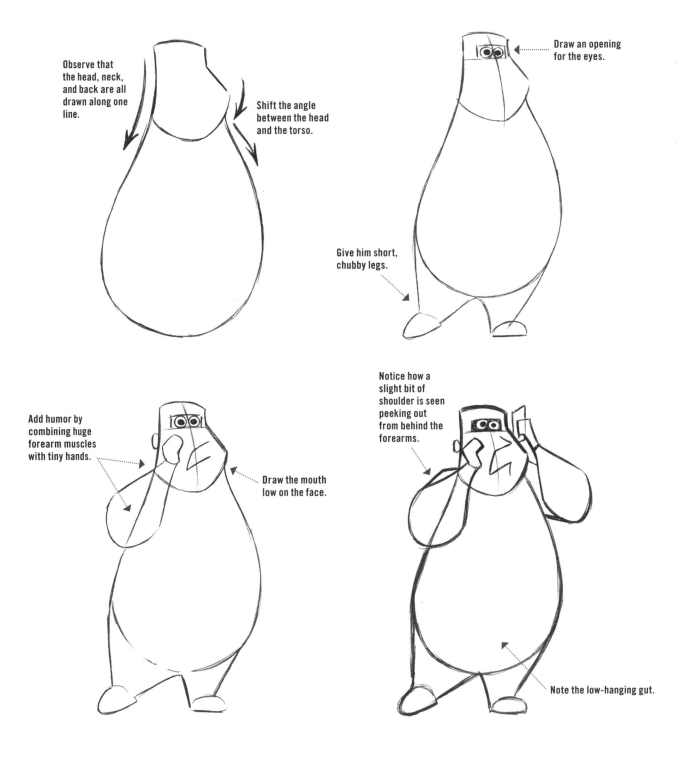

Observe that the head, neck, and back are all drawn along one line.

Shift the angle between the head and the torso.

Draw an opening for the eyes.

Give him short, chubby legs.

Add humor by combining huge forearm muscles with tiny hands.

Draw the mouth low on the face.

Notice how a slight bit of shoulder is seen peeking out from behind the forearms.

Note the low-hanging gut.

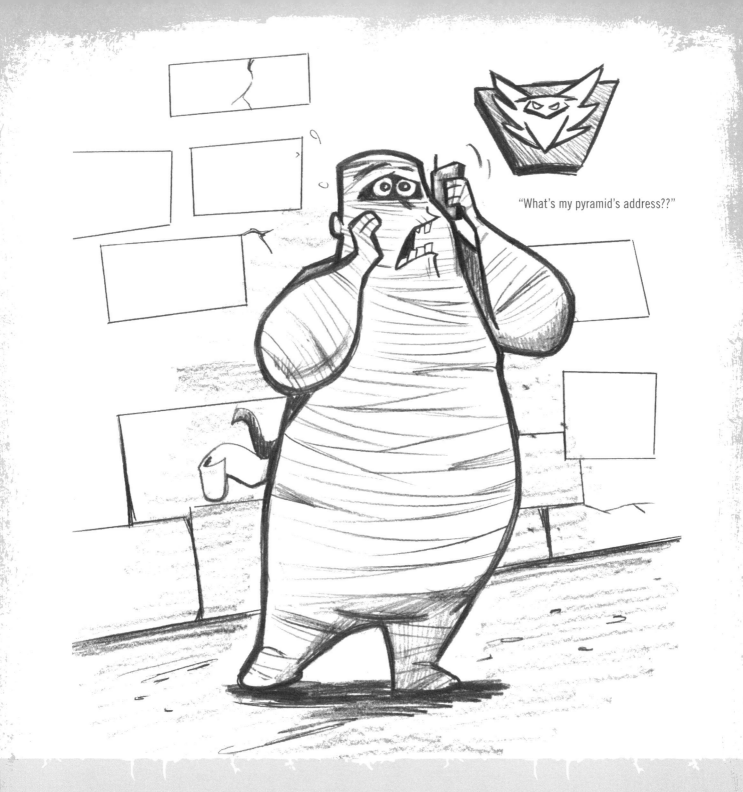

"What's my pyramid's address??"

WRAP THAT UP FOR ME

Most cartoon mummies' bandages are drawn as *thick* bands. Part of the reason for that is time—the thicker you make the bandages, the fewer lines you have to draw. But that can't be the only reason. In fact, there are circumstances under which thinner bandages look funnier. Remember the principle: *Contrast is funny.* Use skinny bandages to cover the frame of a portly mummy. Big Guy + Little Bandages = Funny Picture.

Mummified Pets

It's lonely being cooped up in a sarcophagus for a few thousand years. That's why many mummies have pets. And why the inside of a sarcophagus is such a mess.

MUMMY + PUPPY = MUPPY

Allow me to introduce you to a mummy-puppy, or simply muppy for short. Muppies make great pets. Most mummies were even buried with their muppies in order to have companionship in the next life. Not exactly sure what was in it for the muppy, though.

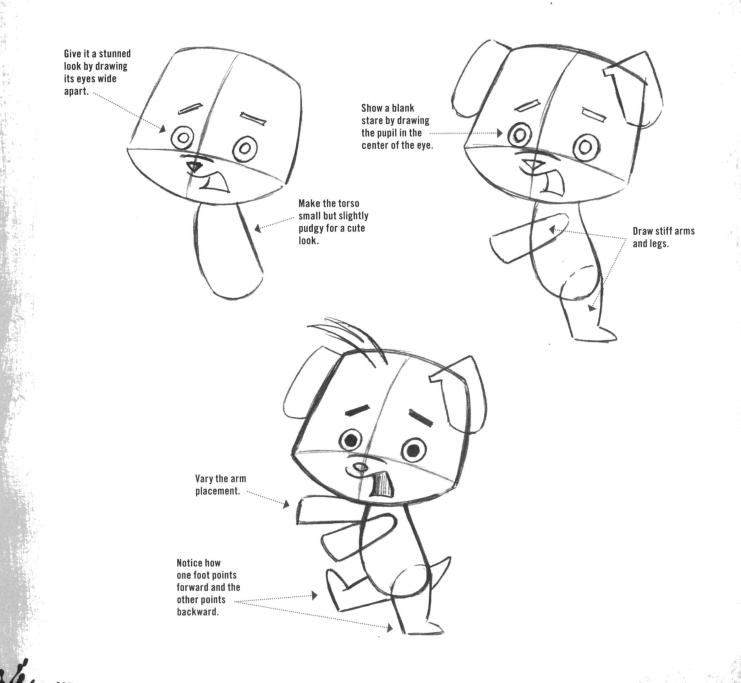

Give it a stunned look by drawing its eyes wide apart.

Make the torso small but slightly pudgy for a cute look.

Show a blank stare by drawing the pupil in the center of the eye.

Draw stiff arms and legs.

Vary the arm placement.

Notice how one foot points forward and the other points backward.

That bone tastes a little stale.

PARA-CREEP

Mummified pet birds often resent the cartoonists who drew them that way. There's all this chirping and whining about how the bandages prevent them from flying. Oh, I'm so sorry that being a mummy doesn't live up to your expectations. It's like that with cartoon characters. You give and give, but you get so little in return.

Notice how the diagonal line of the bandage creates a frowning expression.

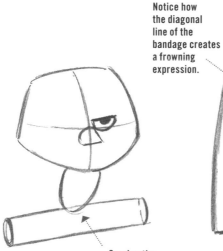

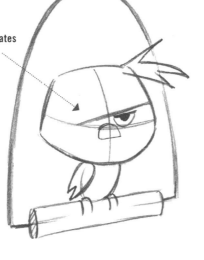

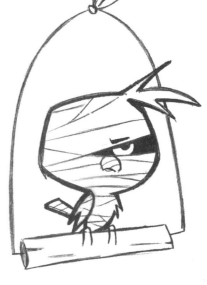

Overlap the wooden perch with the bottom of the body.

"How much is that mummy in the window?"

Who's in Charge?

It's as true for mummies as it is for humans: No matter how important you think you are, there's always someone higher up who you've got to answer to. It's usually a boss, but if you've already passed away, it's probably a floating skull. And it's angry. And it has an evil plan. There may be more to it than that, but that's all I can think . . .

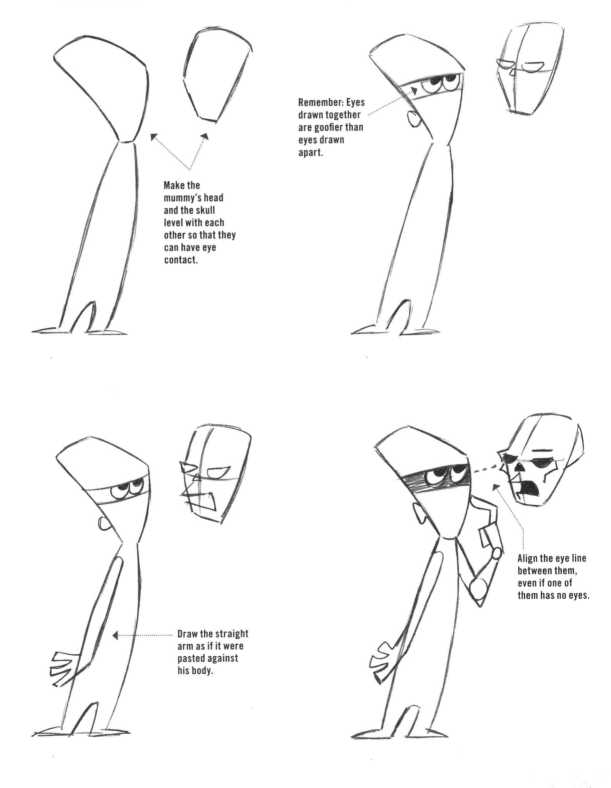

Make the mummy's head and the skull level with each other so that they can have eye contact.

Remember: Eyes drawn together are goofier than eyes drawn apart.

Draw the straight arm as if it were pasted against his body.

Align the eye line between them, even if one of them has no eyes.

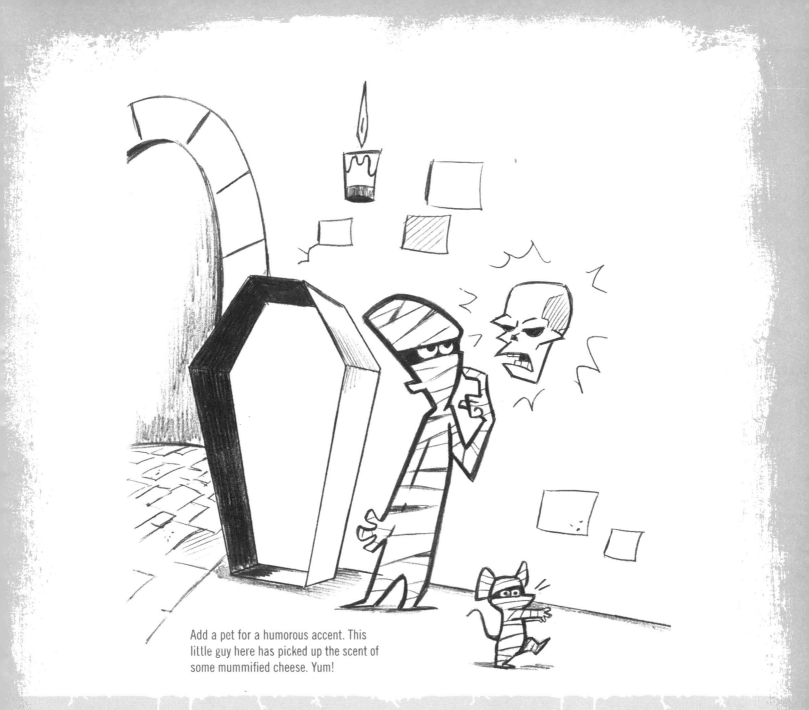

Add a pet for a humorous accent. This little guy here has picked up the scent of some mummified cheese. Yum!

FUNNY MUMMY LIST

- Play with the shape of the head. It can be anything from superbony to a more simplified shape.

- Make the eyes very grave and severe.

- If the mummy doesn't have a mouth, you can add one. If you do, make it really wrinkly.

- Squash and pull the face to create expressions. Don't rely on the features. (After all, you can't see most of them!)

- Make the bandages uneven or unraveling.

- Give the mummy odd proportions.

- Juxtapose bony limbs with a slight potbelly.

- Give the mummy bad knees (depicted in a permanent state of bending).

- Make its joints look knobby.

- Draw a hefty mummy for a change.

- Give it bad or missing teeth.

- Add wrinkles to the face.

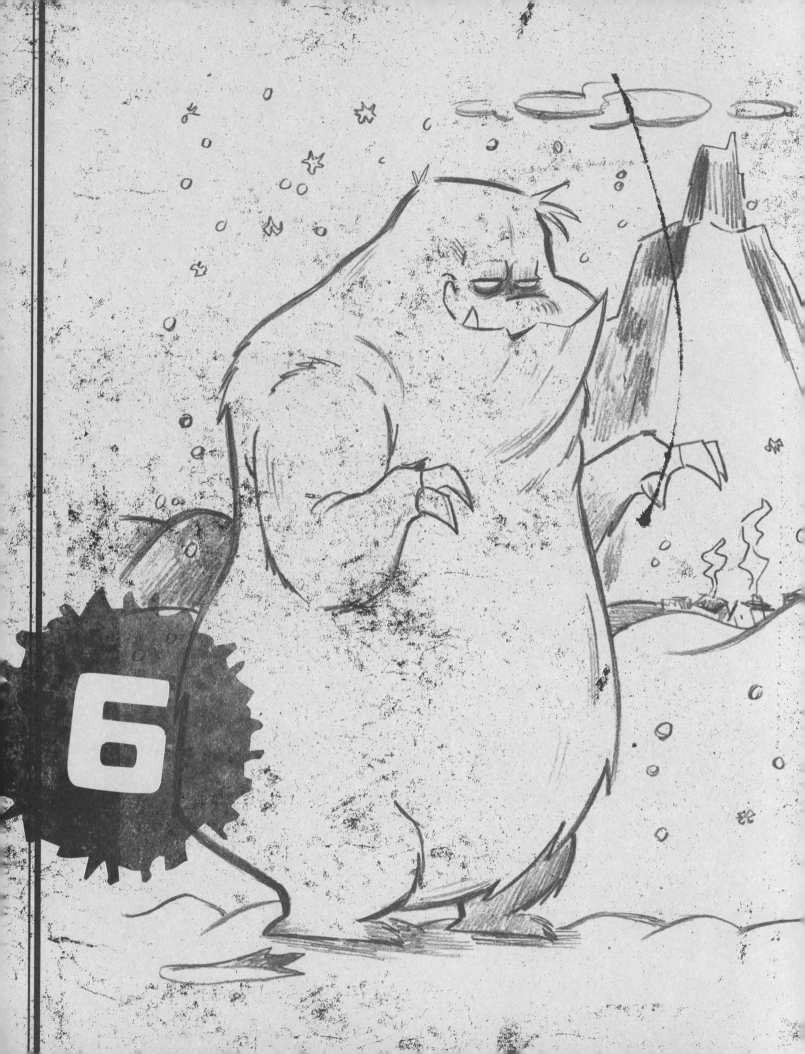

LEGENDARY MONSTERS

LEGENDARY MONSTERS such as Bigfoot and the Loch Ness Monster have many fans and followers. Some believe they are real. Others believe they are not real. Still others believe that professional wrestling is real. There are those who swear they have seen these monsters. These people generally live in isolated rural areas, and belive that opossum is one of the four basic food groups. Oddly, not one of these witnesses to monsters has access to a camera.

Compared with many of the monsters you've drawn so far—such as vampires with their capes— the monsters in this chapter are subject to greater interpretation. That's because almost no one has actually seen them. Therefore, there's really no wrong way to draw these characters. You can use the characters I have come up with as guides or create something completely original.

Ghosts

Cartoon ghosts enjoy scaring the heck out of humans. Ghosts often haunt in teams. After all, what fun is terrifying someone if you can't share the experience with a friend? Because ghosts share a similar look and often haunt in groups, you need to make them look a little different from one another.

Note the difference in personality types among the ghosts in this drawing:

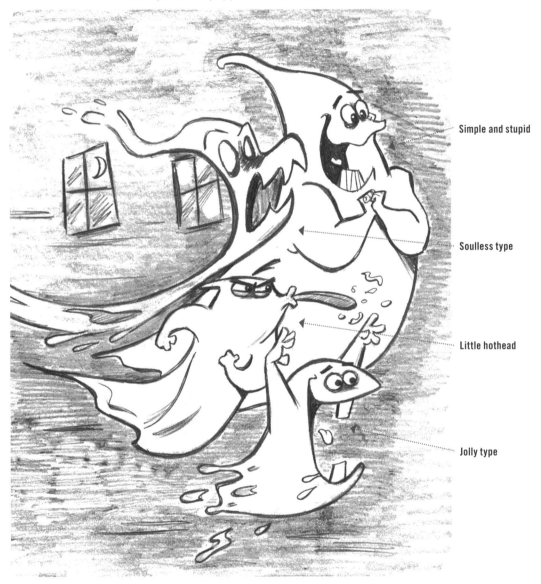

Simple and stupid

Soulless type

Little hothead

Jolly type

HINTS FOR DRAWING GHOSTS

- Draw them different sizes.
- Use different body types.
- Alter the poses so that each one differs from the others.

- Vary the personality types.
- Layer them instead of drawing them all in a row.
- Draw some that float higher off the ground and some that hover barely above the ground.

POLTERGEIST PRANKSTER

Poltergieists are ghostly spirits who are into mischief. They love to have fun. But don't think for a moment that they're laughing *with* you. No, no, my friends, they're laughing *at* you. For those of you who have had a sheltered upbringing and therefore have never seen a nuclear wedgie, this is what one looks like.

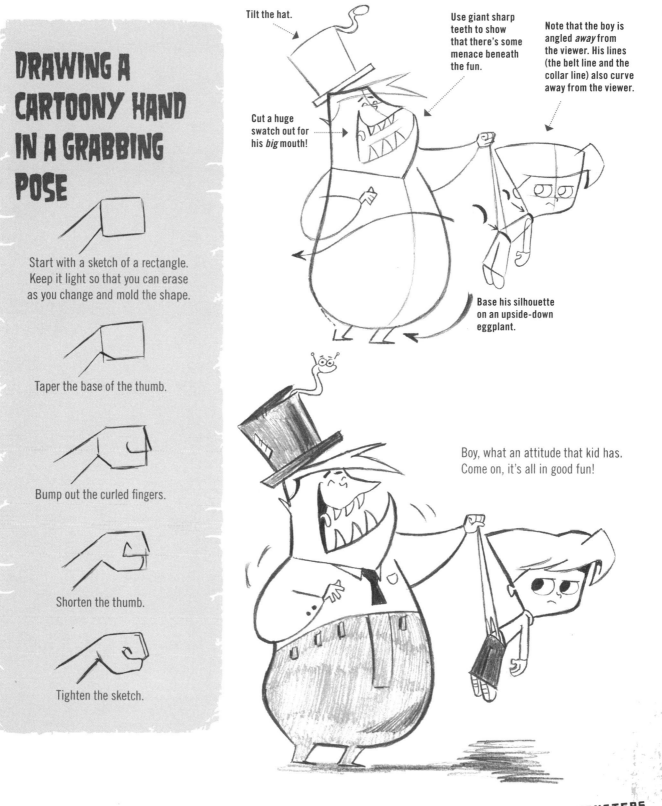

DRAWING A CARTOONY HAND IN A GRABBING POSE

Start with a sketch of a rectangle. Keep it light so that you can erase as you change and mold the shape.

Taper the base of the thumb.

Bump out the curled fingers.

Shorten the thumb.

Tighten the sketch.

Tilt the hat.

Cut a huge swatch out for his *big* mouth!

Use giant sharp teeth to show that there's some menace beneath the fun.

Note that the boy is angled *away* from the viewer. His lines (the belt line and the collar line) also curve away from the viewer.

Base his silhouette on an upside-down eggplant.

Boy, what an attitude that kid has. Come on, it's all in good fun!

Bigfoot (and Littlefoot)

Here you see the superfamous Sasquatch, the half ape, half human also known as Bigfoot. It lives in the woods of North America, coming out only in the spring or when a reporter from a seedy tabloid is in the vicinity. Most people expect Bigfoot to be an aggressive beast. To add a twist to this idea, many cartoonists and animators turn him into a gentle giant instead. I think he's funniest as a doting father who can't say no to his little girl. And for her birthday, she really, really wants a pet human.

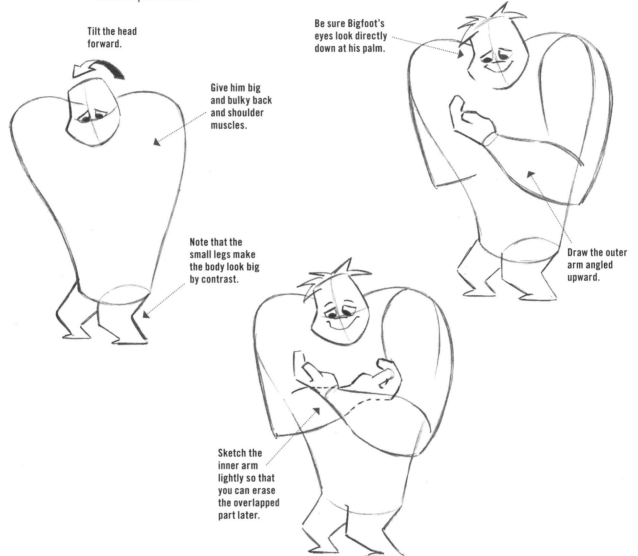

Tilt the head forward.

Give him big and bulky back and shoulder muscles.

Note that the small legs make the body look big by contrast.

Be sure Bigfoot's eyes look directly down at his palm.

Draw the outer arm angled upward.

Sketch the inner arm lightly so that you can erase the overlapped part later.

DRAWING THROUGH AN IMAGE

To make the crossed-arm pose easier to draw, complete each arm, even the part that would be hidden from view. This will make it much easier to find correct positioning.

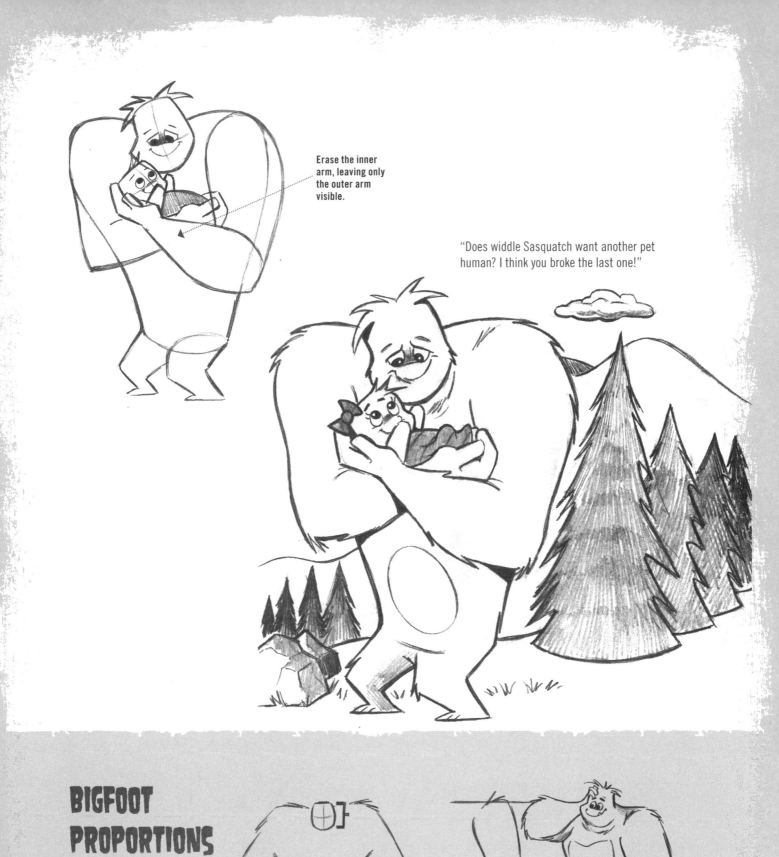

Erase the inner arm, leaving only the outer arm visible.

"Does widdle Sasquatch want another pet human? I think you broke the last one!"

BIGFOOT PROPORTIONS

The head and the legs are the same length.

The arms are as long as the body. You see these weird proportions only on the Sasquatch or teenage boys.

Loch Ness Monster

They call her Nessy, which is short for the "eat your boat and then chew your face off" monster (loose translation). Nessy lives in a giant lake in Scotland. Half of the residents live in constant fear of the creature. The other half sell T-shirts and mugs with Nessy's picture on it.

Cartoonists often run into the problem of making scary monsters look too scary when drawing exceptionally huge ones. The monsters' sheer size is intimidating, which is counterproductive for laughs. One of the most effective ways to create a funny mega-monster is to go for a *goofy* look. The bigger the monster is, the goofier its personality needs to be.

Give her a superbig goofy smile, traveling higher up on the face than even the eyes.

Observe that the far eye breaks reality by appearing halfway beyond the outline of the face (always suitable for a goofy look).

Vary the thickness of the long neck.

Tilt the boat for an unsteady look.

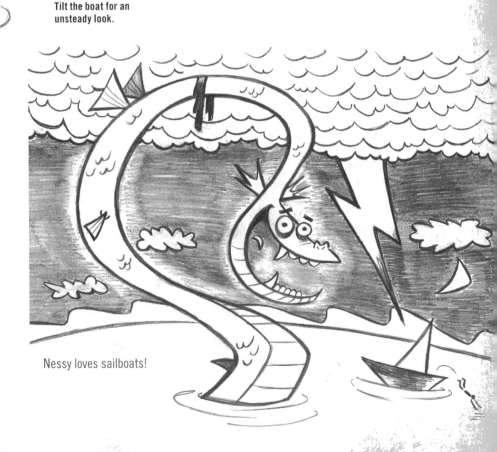

Nessy loves sailboats!

Abominable Snowman

The Abominable Snowman is perfectly camouflaged for its environment. Its furry white coat blends into the snow-covered mountains, which means no one has actually seen one. Which means, how the heck does anyone know it exists?

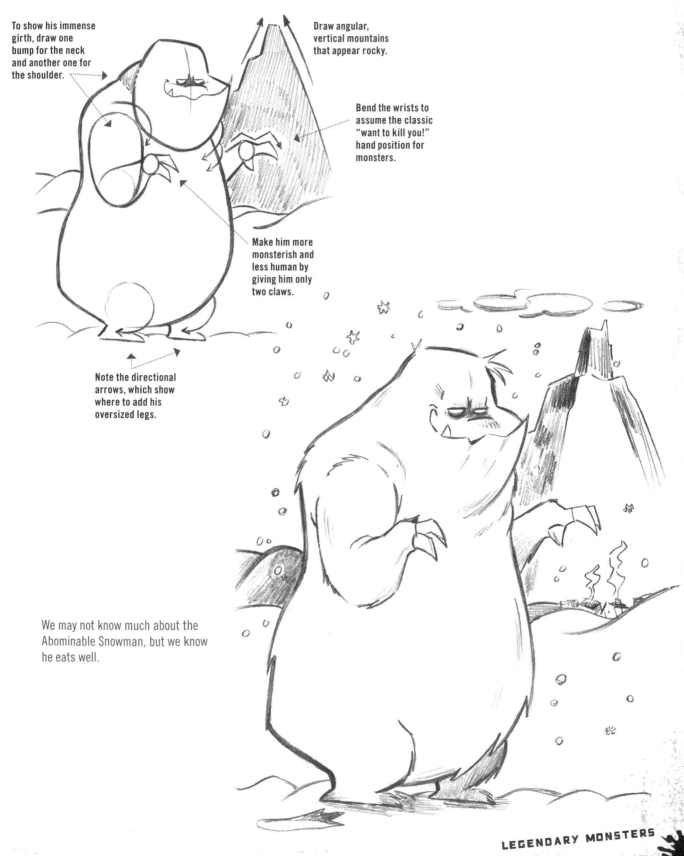

To show his immense girth, draw one bump for the neck and another one for the shoulder.

Draw angular, vertical mountains that appear rocky.

Bend the wrists to assume the classic "want to kill you!" hand position for monsters.

Make him more monsterish and less human by giving him only two claws.

Note the directional arrows, which show where to add his oversized legs.

We may not know much about the Abominable Snowman, but we know he eats well.

THE WEIRD
AND THE BIZARRE

IN THE STREETS of most major cities at night, these monsters scurry past, unnoticed. But if you were to keep your eyes on them, you would see some astonishing things: a tentacle accidentally dropping from a man's sleeve, green slime trickling from a woman's ear, and a man at a newsstand unscrewing the top of his cranium to scratch his brain.

They come from the world of *speculative horror*, a world in which everything appears normal on the surface but is actually weird when you look closely. (Sort of like the typical American family.)

Near-Humans

Near-humans are just like everybody else, only *more so*. If you're observant, you'll spot curious things that make them look somehow . . . wrong. The more mundane the character, the funnier the monstrous elements will be.

SQUEEZY MOM

Take this smothering mothering type as an example. She has the caring look of a loving mom. And a squid.

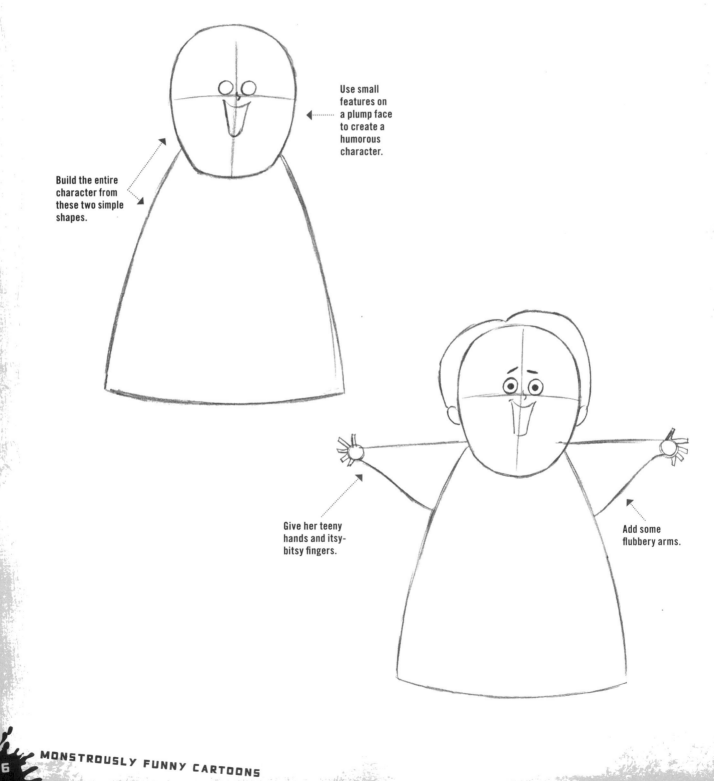

Use small features on a plump face to create a humorous character.

Build the entire character from these two simple shapes.

Give her teeny hands and itsy-bitsy fingers.

Add some flubbery arms.

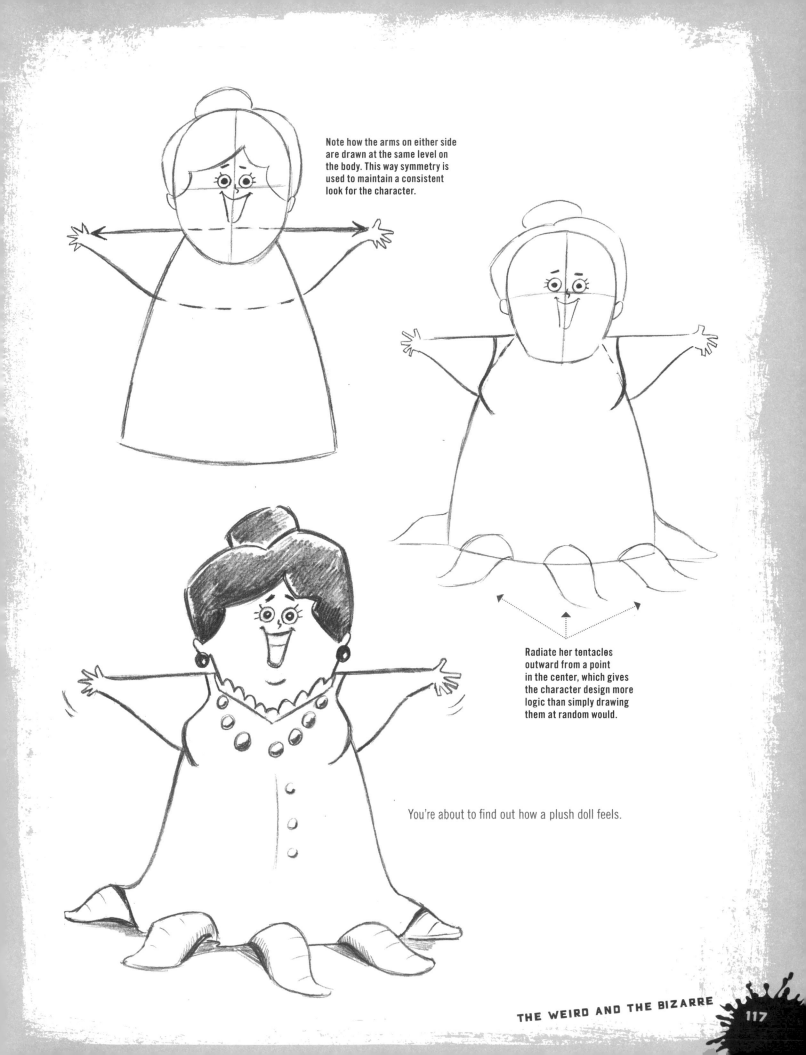

Note how the arms on either side are drawn at the same level on the body. This way symmetry is used to maintain a consistent look for the character.

Radiate her tentacles outward from a point in the center, which gives the character design more logic than simply drawing them at random would.

You're about to find out how a plush doll feels.

THOUGHTFUL DAD

You can always go to this dad when you want to pick his brain. Although the high-concept element for this character is the opened cranium, the humor also comes from his weirdly oversized physique. He looks inflated, like a party balloon with forehead wrinkles.

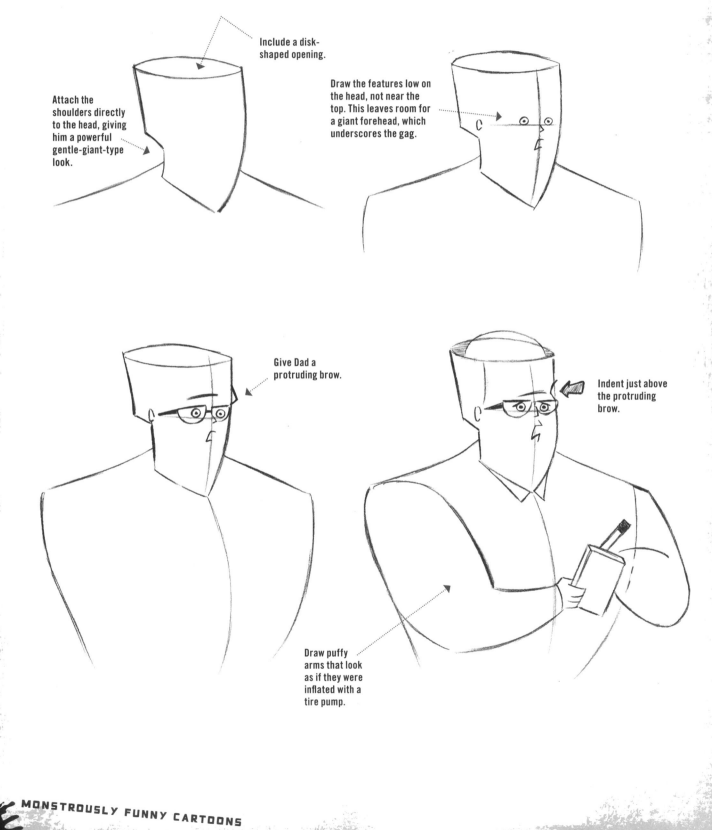

Include a disk-shaped opening.

Attach the shoulders directly to the head, giving him a powerful gentle-giant-type look.

Draw the features low on the head, not near the top. This leaves room for a giant forehead, which underscores the gag.

Give Dad a protruding brow.

Indent just above the protruding brow.

Draw puffy arms that look as if they were inflated with a tire pump.

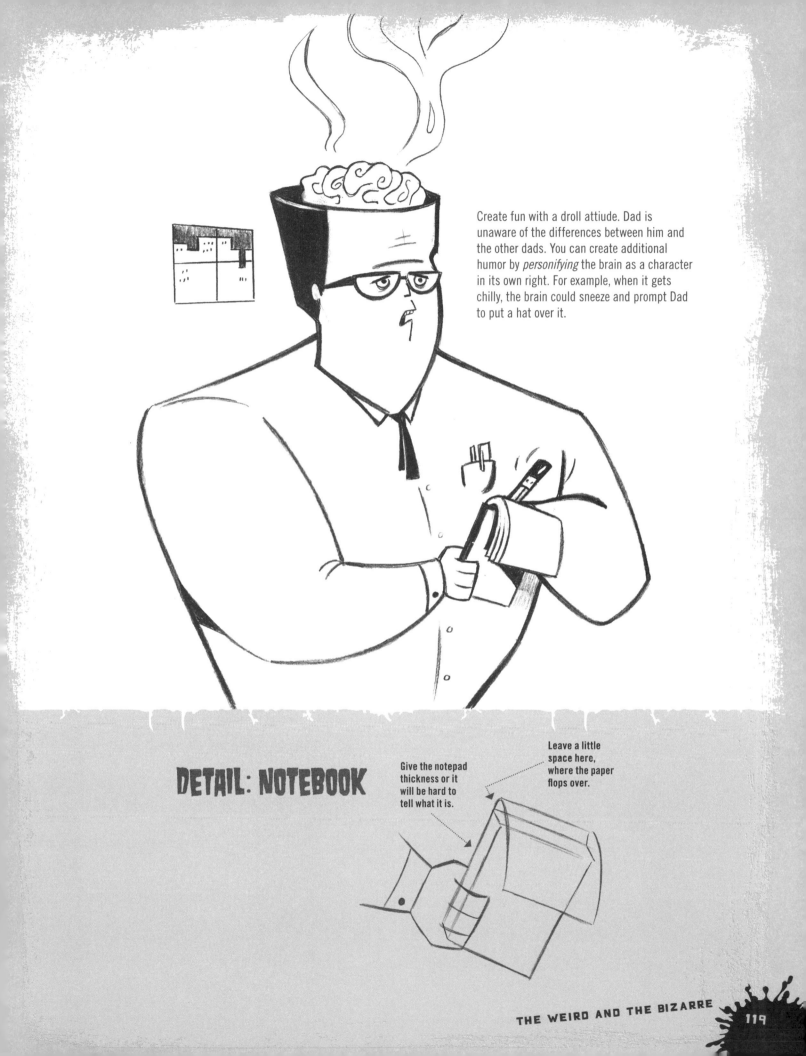

Create fun with a droll attitude. Dad is unaware of the differences between him and the other dads. You can create additional humor by *personifying* the brain as a character in its own right. For example, when it gets chilly, the brain could sneeze and prompt Dad to put a hat over it.

DETAIL: NOTEBOOK

Give the notepad thickness or it will be hard to tell what it is.

Leave a little space here, where the paper flops over.

ALMOST NORMAL . . . BUT NOT QUITE

Most cartoon dads have the same occupation: They crunch numbers without the possibility of advancement in a soulless office environment. So how is the cartoon version different from reality? The cartoon dad *likes* his job.

A small addition of weirdness—like four nearsighted eyes—is just as effective as adding big changes. It's often more effective, as it gets the audience to do a double take.

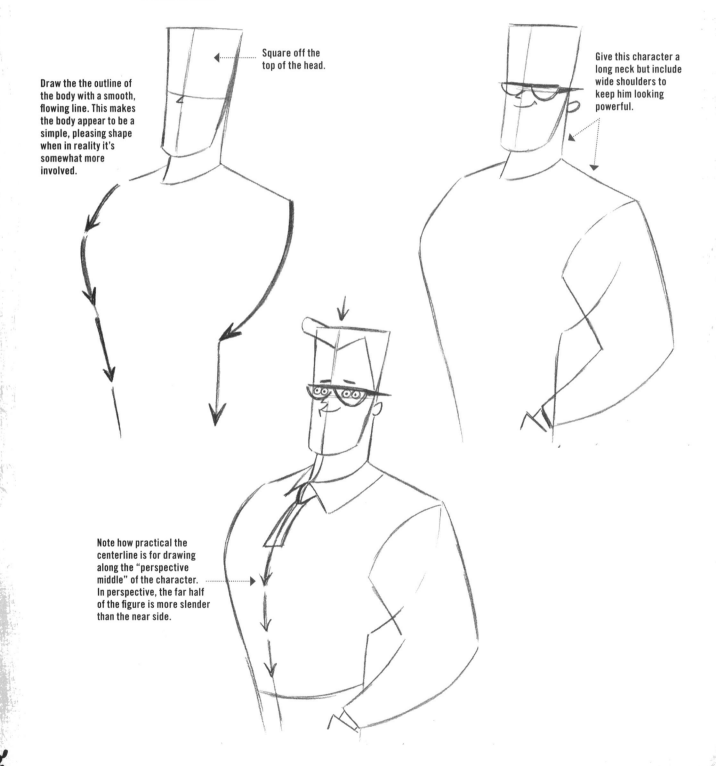

Square off the top of the head.

Draw the the outline of the body with a smooth, flowing line. This makes the body appear to be a simple, pleasing shape when in reality it's somewhat more involved.

Give this character a long neck but include wide shoulders to keep him looking powerful.

Note how practical the centerline is for drawing along the "perspective middle" of the character. In perspective, the far half of the figure is more slender than the near side.

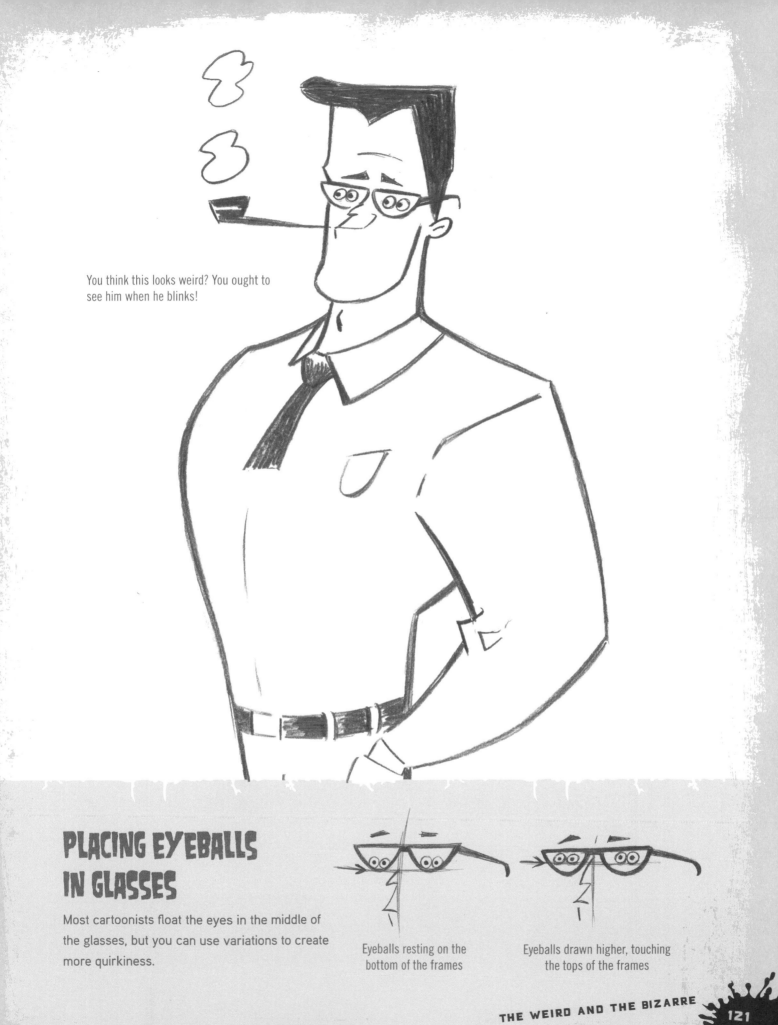

You think this looks weird? You ought to see him when he blinks!

PLACING EYEBALLS IN GLASSES

Most cartoonists float the eyes in the middle of the glasses, but you can use variations to create more quirkiness.

Eyeballs resting on the bottom of the frames

Eyeballs drawn higher, touching the tops of the frames

MOSTLY MOM

This character is a good example of a monster trying to fit into the human world. Even though her appearance is a litte startling, the viewer is drawn to her human characteristics. Make her expression as ordinary as possible. The contrast is funny. Looks like Mom's got almost everything in the grocery store on her shopping list. Now if she could only find where they keep the frozen ants!

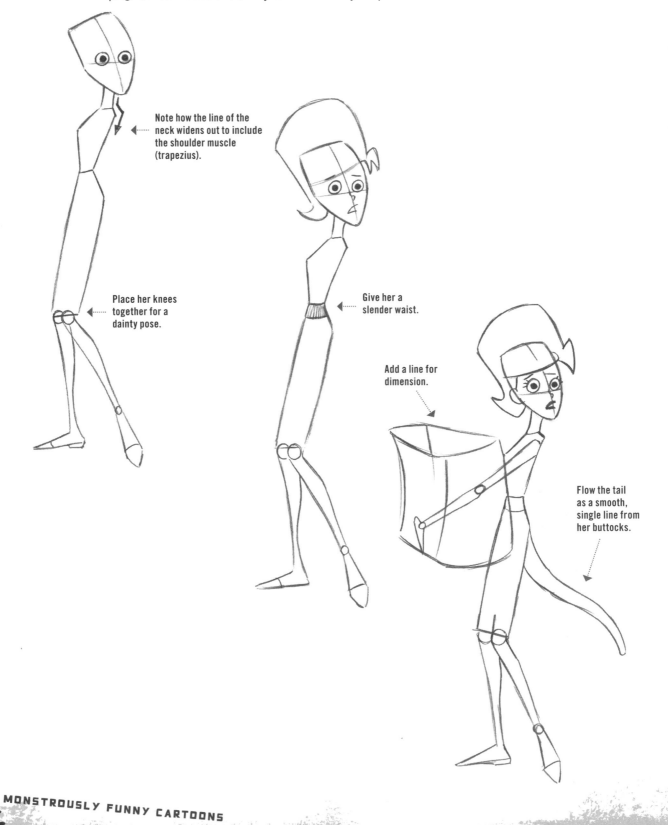

Note how the line of the neck widens out to include the shoulder muscle (trapezius).

Place her knees together for a dainty pose.

Give her a slender waist.

Add a line for dimension.

Flow the tail as a smooth, single line from her buttocks.

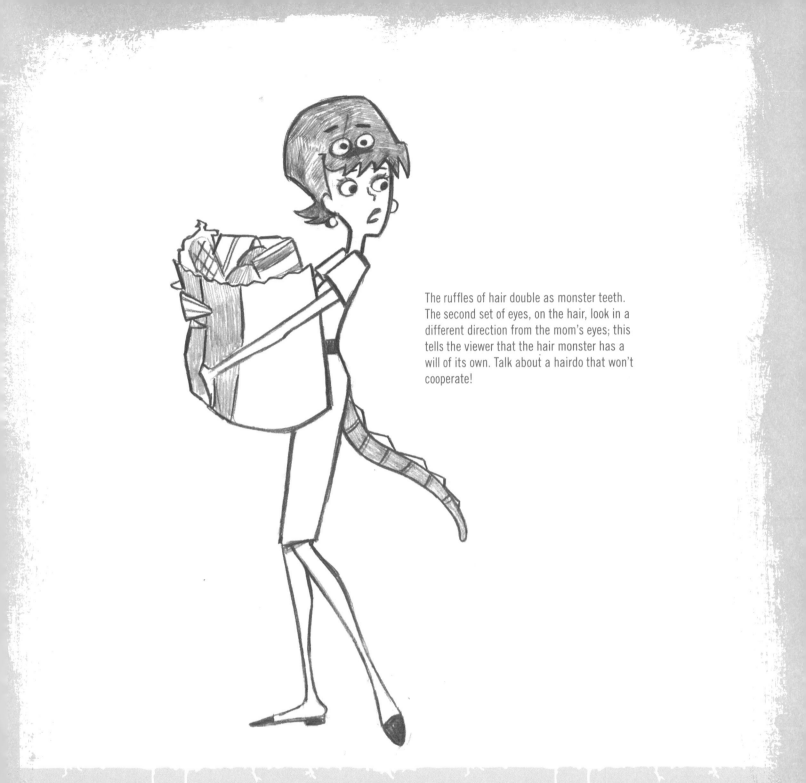

The ruffles of hair double as monster teeth. The second set of eyes, on the hair, look in a different direction from the mom's eyes; this tells the viewer that the hair monster has a will of its own. Talk about a hairdo that won't cooperate!

MONSTER HAIR HINT

Continue the line of the bangs into a smile for the monster. Rest the eys on top of the bangs.

A Boy and His Monster

By giving this boy a "lizard-corn" as a playmate, you tell viewers that they're entering Weirdsville. In addition, the kid's oddly happy expression and dark eyes drive home the point that he's not the typical boy next door.

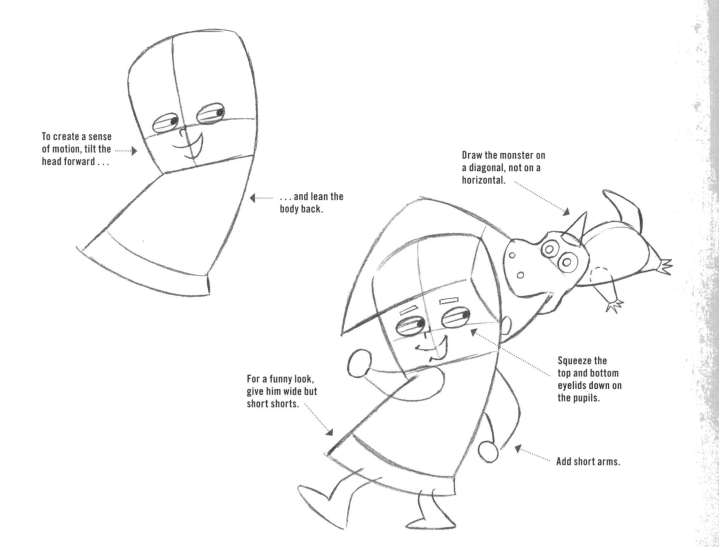

To create a sense of motion, tilt the head forward . . .

. . . and lean the body back.

Draw the monster on a diagonal, not on a horizontal.

Squeeze the top and bottom eyelids down on the pupils.

For a funny look, give him wide but short shorts.

Add short arms.

ORIGINAL SKETCH

As I keep saying, leave the intial sketches messy. Just let your creativity flow. Don't edit yourself until you do a second draft. Editing too soon in the creative process tamps down the imagination.

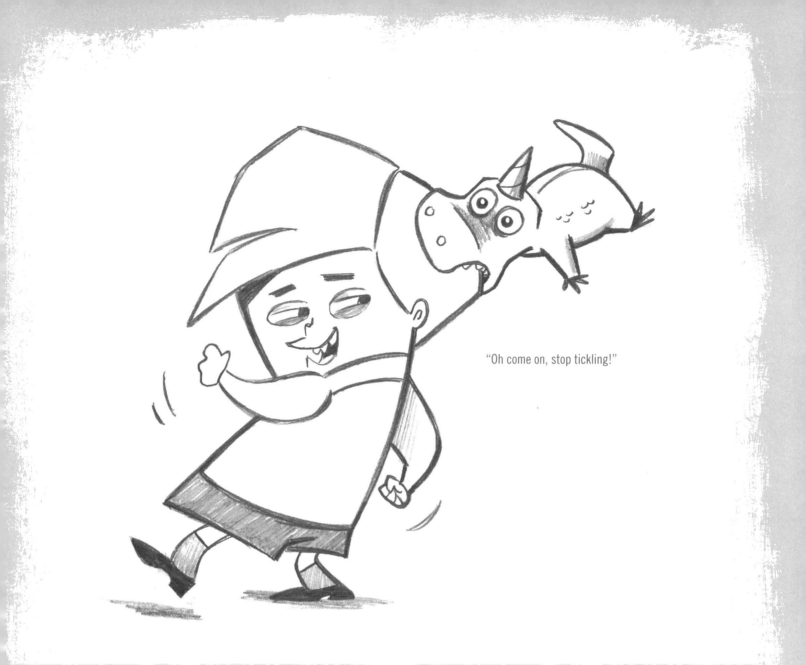

"Oh come on, stop tickling!"

DETAIL: LITTLE MONSTER

Freeze the little monster's pose so that it contrasts with the boy's busy movement. Overlap the boy's .head with the monster's muzzle to make it look like he's got a mouthful of hair.

DYNAMICS OF THE POSE

The arm goes up as the leg goes down.

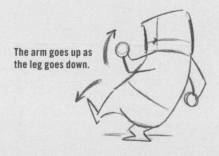

Goons and Ghouls

These monsters are so slimy, they give other monsters the creeps. You will never catch a goon or a ghoul telling the truth. They are sniveling, sneaky, smarmy miscreants. Think of them as the monster version of a best friend who always has to borrow money when you have lunch together.

NOT YOUR BFF

No matter how friendly he appears, never trust a goon. They lie and cheat so often that some people mistake them for real estate agents.

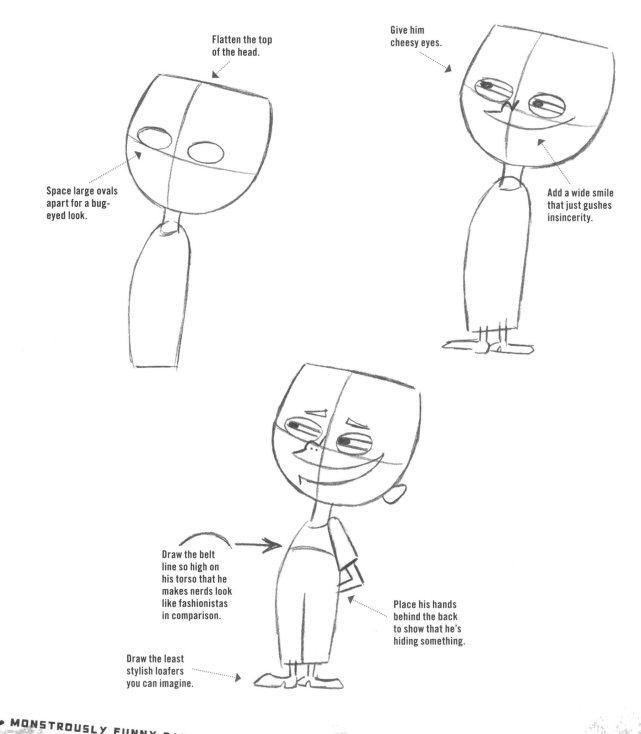

Flatten the top of the head.

Space large ovals apart for a bug-eyed look.

Give him cheesy eyes.

Add a wide smile that just gushes insincerity.

Draw the belt line so high on his torso that he makes nerds look like fashionistas in comparison.

Place his hands behind the back to show that he's hiding something.

Draw the least stylish loafers you can imagine.

Use skinny limbs and floppy hands.

Don't worry, he'll be very careful with your stuff while you're gone.

GOON EYES

The goon's eyes should communicate *cunning*. One of the best ways to do that is to give him a forced smile that pushes his bottom eyelids upward.

Semigoony eyes

The full goony: Darken the upper and bottom eyelids and draw small dots for the pupils.

BEWARE GHOULS BEARING GIFTS

Ghouls are like ghosts who still have their human forms. They are wicked and like to whip up mayhem. For example, do not purchase an exotic pet from a ghoul. You would simply not believe how big the litter box has to be!

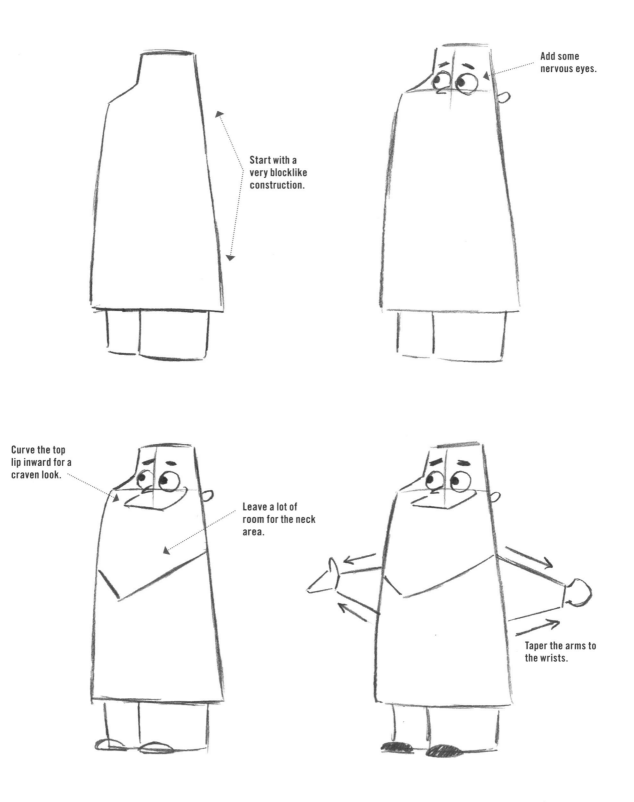

Start with a very blocklike construction.

Add some nervous eyes.

Curve the top lip inward for a craven look.

Leave a lot of room for the neck area.

Taper the arms to the wrists.

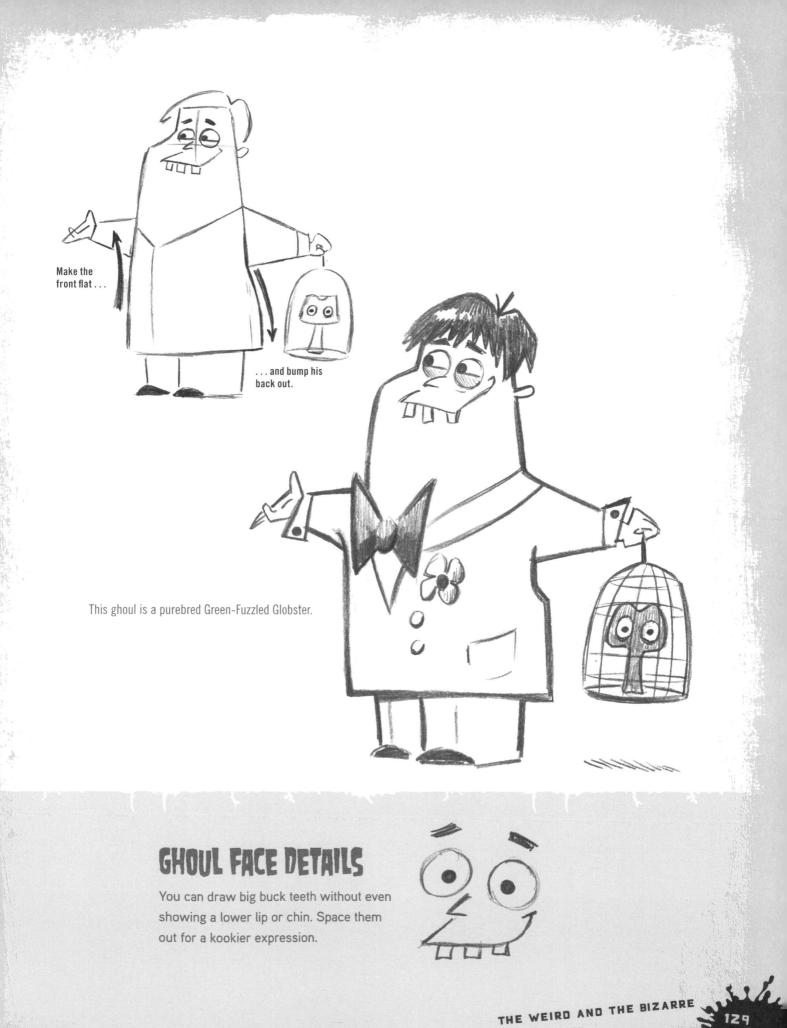

Make the front flat . . .

. . . and bump his back out.

This ghoul is a purebred Green-Fuzzled Globster.

GHOUL FACE DETAILS

You can draw big buck teeth without even showing a lower lip or chin. Space them out for a kookier expression.

Brutes

The brute is the biggest monster among the near-humans. He's powerful and stupid, so it's especially funny to cast him as a self-styled leading man who fancies himself a debonair ladies' man. He's the only monster who tries to get by on his looks alone. It's also funny to give a one-note character like this a range of emotions. I never knew he was so deep!

RANGE OF MONSTER EMOTIONS

Upset

Sentimental

Exhausted

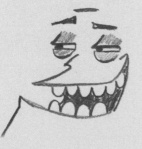

Insincere (note how the teeth can change shape to convey an expression)

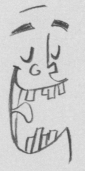

Overly confident

Panicky

YOU'RE SO VAIN

Since this brute's trying to look suave, let's give him a suave outfit. But I'm talking about the type of suave you get from purchasing an outfit at hotel gift store while on vacation. Yep, *that* kind of trendy look.

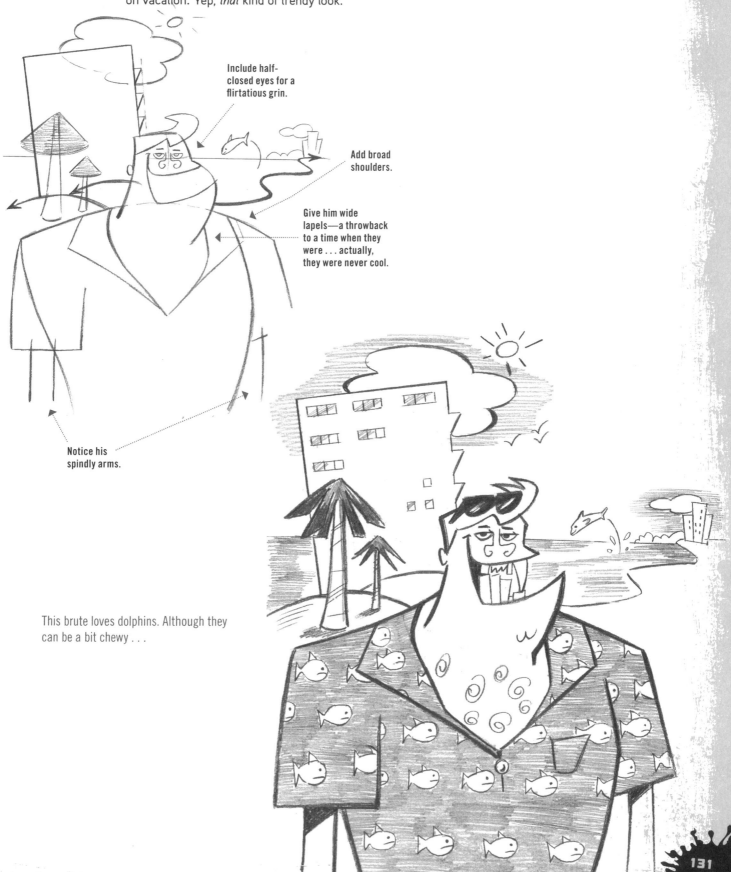

Include half-closed eyes for a flirtatious grin.

Add broad shoulders.

Give him wide lapels—a throwback to a time when they were . . . actually, they were never cool.

Notice his spindly arms.

This brute loves dolphins. Although they can be a bit chewy . . .

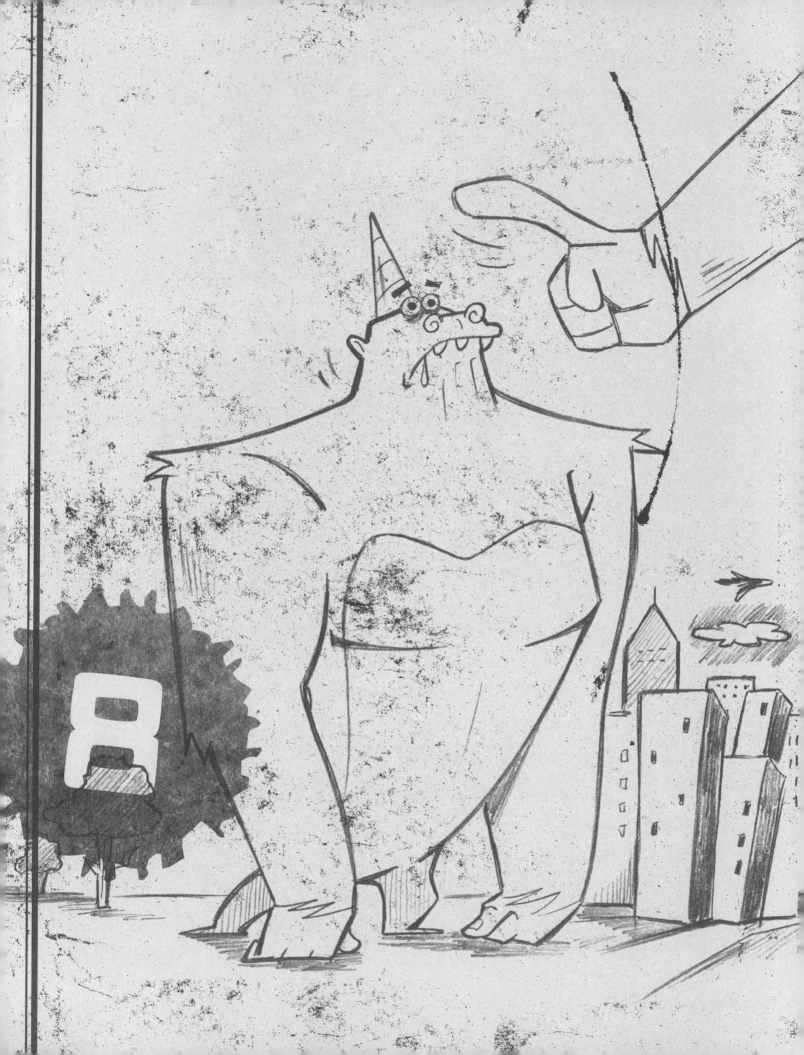

MONSTROUSLY FUNNY LAYOUTS

THIS CHAPTER will show you how easy it is to create a humorous world for your characters. Many aspiring artists who want to draw funny backgrounds avoid them because they think they require too much detail. Not true! You can draw full-looking settings with an economy of line work. Here are two key concepts to keep in mind:

- Don't render a scene, *suggest* one. Draw a limited number of elements that are designed to create *associations* in the eye of the observer. For example, a picture of rolling hills represents a field. But add just two or three tombstones to it and you've created a zombie graveyard.

- Give your scene a visual theme. I'll provide plenty of examples of visual themes to get you comfortable with the basic concept.

Out on a Limb

I love this type of scenario. It gets the audience's attention. Your star character is in danger. There appears to be no way out. (Sounds like midterms, only not quite as bad.) How in the world will he escape?

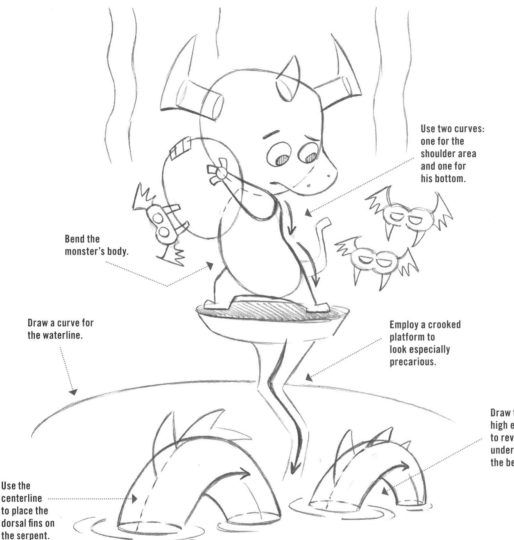

Use two curves: one for the shoulder area and one for his bottom.

Bend the monster's body.

Draw a curve for the waterline.

Employ a crooked platform to look especially precarious.

Draw the arches high enough to reveal the underside of the belly.

Use the centerline to place the dorsal fins on the serpent.

SECRETS TO CREATING A FUNNY LAYOUT

- Maintain the focus on your characters.
- Don't clutter—leave breathing room between characters and things.
- Clearly distinguish foreground from background.
- Imply action by revealing to the audience what just happened or what is about to occur.
- "Reactions" create more impact on viewers than do "actions," so try to show your character reacting to a situation.
- Use props and visual themes to suggest a time and place. For example, a simple pyramid in the background immediately puts us in the Middle East.

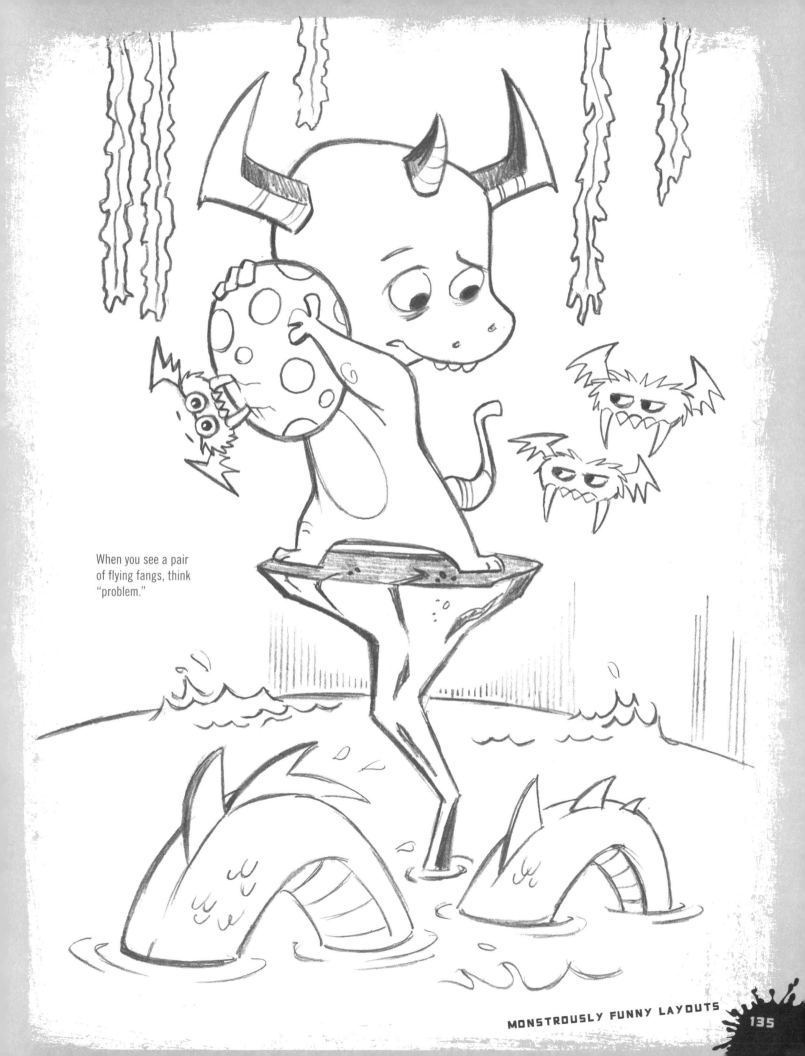

When you see a pair of flying fangs, think "problem."

Anticipation

When something's going to hurt, make it look like it's going to *really* hurt! It's the *anticipation* that gets the viewer going. How do you create the look of terror? First of all, the scene is set in a dentist's office. So right away, we know it's going to be painful. There's also a look of fear in the monster's eyes. And the way he clutches the armrests. And the dentist hasn't even begun to drill yet!

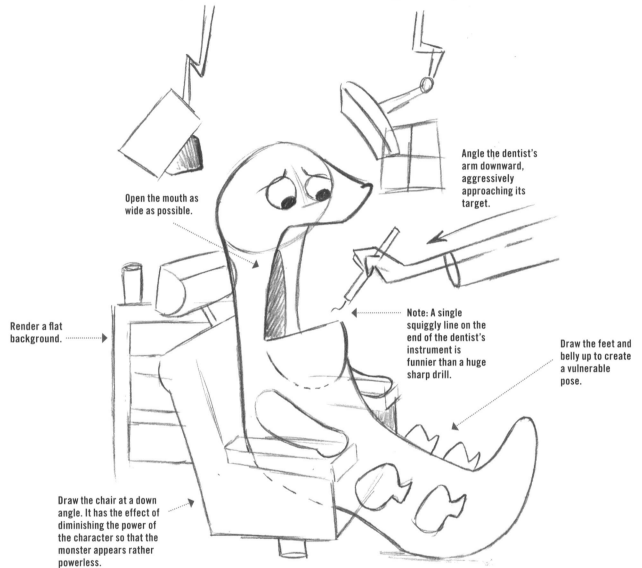

Open the mouth as wide as possible.

Angle the dentist's arm downward, aggressively approaching its target.

Render a flat background.

Note: A single squiggly line on the end of the dentist's instrument is funnier than a huge sharp drill.

Draw the feet and belly up to create a vulnerable pose.

Draw the chair at a down angle. It has the effect of diminishing the power of the character so that the monster appears rather powerless.

ARMREST DETAIL

The monster clutches the armrests for dear life. Both hands face outward to emphasize the act of the monster bracing itself.

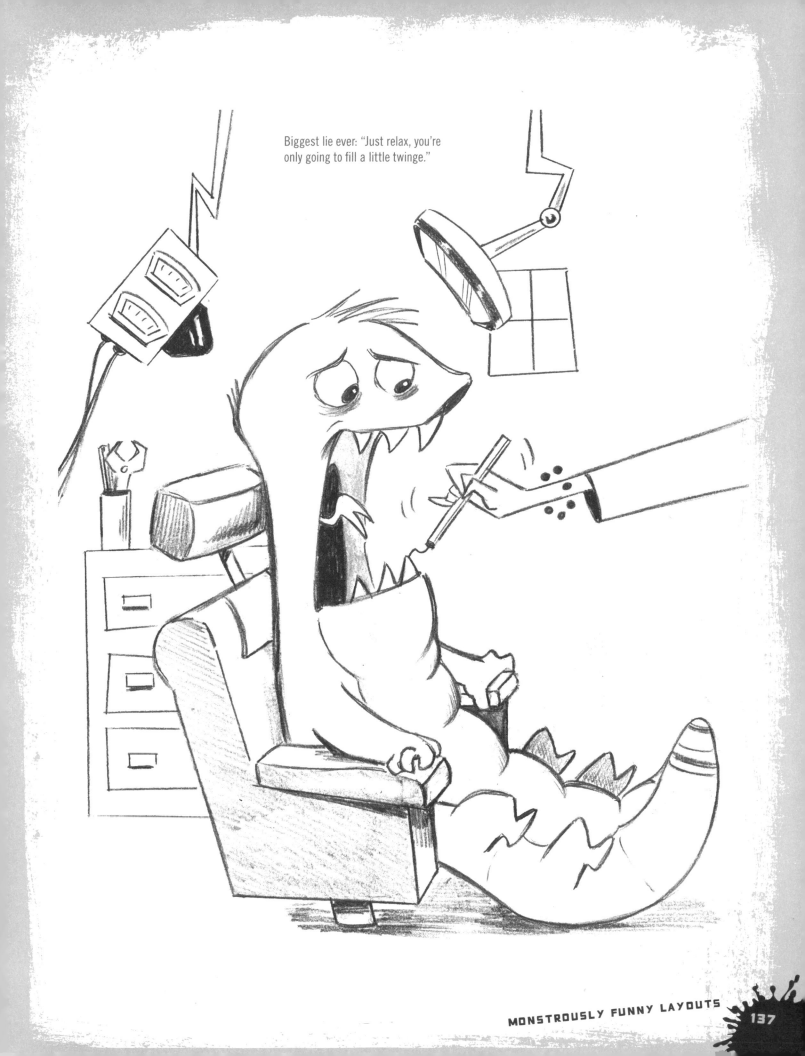

Biggest lie ever: "Just relax, you're only going to fill a little twinge."

Bad Monster!

This type of a layout is one of the most frequently used in cartoons. It focuses on the relationship and communication between characters. In this scene, a dad monster scolds his kid monster for making a small mistake. The viewer feels sorry for the kid monster because of the aggression of the dad and the height difference between the two, which causes the little monster to look up.

Allow the background to recede by keeping it simple and symmetrical. Make it roomy around the characters. In other words, give them a stage on which to perform.

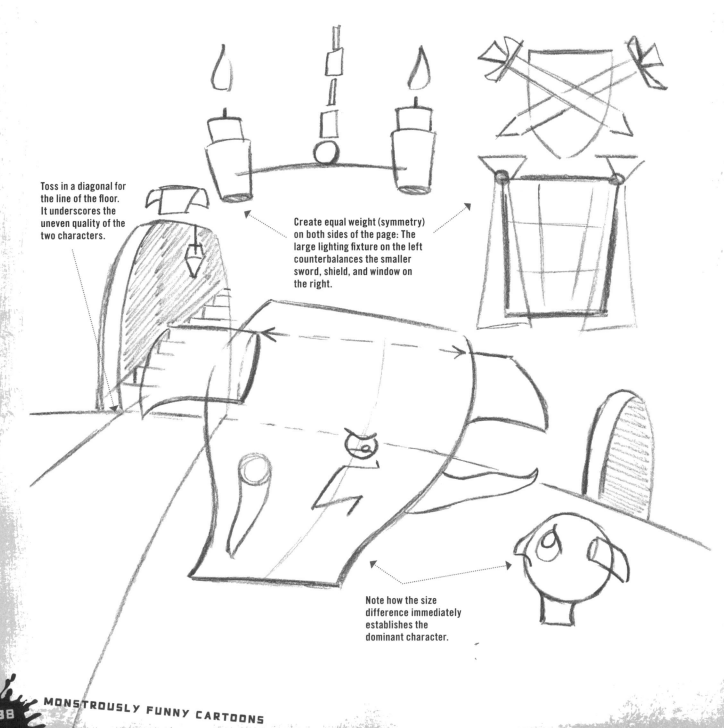

Toss in a diagonal for the line of the floor. It underscores the uneven quality of the two characters.

Create equal weight (symmetry) on both sides of the page: The large lighting fixture on the left counterbalances the smaller sword, shield, and window on the right.

Note how the size difference immediately establishes the dominant character.

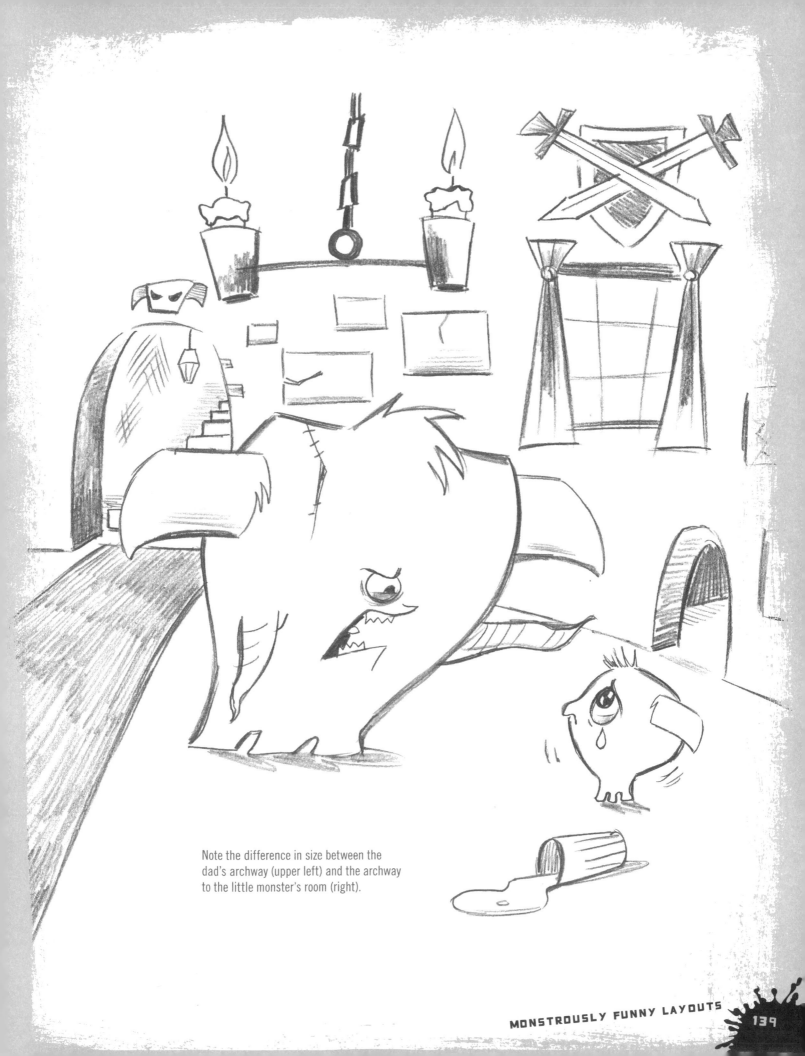

Note the difference in size between the dad's archway (upper left) and the archway to the little monster's room (right).

Who Wants Refreshments?

Monsters and medieval scenes are a natural. They go together like eggs and bacon. The foregound-backround layout is a dynamic one because it uses layering to suggest depth. This layout is used to define the importance of the characters. Foreground placement suggests a powerful character, and background placement suggests a weaker character. In this situation, the dominant character (the Scheming Lady) is positioned on the near side of the floor line, whereas the king is positioned on the far side of the floor line.

The stone wall visually relegates the feckless king character to a small room (indicating *helplessness*) while the Scheming Lady walks toward him (indicating *anticipation*). The caged monsters also provide anticipation: Look what happened to them!

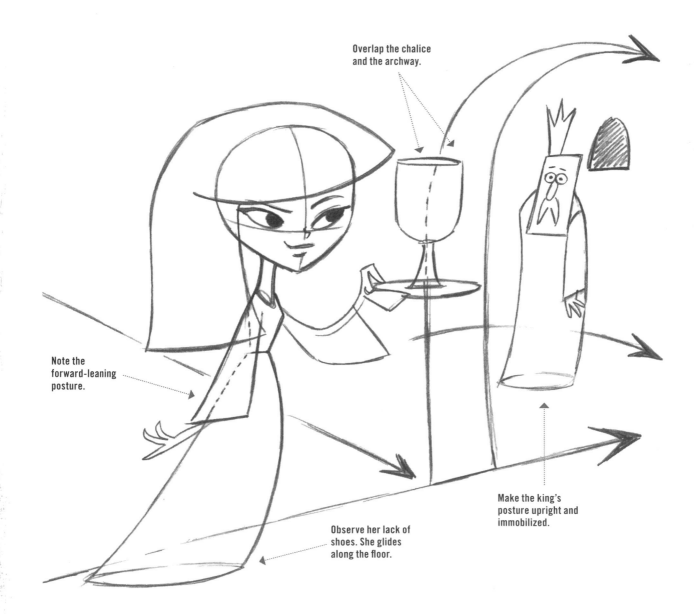

Overlap the chalice and the archway.

Note the forward-leaning posture.

Observe her lack of shoes. She glides along the floor.

Make the king's posture upright and immobilized.

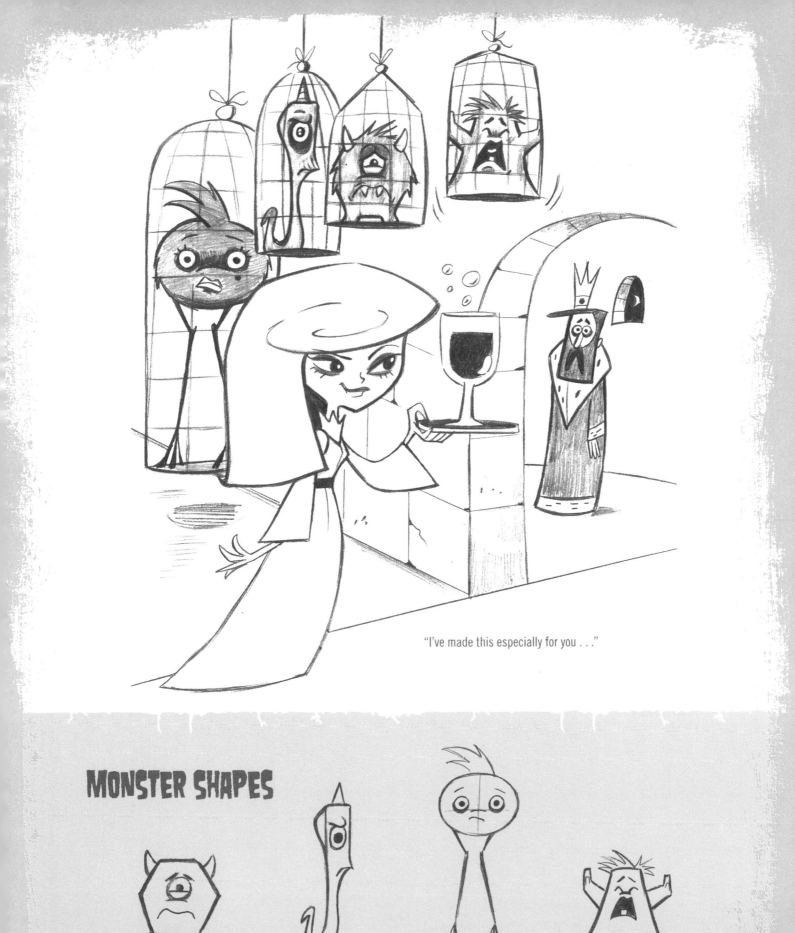

"I've made this especially for you . . ."

MONSTER SHAPES

An anxious pentagon

A worm with a horn

A circle with bird legs

A screaming portion of custard

The Long and Winding Road

In this scene, the two mummies are dummies, because while they are preoccupied with a shiny gem, the dragon is preoccupied with finding something good to eat. Note how the distance between foreground and background adds the element of *time*. Because it will take a few moments for the dragon to reach the mummies, anticipation builds. You can also use the element of time to give these two rocket scientists a moment to effect an escape. When a scene has numerous elements going on, as this one does, keep it clear by simplifying it.

The main element here is really just a modified zigzag. But it also happens to be very effective for creating distance. It often suggests an arduous journey ahead. And it can create the look of peril when drawn to represent a precarious bridge over a steep drop.

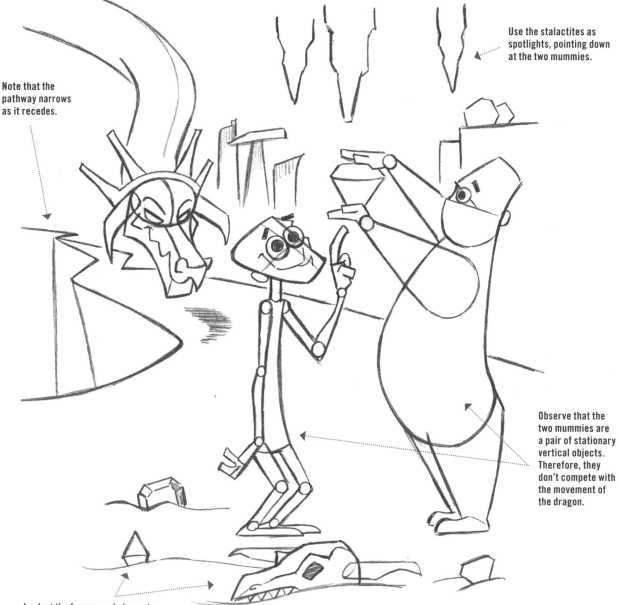

Note that the pathway narrows as it recedes.

Use the stalactites as spotlights, pointing down at the two mummies.

Observe that the two mummies are a pair of stationary vertical objects. Therefore, they don't compete with the movement of the dragon.

Look at the foreground elements.

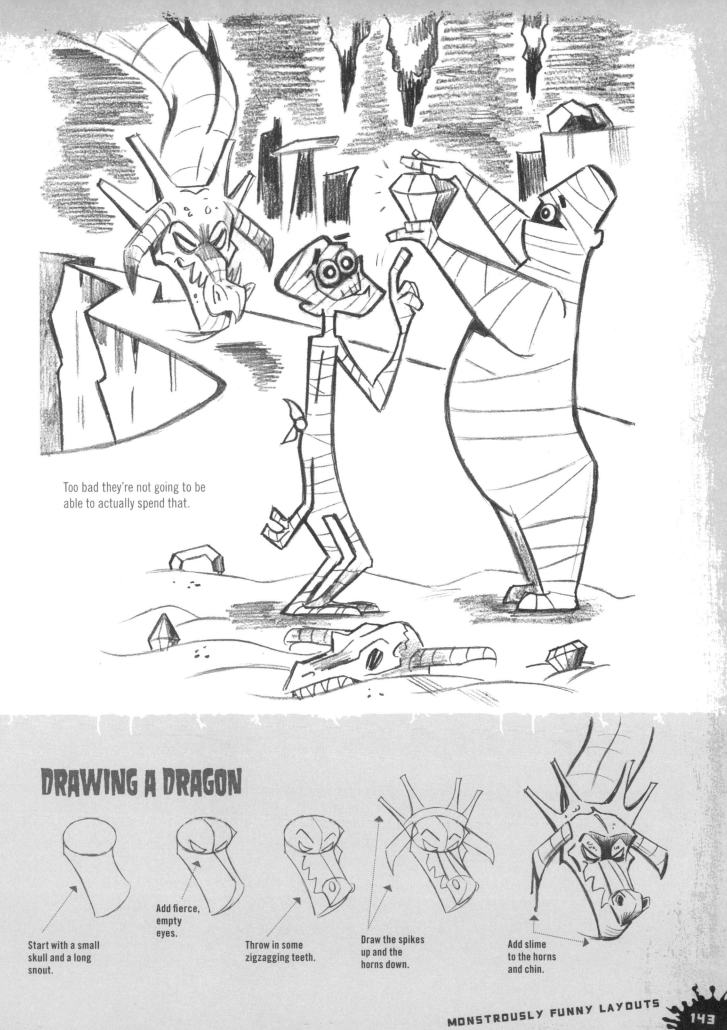

Too bad they're not going to be able to actually spend that.

DRAWING A DRAGON

Start with a small skull and a long snout.

Add fierce, empty eyes.

Throw in some zigzagging teeth.

Draw the spikes up and the horns down.

Add slime to the horns and chin.

Use Sense for Nonsense

This type of layout combines unlikely, random elements. Taken as a whole, this nonsensical environment exudes joy as well as the disturbing unreality of dreams. But if this scene is filled with so much randomness, why doesn't it appear chaotic? Because I've applied the essential formula for creating nonsense scenes, which is $(R + P) \times L = W$.

In case you've never taken a course in cartoon calculus, I'll clarify the equation: "Randomness, arranged in Patterns, tied together by overarching Lines, results in Whimsy." Conceptually, the various elements have nothing to do with one another. However, visually, you can make important connections. For example, volcanoes have very little to do with rainbows or bubbles or an opened hatch in the sky, so the viewer gets a sense that it's a wild image, a sort of carnival fun house. But the layout establishes a controlled environment. If it didn't, the image would give the viewer a feeling of anxiety, not pleasure, because the picture could not be visually assimilated. Let's look at how a sense of order was established.

Note: The hatch in the sky is positioned directly over the two cast members of the scene, suggesting a long, vertical direction to the right half of the page.

Use overarching lines from the rainbow to create a continuous backdrop.

Draw the volcanoes and trees in pairs. This creates a pattern of pairs. Patterns convey a sense of stability and predictability.

Draw an even horizontal line for the ground.

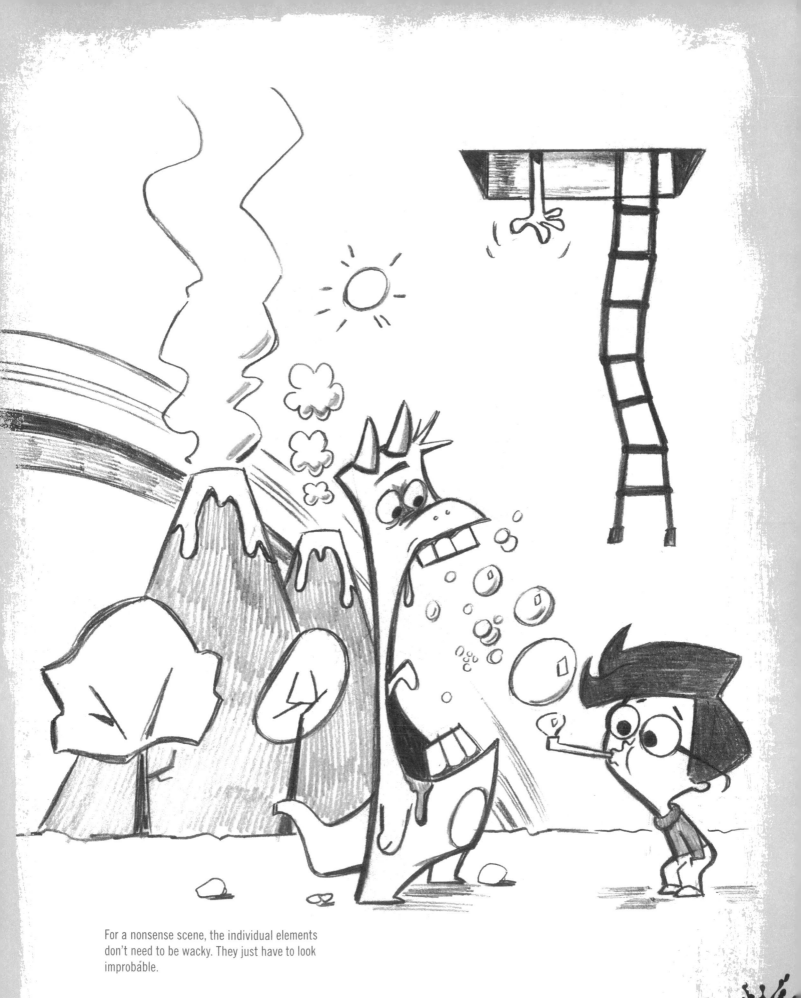

For a nonsense scene, the individual elements don't need to be wacky. They just have to look improbable.

Dead and Buried

The character—or characters—in the scene must be positioned in contrast to the primary orientation of the lines of the layout. In case that sounds complicated, the example on this page should make it crystal clear: The monster and his cat sitting on a tombstone are the only significant vertical elements in this scene, which is otherwise dominated by strong horizontal lines. The cemetery gate, the line of the hills, and the sky (as indicated by the the clouds) are all oriented horizontally.

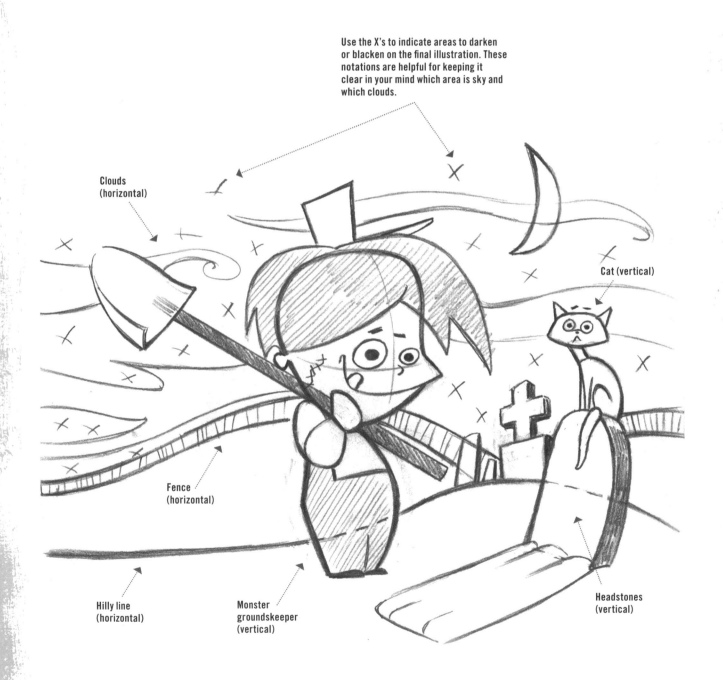

Use the X's to indicate areas to darken or blacken on the final illustration. These notations are helpful for keeping it clear in your mind which area is sky and which clouds.

Clouds (horizontal)

Cat (vertical)

Fence (horizontal)

Hilly line (horizontal)

Monster groundskeeper (vertical)

Headstones (vertical)

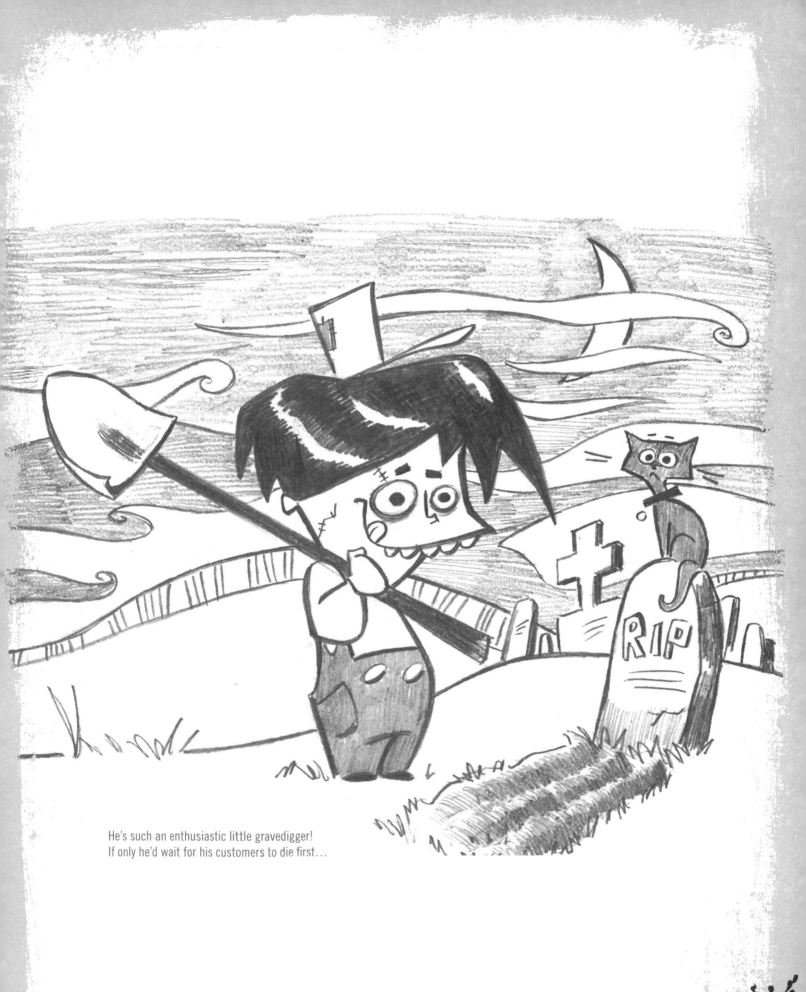

He's such an enthusiastic little gravedigger!
If only he'd wait for his customers to die first...

Axing for Trouble

The dismembered head is the focus of the scene. Therefore, I've elevated it and placed it at the center of the layout, to give it maximum prominence. The two characters here are a classic comedy duo: a short and heavy guy paired with a tall and skinny guy.

Two strong diagonals connect the two characters: the *line of vision* (see the dotted line) and the axe handle.

On a final note, multiple figures in a scene create a pleasing layout when their poses are such that they almost fit together like pieces in a jigsaw puzzle. But the opposite approach gets more laughs. It's funnier when characters are drawn in poses that can't possibly fit together. Just look at the two characters on this page. They've puffed out their chests so far that they are almost colliding with each other!

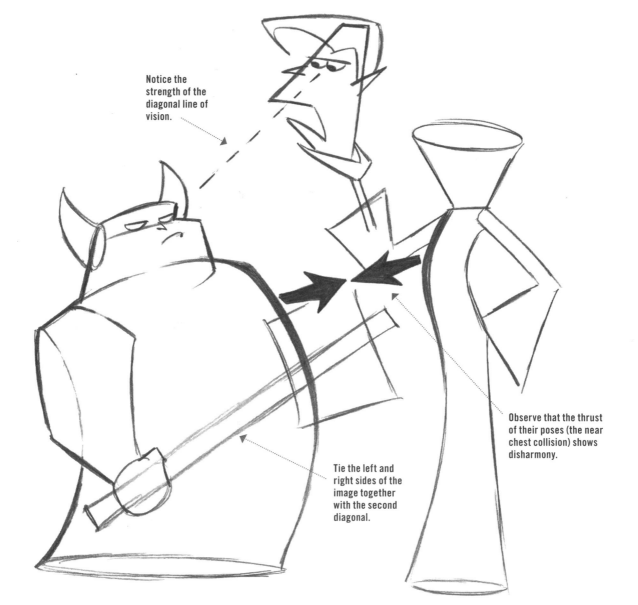

Notice the strength of the diagonal line of vision.

Observe that the thrust of their poses (the near chest collision) shows disharmony.

Tie the left and right sides of the image together with the second diagonal.

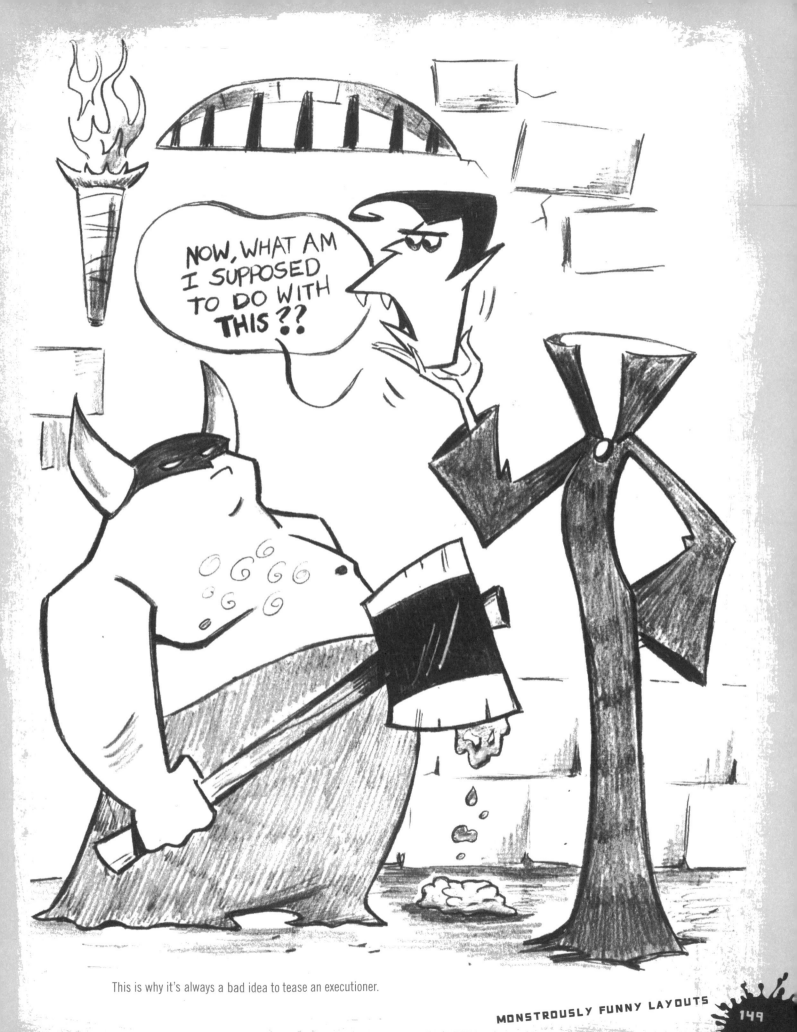

This is why it's always a bad idea to tease an executioner.

Finding the Principles

Now it's your turn to describe what you see. I've posted five simple examples.
Each scene is based on one or more of the layout principles I covered in
this chapter. Observe each one carefully, looking to recognize some of the
principles involved.

Character interaction: Note that each character touches another
character to tie them together.

The long and winding road:
Note the layering as the
mountains are overlapped
by the horizon line.

Horizontals and verticals: The low horizon line, across the page,
provides a strong contrast to the vertical skyscrapers.

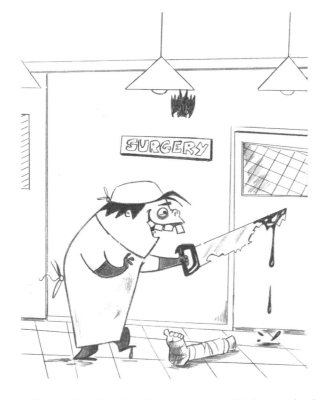

Prominent positioning: The doctor's saw is tilted up to a level
even with his head.

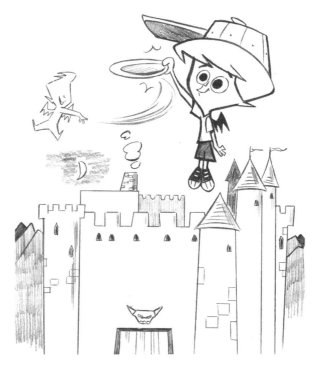

Foreground-background: The castle in the background, as well as
the playmate in silhouette, indicates distance from the character
in the foreground. This is a more inventive way to stage the
scene than drawing the two boys facing each other flatly in a
side view.

Index

31901055686044